Maurizio Cattelan

Patrick Corillon

Eric Duyckaerts

Keith Edmier

Marie-Ange Guilleminot

Emma Kay

Vik Muniz

Paul Noble

Fernando Sánchez Castillo

Katy Schimert

Pierrick Sorin

Momoyo Torimitsu

Patrick Van Caeckenbergh

Xavier Veilhan

Brigitte Zieger

ABRACADABRA

International Contemporary Art

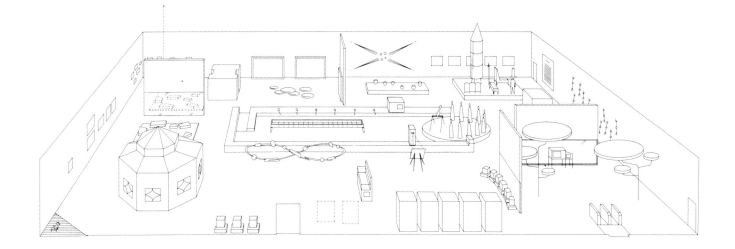

Edited by Catherine Grenier and Catherine Kinley

With contributions by Martijn van Nieuwenhuyzen and Matthew Higgs

TATE GALLERY PUBLISHING

Supported by
The Henry Moore Foundation
And the Association Française
d'Action Artistique,
Ministère des Affaires Etrangères
In association with The Times

Cover: details from
Maurizio Cattelan, *Twentieth Century* 1997 (no.3)
Patrick Corillon, *The Ticket Gates* 1993 (no.7)
Eric Duyckaerts, *The Loop* 1996 (no.23)
Keith Edmier, *Victoria Regia* 1998 (nos.25-6)
Marie-Ange Guilleminot, *Dress no.12. Red Emotion Dress*
 1996 (no.27k)
Emma Kay, *The Bible from Memory* 1997 (no.31)
Vik Muniz, *Babe* 1998 (no.34a)
Paul Noble, *Meet Ineffectual (1)* 1995-6 (no.37h.1)
Fernando Sánchez Castillo, *Explosion Simulator*
 (Casa Desencantada) 1998 (no.38)
Katy Schimert, *The Sun* 1998 (no.47)
Pierrick Sorin, *Pierrick is Cutting Wood* 1997 (no.51)
Momoyo Torimitsu, *Miyata Jiro* 1994 (no.52)
Patrick Van Caeckenbergh, *The Rocket* 1986-7 (no.54)
Xavier Veilhan, *The Weightlifters* 1997 (no.63)
Brigitte Zieger, *Playtime* 1998 (no.64)

Title-page: Plan of exhibition space,
Stickland Coombe Architecture

ISBN 1 85437 294 7

Published by order of the Trustees of
the Tate Gallery 1999
on the occasion of the exhibition at
the Tate Gallery 15 July – 26 September

A catalogue record for this publication is
available from the British Library

Published by Tate Gallery Publishing Limited
Millbank, London SW1P 4RG

Designed by Peter B. Willberg at
Clarendon Road Studio

Printed in Great Britain by Balding + Mansell

Acknowledgements

As always we are most grateful to the numerous people who have given invaluable support to this project. Our thanks go to the staff of the Musée national d'art moderne at the Centre Georges Pompidou, and in particular to Yasmine Dabiens, Johan Leberre and Davis Xavier. Many people helped us and contributed valuable insights during the intial planning stages of the exhibition. Among others we thank Katia Baudin, Phillip van den Bossche, Saskia Boz, Sadie Coles, Alissa Friedman, Laure Genillard, Sarah Greenberg, Jane Hamlyn, Lotta Hammer, Marc Jancou, Jay Jopling, Fabienne Leclerc, Rose Lord, Victoria Miro, Anthony d'Offay, Maureen Paley, Friedrich Petzel, Caroline Schneider, Maud Struyvenberg, Naomi Urabe, Marina Warner and David Zwirner.

It has been a great pleasure to work so closely with all the artists involved in the exhibition and we thank them for their enthusiastic support at every stage. We also thank Nick Coombe and his assistant Hana Ichikawa from Stickland Coombe Architecture for a fruitful and close collaboration and for the exciting scheme that is the result, and Peter Willberg for his innovative catalogue design. We are particularly grateful to Matthew Higgs and Martijn van Nieuwenhuyzen for their thoughtful contributions to the catalogue.

We would also like to thank the many Tate staff who have collaborated or helped on this exhibition. In particular we thank those who have worked closely from the start on the realisation of such a complex project: Liz Alsop, Tanya Barson, Sophie Clark, Carolyn Kerr, Jemima Montagu, Ruth Rattenbury and Sarah Tinsley. Among many others we also thank Ray Burns, Stephen Deuchar, Sionaigh Durrant, Rick Forbes, Jim Grundy, Jackie Heuman, Mary Horlock, Jeremy Lewison, Frances Morris, Sandy Nairne, Katherine Stout, Sheena Wagstaff, Simon Wilson and Calvin Winner for their invaluable help and support.

Catherine Grenier and Catherine Kinley

Director's Foreword

This exhibition brings together a group of fifteen young artists who reconcile two apparent polarities, the worlds of the everyday and the imagination. Coming from Belgium, Brazil, France, Germany, Great Britain, Italy, Japan, Spain and the United States of America, these artists communicate in diverse ways and with great freedom of reference. Their audiences are invited to share private fantasies and obsessions mediated through the familiar images and preoccupations of daily life.

The exhibition developed from conversations in 1997 between colleagues at the Tate and Catherine Grenier, curator of contemporary art at the Centre Georges Pompidou in Paris. She had identified a number of young artists who were increasingly resorting to fantasy and humour as the vehicles for their personal concerns and experiences. Grenier characterised their approach as reminiscent of the traditional salon 'where serious topics may be discussed in light and accessible ways, freed from constraints'. She noted that this tendency called for a particular type of exhibition, one that responded to the congenial spirit of the work. Her challenge was taken up by Nick Coombe, the architect for *Abracadabra*, who in opening up the gallery spaces has enabled us to show work of great physical diversity in new and innovative ways. During the development of the exhibition regular discussions between artists, architect, designers, authors and curators have continued to reflect the collaborative and inclusive spirit of the project.

The exhibition has been selected by Catherine Grenier working closely with Catherine Kinley, curator of contemporary art at the Tate Gallery, both of whom have written essays for the catalogue. We are most grateful to Catherine Grenier for sharing her extensive knowledge of international contemporary art with us, and for her elegant and informative essay. We also thank Martijn van Nieuwenhuyzen, curator at the Stedelijk Museum in Amsterdam and head of the Stedelijk Museum Bureau, and Matthew Higgs, artist, writer and curator, for their illuminating and thoughtful contributions to the catalogue.

We particularly thank the artists, who all responded so enthusiastically to the project and who have collaborated at every stage. We are also extremely grateful to those who have so generously agreed to lend works to the exhibition from public and private collections. To them we offer our warmest thanks.

We must also thank all those individuals at the Gallery and beyond who have supplied advice and technical expertise at each stage.

We are also most grateful, on this occasion as so often before, to the Henry Moore Foundation and the Association Française d'Action Artistique for their support of exhibitions at the Gallery.

Nicholas Serota
Director

Introduction by Catherine Kinley

The title *Abracadabra* gives a feeling of precarious balance. It anticipates change, provisional states and transformation, but it also intimates blind faith, incantations and the rackety charm of domestic tricks, where sleight of hand can reveal magic in the everyday. The essentially optimistic message of this exhibition is that there is art now being made that can be approached as an ameliorative zone, a common ground for audience and artist, where communication is direct, authentic, informal and negotiable. In the words of Charles Baudelaire, 'I like to imagine an art whose enduring nature would give way to the provisional. An art applied constantly to life. Spectacles. Seasons. The sun. Dancers and dance.'

This publicly personal art challenges assumptions about the power of the virtual over the real in a world where it is thought increasingly difficult to distinguish one from the other. A decade ago, artists had begun to doubt that the real could still be easily identified. Their art was made in the context of propositions by post-modern critics and philosophers who were examining the effects of the proliferation of electronic media and the power of the information explosion. In the 1950s and 1960s advertising and film, earlier manifestations of the information age, had been co-opted and celebrated by artists. Later, television, video and computers offered new possibilities for art, but were also seen as having the power to dull 'real' experience and to fuse the real and the imaginary. The palpable world appeared impenetrable and opaque. A common response — whether a symptom of resignation or a strategic act of alliance — was to mimic this new artificiality.

But the artists in *Abracadabra* do not display what has been described as the 'fetishised helplessness' of some of their immediate predecessors, although some, like Xavier Veilhan, have quoted post-modern theory in their work. A number of them have bridged the gap between the phenomenal and the actual by openly demonstrating the physical constituents and internal workings of their art. Fernando Sánchez Castillo's *Explosion Simulator (Casa Desencantada)* is a home-made device that reveals its materials and mechanics. Like Maurizio Cattelan's football table, which needs players to animate it, *Explosion Simulator (Casa Desencantada)* is a reminder that the untidy and eclectic nature of the real world has been a continuous feature of art in the twentieth century. Nature has not entirely been subsumed by culture.

Today, heterogeneity and eclecticism are orthodox, in that so much current art involves the bringing together of physically and culturally disparate elements. To this extent the late twentieth century may be seen as open season for artists still working broadly in the tradition of Marcel Duchamp, but now supported by an information network that can effectively short-circuit research and conflate history. The works in *Abracadabra* are approachable; the objects, dresses, stories, games and cooking pots appear domestic, but while this makes

them accessible, it does not make them simple. Their makers' fascination with the apparently everyday is a side-step around cloned images, surrogate experiences and information overload into more rewarding obsessions. This generation feels free to adopt a pick-and-mix approach to art history. Its work might include ready-made objects (with cultural baggage intact), replicas or inventions, in any combination. Maurizio Cattelan has commented on the historical specificity of Duchamp's use of the ready-made, '[he] was reacting to the era he was living and working in … I use the things that surround me from the society I live in'.

In *Abracadabra* the viewer is asked to engage with a range of languages, grammars and cultural references. Low-budget films, *povera* materials, personal reminiscences, home-made moon rockets and small domestic tragedies sustain a network of references that extend beyond their often playful singularity. Thus it takes time to gain access to Eric Duyckaerts's ironic video work, *How to Draw a Square*, without knowing something of the academic discourse and particular genre of science programme that he parodies with his genetic improbabilities and relentlessly frustrated logic. Likewise, it is necessary to know something about urban life in the industrialised world and perhaps to have experienced the depression of Britain's inner cities to understand fully the 'otherness' of Paul Noble's darkly humorous game.

In the twentieth century, fantasy and imagination have jostled the everyday as agents of authentic experience from Dada to Fluxus and Pop art. Even non-fantastical *Arte Povera* has celebrated the artist as alchemist, revealing magic in base materials and ordinary things; Minimal art is as much about perception as about an architectural relationship with its audience; and Conceptual art, despite its aloofness from popular reference and consumption, has required a certain leap of faith, often applying extreme logic to incidental events and direct personal experience. The artists in *Abracadabra* have adopted strategies from most of these avant-gardes. The humour and anarchy of Dada and Fluxus can be seen in Pierrick Sorin's *Awakenings*, a series of ephemeral snapshots of his everyday life, and in Patrick Van Caeckenbergh's hybrid *Potty Chair*. The scale and glamour of Pop is exemplified in the polished surfaces of Xavier Veilhan's digital images. Equally present are echoes of the obsessive accumulations of Outsider art, as in the work of Noble and again in that of Van Caeckenbergh. A more contemplative, though no less constructed, world of literature, film and pulp fiction is explored by Patrick Corillon, Emma Kay, Katy Schimert and Brigitte Zieger.

Past British models for this type of work might be the Independent Group in the 1950s or the architectural practice Archigram working in the 1960s with its schemes that combined different modes and scales of representation within one model. Individual artist precursors include Marcel Broodthaers — poet, photographer, film-maker and artist — whose work relies on the playful and subversive relationship of word to image, and Andy Warhol, who has revealed the incidental within the general and made the superficial enthralling.

Although none of the participants in this exhibition presents a heavy-handed social agenda, artists like Cattelan and Veilhan have acknowledged a political dimension to their art and others infer it. Many of the works play on instability, combining images of authority and anarchy. Several suggest imaginary zones where rituals may be played out, but where dynamic action is destined to be frustrated and the truly destructive (or generative) moment is held in check. Veilhan's *Republican Guard*, a symbol of the state waiting to be mediated through the lens of a tourist's camera, his cardboard-clad patriarchs suspended in a frozen world, and his spinning disks which literally undermine the physical order of the space seem to express this paradox. An equally playful destabilisation is echoed in Marie-Ange Guilleminot's unpredictable rotating machine with its own eccentric dynamic and in Sánchez Castillo's exploding *Explosion Simulator (Casa Desencantada)*, endlessly destined to destruct and recon-struct — a parable about the individual facing the state. An altogether darker manifestation of futile protest is seen in Zieger's video, ironically titled *Playtime*, where a sniper, an alienated boy-man, 'shoots' invisible passers-by from his upper window with a cardboard gun, and again in Cattelan's immobilised animals and child. Frustration and pathos mark Noble's 'game' about the dole and Torimitsu's abject crawling businessman. Van Caeckenbergh's journeys of self-exploration lead him, by his own admission, right back to where he started.

All these works have a metonymic as well as a concealing function. A number are self-portraits, which either use the artist's image — Duyckaerts, Zieger, Sorin, Veilhan and Torimitsu — or which infer their presence with support mechanisms and domestic necessities — Van Caeckenbergh, Guilleminot, Corillon. Guilleminot exhibits her dresses and wears them in performance, but they are stand-ins and masks for the real person; Corillon's alter-ego is a poet-musician who inhabits a romantic fictitious past. Equally strong throughout is the suggestion of a hyper or meta-world. Zieger, for example, has spoken of her interest in science fiction, and the humming sound in *Venus* is intended to evoke the soundtrack of a low-budget science-fiction film, while Schimert's narcissistic dream-world and Veilhan's hyper-real scenarios also suggest heightened dream-like states.

Five years ago, in her essay 'What Good are Artists Today', Julia Kristeva wrote: 'Artists no longer have a base and art no longer the certainty of being the cornerstone … it is as though artists were inventing quasi-sacred spaces for us … it is as though they were asking us to commune with other beings, or with Being itself … the aim of art is not only incarnation but also narration … An installation invites us to tell our own little stories, to commune with Being through our sensations and our stories.' With *Abracadabra* we have attempted to facilitate a similarly non-prescriptive alignment between artist, artwork and audience. The works in the exhibition are not presented as the last word but as the tip of an iceberg. We have deliberately softened the curatorial reins because it is prudent to remain somewhat equivocal when introducing such physical and syntactical diversity. This is an exhibition that invites its audience into

many different sorts of space: social, conceptual and aesthetic. It offers many different routes to familiar questions about interpretation and intention, and invites quite a degree of commitment from the viewer. As the photographs and press cuttings of Vik Muniz suggest, nothing here is quite what it might at first seem. As with all good art it is in the possibility of each artist's 'then' existing in the viewer's 'now' that the real magic resides.

Conjuring Fantasy by Martijn van Nieuwenhuyzen

Faced with an exhibition that explores the spirit of fantasy in contemporary art (and life), one's first impulse is to ask whether fantasy, in the broadest sense, is not implicit in every work of art, even in a work that refers in the most unequivocal and direct sense to everyday reality. Does the stunning perspective in Gustave Caillebotte's painting of a Parisian street, *Boulevard Seen from Above* (1880), a subject so apparently inconsequential and neutral that it had scarcely ever been chosen as the theme of a painting, have less to do with the power of imagination than the vision of a group of onrushing wood goblins in Max Ernst's *The Horde* (1927)? Does Andreas Gursky's photo image of an archaeo-logical site (*Thebes, West*, 1993) qualify as less fantastic than a grotesque mutant assembled from shop-window mannequins by Jake and Dinos Chapman? There are images of great artistic invention, which change the rules of intelli-gent viewing, but which are by no means the product of a fantastical mind. Yet of these images too it can be said: without fantasy no imagination, without imagination no image.[1] Every image that demands to be looked at also stimu-lates the viewer's imagination and in doing so becomes a product of fantasy. One cannot help wondering, therefore, whether those who claim to see the role of fantasy in contemporary art as an expression of the *Zeitgeist* do not both over-rate and underrate fantasy. If fantasy is immanent in every work of art, it has never been absent and cannot, therefore, reappear — for it was there all along.

To suggest, as Catherine Grenier has done, that there has been a recent, not to say *fin de siècle* resurgence of fantasy among today's young artists, is to invite debate. Given the broad area in which art currently operates, such a debate might be more complicated and less conclusive than the one that preoccupied the painting- and sculpture-dominated 1980s, when we saw discreet remakes of Alfred Barr's *Fantastic Art, Dada, Surrealism* exhibition of 1936/7. In those years neo-surrealism was touted in shows like *New Handpainted Dreams: Contemporary Surrealism* with the suggestion that young American painters had reinstated Surrealist methods and doctrines.[2] But it soon became clear that there was no question of a new, programmatic surrealism but rather a readily marketable surrealistic iconography that had welled up from the oft-tapped caverns of the unconscious.

Perhaps what best characterises recent art, witness the practice of several artists represented in this exhibition, is its tendency to elude our avid attempts to categorise it. Artists have been playing around with the rules of the game since the mid-1990s with the ultimate aim of giving artistic frames of reference a thorough shake-up. Painting behaves as if its remit had been broadened and turns to a pictorial use of photography, film and other non-painterly techniques, indulging its urge to expand in pictorial installations that completely trans-form space. Sculpture, too, is at its most flexible and ephemeral, merging into ambient spaces which not infrequently include hired extras as living sculptural

1. These ideas on artistic invention and the example of Caillebotte are loosely based on Kirk Varnedoe's *A Fine Disregard*, New York 1990. See in particular ch.5, 'Overview: The Flight of the Mind'.
2. *New Handpainted Dreams: Contemporary Surrealism*, Barbara Gladstone Gallery, New York 1984.

3. Maria Lind, 'Spatial Facsimiles and Ambient Spaces', *Parkett*, no.54, 1998/9, pp.191-4. See also the *WildWalls* catalogue, ed. Leontine Coelewij and Martijn van Nieuwenhuyzen, Stedelijk Museum, Amsterdam 1995.

elements in testimony to the artist's deep-felt desire to animate the work of art, to bring it to life.[3] Image and image formation extend into areas far beyond the traditional confines of visual art. Art has even ventured into the world of fashion, with all the mutual feelings of unease that accompany such border-hopping exercises. But the most challenging developments since the mid-1990s concern artists who employ strategies aimed at evoking direct experiences and bridging the distance to the public, in some cases resulting in works where artist and viewer come within touching range. Marie-Ange Guilleminot demonstrated this almost literally in *Gestes* (1994) a work in which she shut herself up in a cubicle and stretched her hands out towards passers-by through holes in a wall. 'Social performance' is the term coined to describe this process-like, interactive form of art. With a renewed orientation to action and performance, using the city as a stage for direct interaction with the public, these artists attempt to reinstate the avant-garde ideal of uniting art and life.

fig.1 Marie-Ange Guilleminot, *Salon de Transformation No.1 - CAURIS (collant-sac à dos, sac à dos-collant)* 1997, Venice Biennale

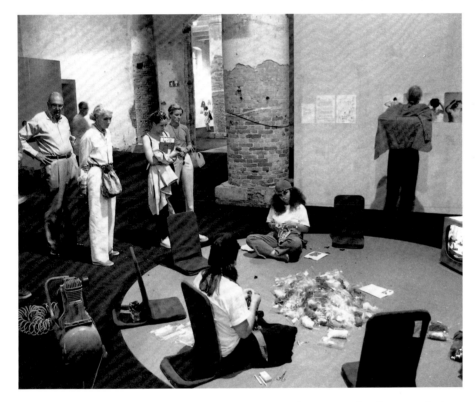

When such artists work within an institutional context, the desire to bring art and life closer together finds expression in interventions intended to undermine the rituals of the museum visit and to coax the public into collaborating in the work of art. At the 1997 Venice Biennale, Guilleminot set up *Salon de Transformation No.1 — CAURIS (collant-sac à dos, sac à dos-collant)* (fig.1) where she invited members of the public to join her in a process of transformation: participants sat on specially designed and covered chairs arranged on a circle of red cloth and made backpacks (*sacs à dos*) from piles of multi-coloured women's tights. Guilleminot's helpers showed them how to manipulate the nylon tights by filling them with balloons. There were also videos demonstrating

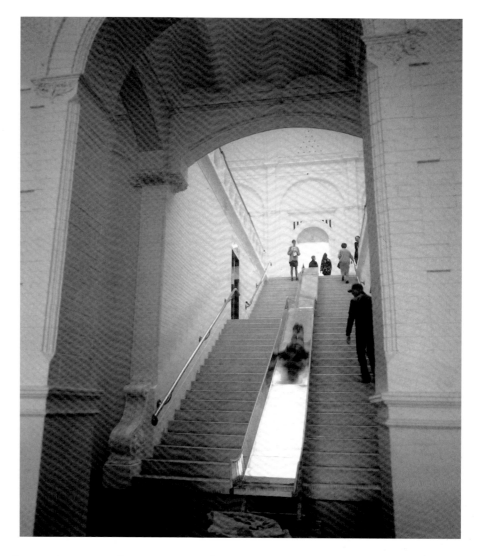

fig.2 Alicia Framis, *Emergency Architecture* 1996, Stedelijk Museum, Amsterdam

how this mundane material could form the starting-point for a coming and going of sculptural inventions. Guilleminot said of her volunteers, 'I try to give them an opportunity to practise a *geste*, to create a kind of relationship they have never had before.'[4]

As part of the *Peiling 5* exhibition in the Stedelijk Museum Amsterdam (1996), Spanish artist Alicia Framis installed a slide on the building's monumental staircase so that visitors could exit the building at breakneck speed (fig.2). *Emergency Architecture* was the title of this light-hearted artwork, simultaneously an unmistakable vote of no confidence in the institutional framing of art. In the same exhibition, the Rotterdam-based English/Dutch collective Bik Fillingham Van der Pol presented a mirror-image reproduction of their kitchen in the Rotterdam artists' centre Duende. The original kitchen provides a meeting place for the artists and foreign colleagues staying in the guest studios. The replica of the kitchen in the exhibition, *The Kitchen Piece* (1995), served a similar lively purpose within the museum setting: during the exhibition visitors to the Stedelijk Museum were received in the kitchen by the artists and their assistant and entertained with food, drink and conversation.

4. Ann Wilson-Lloyd, 'Reactionary Transactions', *Sculpture*, vol.16, no.9, Nov. 1997

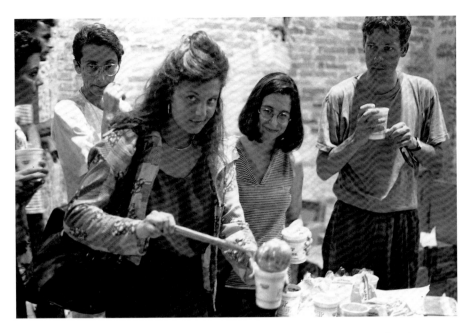

fig.3 Rirkrit Tiravanija's installation at the 1995 Venice Biennale

Whether they are inviting the public to join them in cooking (Rirkrit Tiravanija, fig.3[5]), making objects (Marie-Ange Guilleminot) or sleeping (Alicia Framis's *Dreamkeeper* project, fig.4[6]), it is clear that young artists today are asking similar questions of art to the ones posed in the 1960s and 1970s by Fluxus artists and Situationists in happenings and performances. Their fresh explorations of everyday life and public participation can be compared to the activities of the neo-avant-garde two or three decades ago. But there are differences too, the most important being the absence of an idealistic and utopian framework — the belief that art and artistic representation had the potential to change society. In present-day art one detects a more light-hearted, apolitical attitude, which is perhaps not surprising now that so many big political ideologies have been resoundingly demolished, leaving only a ubiquitous consumerism to be dominant.[7] The strongest comparison from the art of the 1960s and 1970s would probably be the work of artists like Robert Smithson and Vito Acconci. Acconci's *Following Piece* (1969), for which he followed random passers-by on their travels through the city, is prototypical of the way today's artists interpret their role as mediator between art and life and centre their imagination in the social domain.

The *Abracadabra* exhibition approaches the flexible spirit of 1990s' art from the co-ordinates of 'art-reality-fantasy'. The playful character of the art is echoed in the design of the exhibition space — an open environment in which visitors are free to wander around at will, as if in an amusement arcade or shopping complex, able to pick and choose from the range of entertainments vying for their attention. In *Abracadabra* the artist is the ultimate *homo ludens* who, at the century's end, lets art and life run playfully through his fingers and cordially invites viewers — indoors or out — to join in the game. Momoyo Torimitsu, for example, sent a robotic, Japanese salaryman crawling over the pavements of the financial districts of Tokyo, New York and London. Video

5. Rirkrit Tiravanija, an artist of Thai origin, creates site-specific installations that develop through visitor participation. He has produced bars, lounges and restaurant facilities in a variety of exhibition spaces with the aim of creating places for communication and social interaction, linking art with rituals of everyday existence. He has brewed coffee for the public (Max Hetzler Gallery, 1993); served Thai noodle soup (Venice Biennale, 1995); recreated his New York apartment (Kunstverein, Cologne, 1996); and redesigned an entire museum space with places to eat, drink, hear music and buy consumer products (Migros Museum für Gegenwartskunst, Zurich, 1998).

6. Alicia Framis's *Dreamkeeper* project was organised by the Stedelijk Museum Bureau Amsterdam, 24 Jan.– 8 Mar. 1998. It involved Framis spending the night with ordinary Amsterdam citizens who had volunteered to take part. The Spanish artist would arrive at their homes clad in a special outfit and clutching a rolled-up sleeping mat which she spread out on the floor beside the volunteer's bed. When darkness had fallen, the 'dreamkeeper' would cautiously begin to explore the dreams, fantasies, fears and obsessions of her host or hostess for the night, the ultimate aim being to dream a dream together' and so dispel, if only for a moment, the existential solitude.

7. For a fairly critical approach to the art—life relationship as a current artistic stance, see: Jeroen Boomgaard, 'De utopie van de argeloosheid', *De Witte Raaf*, no.77, Jan./Feb. 1999, pp.23–5.

recordings of these ironic proceedings show us how the public reacts to this fallen 'Master of the Universe' (Tom Wolfe) and to the artist who, dressed in a nurse's uniform, accompanies him on his abject passage through the bustling canyons of high capitalism.

However, if any artist knows how to combine fantasy, play and everyday reality in his work, it is Maurizio Cattelan, whose subversive interventions in the mechanisms of the art world are designed to confront curators and gallery owners with moral dilemmas. Cattelan has closed exhibitions to the public, sub-let expensive biennale wall space and persuaded gallery owners to don embarrassing fancy dress. He playfully attacks the art system from the inside, at the same time posing fundamental questions about what it means, here and now, to make art and to be an artist.[8] One of Cattelan's most imaginative actions, dubbed *Another Fucking Readymade* (fig.5) was mounted in 1996 in Amsterdam within the context of the exhibition *Crap Shoot*, the graduation project of a group of young curators at De Appel gallery. The artist gained access, after opening hours and without the knowledge of its owners, to the Bloom Gallery, a well-known contemporary space in the city, and proceeded to dispatch the entire exhibition on display there to De Appel, with the intention of presenting it as his contribution to *Crap Shoot*. Police intervention and the refusal of De Appel's director, who had not been informed of the plan either, cut short this attempt, literally, to steal the show. The booty, still packed in the cardboard removal boxes in which it had arrived, was returned to the Bloom Gallery the next morning. Displayed at De Appel, in its place, were type-written statements by the director and team of curators.

8. See the reviews and other writings reprinted in facsimile in a catalogue of Maurizio Cattelan's work published to accompany exhibitions by Cattelan in Centre d'art – Espace Jules Verne, Brétegny-sur-Orge, Le Consortium, Dijon, Galerie Emmanuel Perrotin, Paris, in 1997 and 1998 – in particular Nina Folkersma, 'Like a Thief in the Night', *The Crap Shooter*.

fig.4 Alicia Framis, *Dreamkeeper* 1998, Amsterdam

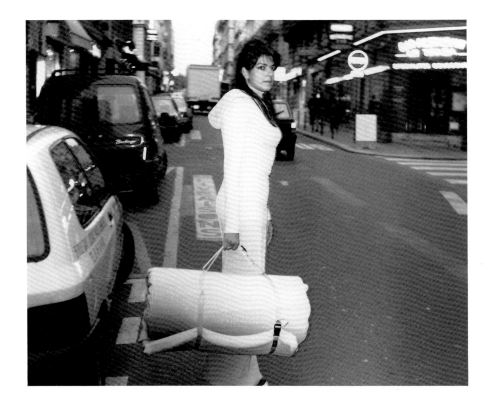

fig.5 Maurizio Cattelan, *Another Fucking
Readymade* 10.30am, 11 April 1996, De Appel,
Amsterdam

Clearly, fantasy and the fantastic used in relation to art are rather elastic concepts. The contingent of young artists whose work could be associated with the notion of fantasy is as diverse as opinions about its role in the production of art. Where exactly should this catch-all concept be located at the end of the millennium — especially with regard to an art that is intent on crossing boundaries and finding a valid relationship with the everyday? Perhaps, for the time being, we should simply let the ball roll where it will, following the example of the editors of *Visionaire*, a New York periodical that operates on the fringes of fashion and art. In late 1998, they published a special *Fantasy* issue which included contributions from noted genre-benders like Sylvie Fleury, Tony Oursler, Inez van Lamsweerde, Jack Pierson and Viktor & Rolf. Partly indebted, but above all unfaithful, to the emphatic idealism of modernism, they, like many of their contemporaries, engage in visual culture in the widest sense. In their work they combine high points in Western art and culture with trivial images from media culture confident that both can be used to create new and meaningful images of our own time: cut, dub, sample, paste, mix, remix.[9]

Translated from the Dutch by Robyn de Jong-Dalziel

9. See the *WILD WALLS* catalogue, ed. Leontine Coelewij and Martijn van Nieuwenhuyzen, Stedelijk Museum, Amsterdam 1995.

The Turn of the Page by Catherine Grenier

It is not long since it seemed that seriousness had definitively descended on art, that artists had taken up the torch of reason to become the new priests, philosophers and healers of a world that had lost its head, and even that their craziest or most pointless manifestations could be read as prophetic scepticism. We imagined them as an army of oracles, answerable equally to art and to the world for the destiny of a civilisation sunk in gloom, guardians of its culture, its identity, its very being. Philosophy and Literature held hands; there was a rush to the bedside of *fin de siècle* Vienna; words, bodies, history were peeled open, the better ever more thoroughly to ransack them. Above all, everything was recorded with a precision and accuracy borrowed from the archaeologists, that sealed the indissoluble alliance between art and memory.

So there it was; the end of the twentieth century would replicate that of the stupid nineteenth century (as Léon Daudet saw it). The arts would gorge themselves on symbolism to the drumbeat of decadence, and the response to an anaemic society would be a dessicated creativity that could be revived only by the efforts of artists become class warriors. Have not many texts been written by informed writers, only a few short years, not to say months ago, that described in these terms the inevitable outcome of the millennium, predicting that history would repeat itself and that modernism would be defeated, and which offered salvation only through the victory of pessimism and the liberal conscience.

What demon has now taken possession of artists, what spell has been cast on them, what bug has bitten them, that the prophecies of these doom merchants have been revealed to be as false as their admonishments were futile? In recent months we have seen a turnaround, the early signs of which, though detectable for some time, had given no indication of its scale. Everywhere, in Europe above all, but throughout the West, we are seeing the flowering of a new spirit, whose spontaneous dynamic favours immediacy, light-heartedness, humour, frivolity, inventiveness and proliferation. This spirit of fantasy is rooted in the everyday: the raw material, familiar and available, for all these artists.

Those who delighted in the magic of the everyday burlesque in the art of Annette Messager, Markus Raetz, Fischli and Weiss or William Wegman have something to get excited about these days. Our world has been re-examined from every conceivable angle by these young artists, who are reoccupying the frontier between art and life. To destabilise life and the real, to turn them into something else, in the heart of a shifting yet familiar territory which is here proposed as the territory of art, is the common aim of these multiple initiatives, all strongly marked by the artist's own personality. To this end are employed all the traditional means of entertainment: laughter, surprise, provocation, association, word play, tricks and cock-and-bull stories have replaced the artist's usual concepts and materials. The spirit of play, which pervades the whole history of human relations and which has presided over the myriad

forms of theatre, parlour games, fairground entertainment, cinema, is stamping itself on art as the agent of a freedom whose place of refuge that spirit has always been.

Has the nightmare become a daydream? Does this movement represent a flight to the dizzy realms of psychedelia? Or a loss of awareness? Quite the contrary: these new forms of art trumpet their refusal to set an example, as they do their denial that they are a substitute for reality. They are profoundly and unconditionally anchored in reality. The friendly interaction they invite is often more than a suggestion, it is a condition of their accessibility. If they often present a smiling face, nevertheless they harbour a full range of human traits: cruelty, egotism, pride, meanness, failure and helplessness are not masked, but on the contrary provide the foundation of the work. Drawing on the everyday, the narratives of this art often relate to the small failings, the minor acts or obsessions that dot our lives: being ill, smoking, drinking, collecting, tidying, being untidy, dressing, digesting, amusing ourselves, remembering, quarrelling, complaining … are the principal activities presented or suggested to the spectator. None of these artists seeks to deny or fight reality but simply to render it bearable, to tenderise it under the hammer of the imagination. As in the world of fairy-tale, to which several of these artists refer, the subject is displaced into the realm of the improbable in order to reinforce its impact. In contrast to the duty felt in the 1970s and 1980s to be true either to a principle (conceptual or behavioural) or to a particular medium, all these works are based on exaggeration: of narrative by means of comic or spectacular effects, of form through enlargement or distortion, of perception by alternate effects of nearness and distance. Reality itself is thus exaggerated so that it sharply strikes the spectator. This is how it is with the absurd and amusing situations that we are drawn into by Patrick Corillon, with the silly and subversive game invented by Paul Noble, the familiar fantasies of Pierrick Sorin, the amazing assemblages of Patrick Van Caeckenbergh, the disconcerting creations of Maurizio Cattelan, Katy Schimert's vision of the cosmological in the contemporary world, the costumed figures of Xavier Veilhan, Emma Kay's massive yet ludicrous feats of recollection, the genuine fake photographs of Vik Muniz, the detail and the protuberant appendages of Marie-Ange Guilleminot's clothes, Eric Duyckaerts's parodic imitations of reality, the terrible toys of Fernando Sánchez Castillo, Momoyo Torimitsu's comic derangements of normality, the world in kit form presented by Brigitte Zieger, and Keith Edmier's giant lilies.

In our culture exaggeration is the prelude to transgression; it is an area tolerated but equally rejected by reason, illuminated by shafts of private fantasy. Imponderable, unstable, it is a disruptive element that is both amusing and disturbing. The cinema has turned it to great advantage, directors often treading the tightrope between its great power of realism and its element of fantasy. Taking a leaf out of this book our artists are following in the footsteps of a cinema that has abolished the restrictions of genre and pushed back the limits

of convention, a cinema in which comedy is no longer the enemy of tragedy, where Toto can meet Pasolini and Jerry Lewis can join Cassavetes. Many of them are thus playing in two fields simultaneously, expressing both a futility that is not devoid of sense and a superficiality that is not without depth. None of them, however, speaks with a single clear voice, none of these fables ends with a moral. No responsibility is accepted or offered by the artist. Confronted by works that tease the reflexes of laughter, curiosity and rejection, the spectator is free, wholly or in part, to embrace them, to interpret them, to graft his or her imaginings onto the branching growths presented by the artist. Each of these works devotes itself to the present with no other context than the common ground of everyday experience. The forms they assume are often random, often diverse. Drawing, video, objects, painting, writing, sound, among myriad intermediate forms, are given equal value whether used individually or combined in one work. While they are not all installations that follow the 1980s model of a formal structure arranged in relation to a given space, these works are usually sequences whose parts are autonomous but linked by a narrative thread that appears and disappears as in a conjuring trick. The space, the environment, is a given taken into account by the artist but extrinsic to the work, which is distinguished both by its autonomy and by its availability – its adaptability, for all that it finds itself in an exhibition context. Indeed for many of these artists, the work in the studio does not exist, and a number of them have given up situating their work in any particular space. Only through exhibition or, in the case of artists such as Marie-Ange Guilleminot and Momoyo Torimitsu, performance, can the work become a reality. For these artists exhibiting no longer means presenting to the public a finished work, but rather putting it into play, like starting off a game of cards or a piece of theatre. And the dimension of theatre is not neglected, but on the contrary is exploited, in its different aspects, by these artists. They devise sets like Patrick Corillon and Pierrick Sorin, improvise productions like Eric Duyckaerts and Maurizio Cattelan, construct habitats like Patrick Van Caeckenbergh, create an environment in which to arrange works that often present themselves as theatre in miniature, as with Paul Noble and Fernando Sánchez Castillo, Xavier Veilhan, Katy Schimert, Brigitte Zieger or Keith Edmier. Even in the case of artists like Vik Muniz and Emma Kay, who work in the more classic territories of photography and the written word, the theatrical is expressed by a kind of displacement, an excessiveness of the object in relation to the concept, that borders on the extraordinary. These works are thus often provocative, the spectator's reactions not having been conditioned in the way that they have been by the many interactive (transactional) works of recent years with a more deliberate social agenda.

This reciprocal play between the innate theatricality of the work and its presentation in the gallery had a strong effect on the way we envisaged the exhibition space for *Abracadabra*. We were led to imagine an unorthodox environment, the spirit of which would respond to the originality of stance of

the artists. Accordingly, the architect Nick Coombe has devised a kind of stage or arena to replace the normal design of museum displays. Not afraid to take the fairground as his model or revive the spirit of Wonderland, he has been sympathetic to the whole range of specific effects and nuances sought by each artist. The relatively small number of artists involved has allowed him to choreograph a fluent relationship between the works and the varied settings created for them.

Of course there are others who could have been included in this exhibition: Damien Hirst, whose work now needs no introduction, as well as several other British artists; internationally, among others, Carsten Höller, Aernout Mik, Peter Land or Claude Closky, as well as numerous young artists who have emerged recently and are being recognised as a new constellation. Whereas art since the 1960s has repeatedly failed in its attempts to reach out to a wider audience, whether through a didactic approach or provocation, this new generation has been able to put itself on an equal footing with the general public. The dazzling success of some of them, while it certainly has something to do with fashion, is evidence as much of the infatuation of the public as of the support of the professionals. One is reminded of Pop art, whose state of mind and defiant freedoms these artists share, without nurturing, as did their predecessors, a certain critical and formal distancing from their subject, that is to say sweeping aside all claim to be making art.

It is notable indeed that in all these works the central place is occupied not by art, subject or society, but by humanity – a term that here denotes its meaning less as a collection of individuals than as a concern, alternately tender, irritated or amused, for the common man and his condition. Man is thus looked at with a gaze that is neither narcissistic nor ideological, soppily benevolent nor sadistically critical. The woebegone eye of Maurizio Cattelan's stuffed horse with its elongated legs, hanging pathetically in the air, is directed at us; Marie-Ange Guilleminot's *Life Hat* is a handy shock absorber designed to protect our delicate heads from the hardness of the world; the Pasolini-like fictions of Katy Schimert speak to us of the insignificance of man against the exterior world; Pierrick Sorin's recordings of his life could be our own of those days when getting up is difficult; the partial memories that Emma Kay squeezes so painfully from her brain can be measured against our own; the big baby who heroically assembles a cardboard submachine-gun under the lens of Brigitte Zieger is us; Momoyo Torimitsu's Japanese businessman who crawls around town clinging to his briefcase is us; Patrick Corillon's old-world hero and heroine, Oskar Serti and Catherine de Sélys, who constantly come up against the extravagance of ordinary life are us. And we marvel at the giant flowers of Keith Edmier, are intimidated by the false Republican guards of Xavier Veilhan, fascinated by Patrick Van Caeckenbergh's world of fantasy, taken in by Vik Muniz's false newspaper articles, disconcerted by Eric Duyckaerts's pseudo-scientific explanations, flabbergasted by Fernando Sánchez Castillo's unlikely

toys, amused but discomforted by Paul Noble's game for people on social security, *Doley*.

Before our very eyes these artists are inventing an art that wishes no longer to change the world but to tame it; the longing to transform creation has been replaced by the desire to let it live. They show a genuine aspiration to free themselves, and us, of all the constraints, theoretical, material, financial, moral, that for too long have inhibited art. For them art is no longer a place to plant their flag, but a territory of exchange; the execution of a work is no longer an end but a means; technique may be necessary or it may be circumvented. Above all art is never presented as a form of work or as a system: everything appears easy on the banks of the river of invention, transformations are effortless, and this art frees itself, literally and figuratively, from every sort of weightiness. So the spirit of childhood is rediscovered, and vaulting the barriers of convention both artist and spectator leave seriousness far behind, freed from the indifference of history, time, space, giving free rein to their fantasy.

We cannot expect a revolution in contemporary art to result from what is more a phenomenon than a movement, rather we can hope for its exculpation. Against the traditions of the avant-garde, none of these artists wants to pick a fight with the previous generation even though they took in with their mother's milk a radical and conceptual culture that has not cut them off from modern thought. Unlike their immediate predecessors they are not plunged into despair by the fall of utopias or the ills of our civilisation, disillusionment does not come to them as a sickening blow, it is the soil in which they have to put down their roots. It is notable moreover that a number of them share some pretty tough life experiences, that an engagement with art is less and less the province of gilded youth, and that the art of today, more directly at grips with the real, is less inclined to lend itself to academic discipline. It is all the more difficult to foretell the future when these artists go out of their way to throw open every door, make mock of prohibitions and draw blithely on every source offered. It may be that their paths will quickly diverge after they have re-established the fundamentally inclusive and non-utilitarian nature of artistic creation. Then perhaps we shall be happy once more to be serious, to revisit the twentieth century in the light of the extraordinary personal and collective adventures that it has seen, while rejecting the historicising view that has been inflicted on us these recent years in the name of a supposed moral and social failure of modern art: that vision of decadence in which everything is equivalent to everything else and which advocates the negation of opposites. No, art and science, art and morality, art and academe do not good bedfellows make, as several of our artists ironically remind us; just as Derain is not Duchamp, Picabia is not an accident of history, and the spirit of Dada is still ruffling the feathers of the history of art.

Translated from the French by Simon Wilson and Barbara Wright

CATALOGUE NOTE

The following abbreviations indicate the authorship of the text for each artist:

TB Tanya Barson

CK Catherine Kinley

JM Jemima Montagu

Titles of works have been translated into English. They appear in their original form, in brackets, at place of first mention and in the list of exhibited works at the end of the catalogue.

The numbers in brackets at the end of the captions correspond with those given in the list of exhibited works.

Works without an exhibition number are illustrated for comparison and do not appear in the exhibition.

Where an asterisk appears at the end of a quotation, its source can be found in the short bibliography of the same section. (Unpublished statements appear without asterisks.)

Maurizio Cattelan

Patrick Corillon

Eric Duyckaerts

Keith Edmier

Marie-Ange Guilleminot

Emma Kay

Vik Muniz

Paul Noble

Fernando Sánchez Castillo

Katy Schimert

Pierrick Sorin

Momoyo Torimitsu

Patrick Van Caeckenbergh

Xavier Veilhan

Brigitte Zieger

MAURIZIO CATTELAN was born in Padua, Italy, in 1960. He received no formal art training and worked as a cook, gardener, nurse, mortuary attendant and furniture designer before turning his attention to art. His work engages with the ideas of Dada, Surrealism and *Arte Povera*. *Permanent Food*, a magazine conceived by Cattelan in collaboration with the artist Dominique Gonzalez-Foerster, has been published at intervals since 1995. He has exhibited widely in Europe and the United States. Solo exhibitions include: Daniel Newbury Gallery, New York (1994); Le Consortium, Dijon (1997); Weiner Secession, Vienna (1997); Castello di Rivoli, Turin (1997); Project 65, Museum of Modern Art, New York (1998). His work has been included in: *Una Domenica a Rivara* (1992), Castello di Rivara; *L'Hiver de l'amour* (1994), Musée d'Art Moderne de la Ville de Paris and PS1, New York; *Crap Shoot* (1996), De Appel, Amsterdam; *Traffic* (1996), capc Musée d'art contemporain, Bordeaux (1996); Venice Biennale (1997); *Skulptur. Projekte* (1997), Münster; *Made in Italy* (1997), ICA, London; *Wounds* (1998), Moderna Museet, Stockholm; and *Manifesta 2* (1998), Luxembourg. Cattelan has no permanent base, living and working, as he says, '*in situ*'.

Bibliography
Mikhail Bakhtin, *Rabelais and His World*, trans. by Hélène Iswolsky, Indiana, 1984, p.7*
Maurizio Cattelan, exh. cat., Le Consortium, Dijon 1997**
Maurizio Cattelan, exh. cat., Museo d'Arte Contemporanea, Castello di Rivoli, Turin 1997
Maurizio Cattelan, exh. cat., Wiener Secession, Vienna 1997
Fatto in Italia (Made in Italy), exh. cat., Centre d'Art Contemporain, Geneva, and Institute of Contemporary Arts, London 1997

Maurizio Cattelan has been described as an 'artful dodger', escaping from one venue the evening before the opening of an exhibition by using a rope of knotted sheets hung from a window, the traces of his departure left as his contribution to the exhibition. Much of his work functions as spectacle, disrupting the conventions of the gallery. His exhibition at the Daniel Newbury Gallery, New York (1994), where he showed a live donkey illuminated by an ornate chandelier, is another notorious example. This piece recalls the installation work by Jannis Kounellis shown at the Galleria L'Attico, Rome (1969), in which twelve live horses were tethered inside the gallery. Kounellis's aspiration was to achieve 'the return of poetry by all means available: through practice, observation, solitude; through language, image and insurrection', an intention shared by Cattelan, whose visual metaphors disturb as much as they seduce the viewer. *Twentieth Century (Novecento)* (1997) presents a taxidermic horse suspended high above the gallery space. The work expresses a sense of frustrated dynamic, a deprival of the means to decide and act. The elongated legs of the horse reinforce this impression as well as introducing an element of grotesque improbability. Although evidently staged, the absurd theatricality of *Bidibidobidiboo* (1996) is tempered by pathos. The artist's squirrel has met a desperate, melancholic end.

Cattelan revives the same spirit of laughter and liberating irreverence towards official, dominant culture that is evident in Mikhail Bakhtin's readings of Italian carnival. Bakhtin describes how during carnival 'an ideal and at the same time real type of communication, impossible in ordinary life, is established';* authority and privilege are suspended, along with the norms and taboos of daily existence. Cattelan undermines prevailing social

Stadium 1991 (no.1)

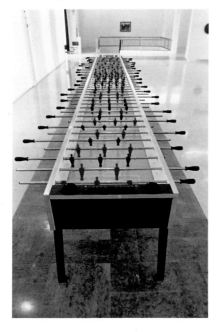

hierarchies by making use of the popular national obsessions in Italy, such as hunting and football, producing 'potential detonators of public reaction'.** Art as play occurs literally in *Stadium* (1991), a table-football game adapted for use by two teams of eleven players. Players have included a football squad of Senegalese immigrants founded by Cattelan and called A.C. Forniture Sud (A.C. southern supplies), alluding to the exploitation of ethnic minorities.

The title *Charlie don't surf* (1997) is from a 1980 track by The Clash, itself a quote from Francis Ford Coppola's Vietnam epic *Apocalypse Now*. The phrase establishes the otherness of 'Charlie' (the American soldier's slang for the Vietcong), the opponent who does not enjoy

all-American pursuits. Cattelan's 'Charlie' is a small child who sits at a school desk pushed against a wall. Employing a suspense technique familiar from horror movies, the work is approached from behind, so it is not until the last minute the viewer sees that each of the child's hands is pinned to the desk with a pencil. The work evokes a sense of isolation and vulnerability, and creates an image of the individual set against the system. TB

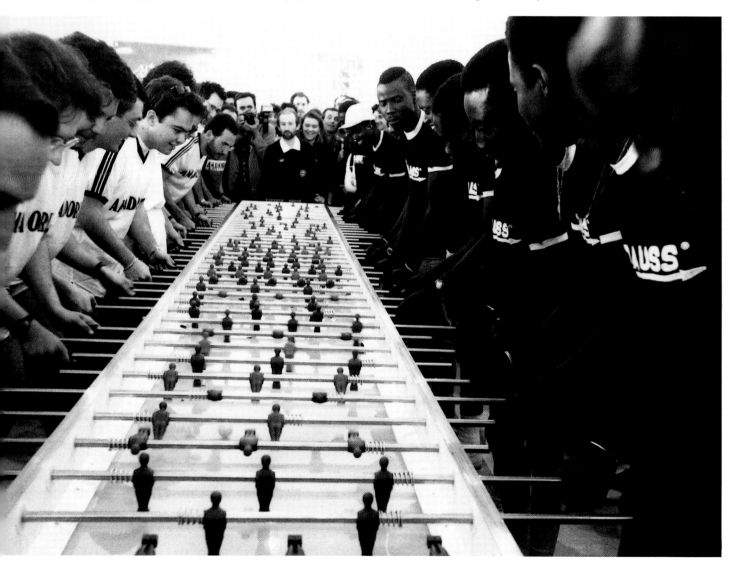

Maurizio Cattelan

'I think that, most of all, I'm interested in the tragic–comical element: there's humour and there is humility. I'm specifically interested in any kind of emotion that could enter my work. Some of my pieces are very depressing … But I also humiliate myself: at the end of the day, the only person who really turns out to be ridiculous is me.' Maurizio Cattelan

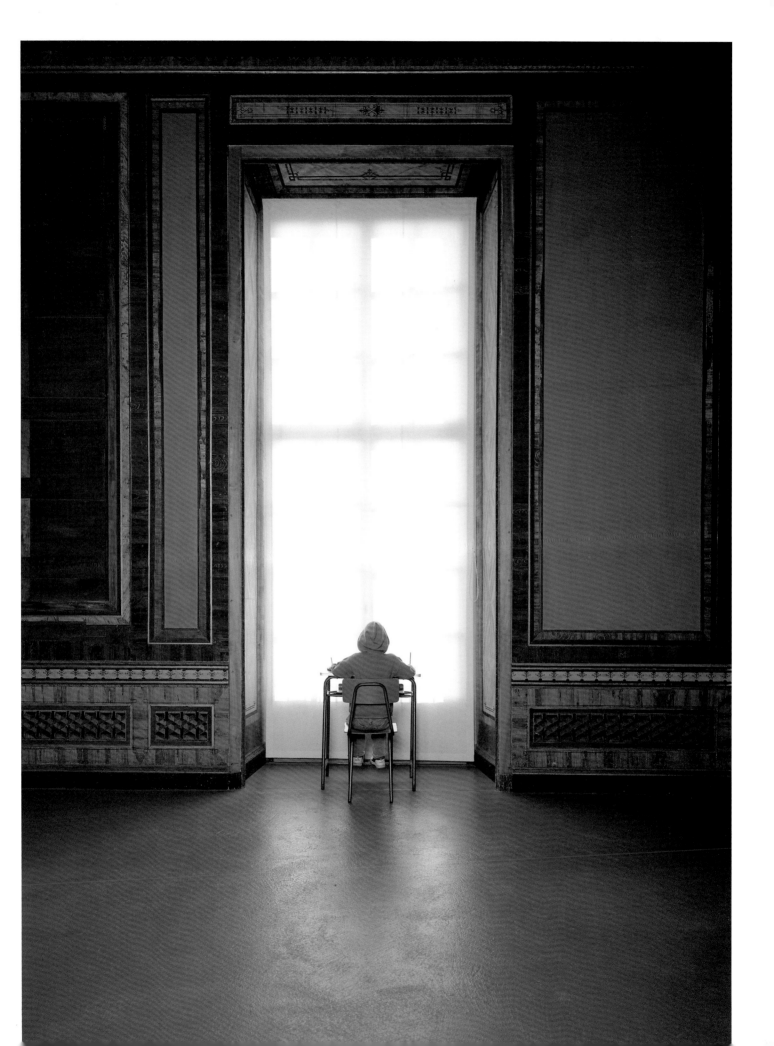

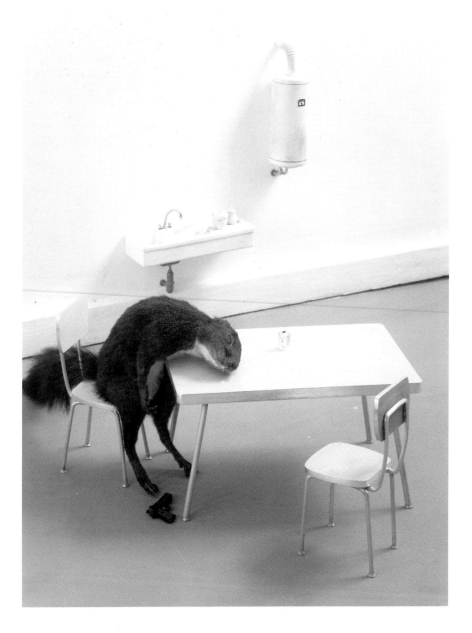

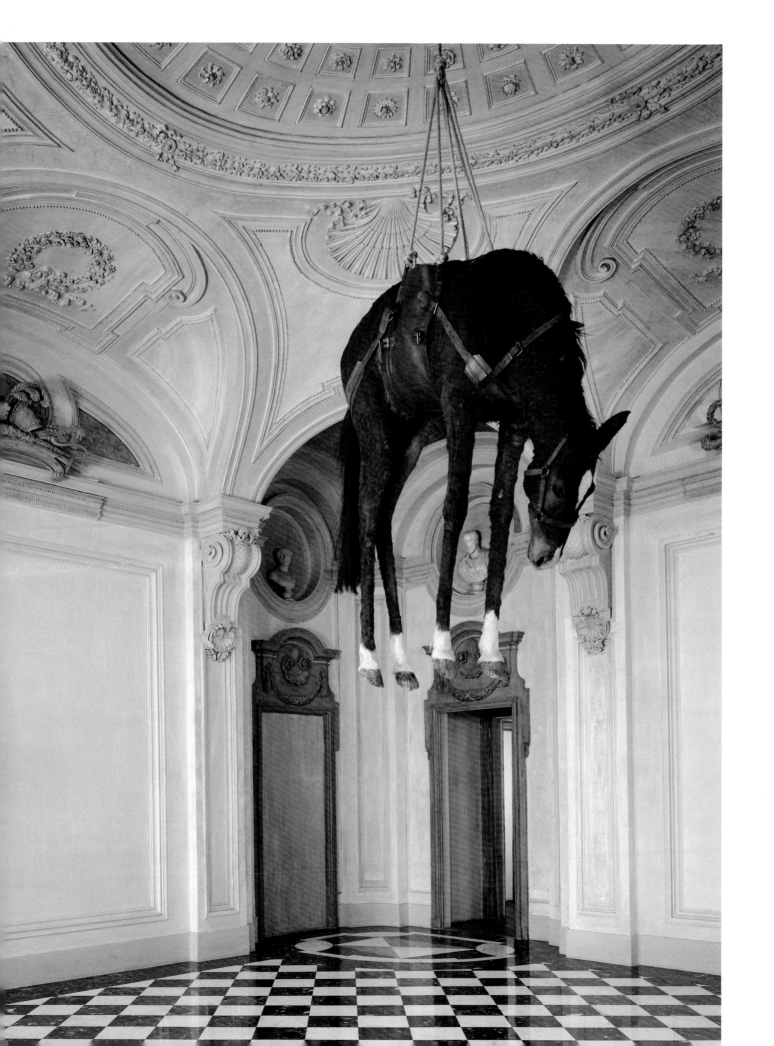

PATRICK CORILLON was born in Knokke le Zoute, Belgium, in 1959. He studied at the Institute des Hautes Etudes en Arts Plastiques, Paris, 1988-90. Corillon cites Kafka, Poe, Flaubert and Céline among his influences and his early works were interventions involving these literary figures. Since 1988 Corillon has developed a series of works involving his fictional character Oskar Serti and other imaginary people. Group shows include: *Documenta IX* (1992), Kassel; the biennales of São Paulo (1994), Venice (1995) and Lyons (1995); *Make Believe* (1995), Royal College of Art Galleries; *Chute Libre* (1996), Le Centre d'Art Contemporain de Neuchâtel; and *Poussière* (1998), FRAC Bourgogne, Dijon. Solo exhibitions include: *Les Visiteurs* (1993), Centre Georges Pompidou, Paris; Galerie Yvon Lambert, Paris (1993); Kunstraum, Munich (1993); *Trois sortilèges* (1996), Musée Zadkine, Paris; *Last Words and Tales of Oskar Serti* (1996), Oakville Galleries, Toronto; and *La Maison d'Oskar Serti* (1997), Galerie des Archives, Paris, and University of South Florida Gallery, Tampa. Corillon lives and works in Paris.

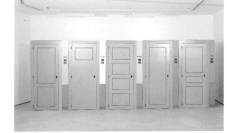

Bibliography

Jérome Sans, 'Patrick Corillon', *Galeries Magazine*, Dec. 1992, pp.68-9°

Patrick Corillon, exh. cat., Kunstraum, Munich 1993

Make Believe, exh. cat., Royal College of Art Galleries, London 1995

Patrick Corillon: Last Words ... and Tales of Oskar Serti, exh. cat., Oakville Galleries, Oakville, Canada 1996

Fabrice Reymond, 'Patrick Corillon: From My Room to the Moon', *Cimaise*, Apr.-May 1997, p.44

Corillon has been called a 'tale-teller and troubadour of modern times'. He juxtaposes narrative text with images and objects, often focused on his fictional poet and composer, Oskar Serti, whose story is partly based on the life of Béla Bartók (1881–1945). Serti, the artist tells us, was born in Budapest in 1881 and died in Amsterdam on Corillon's birthday in 1959. Through his tales, Corillon investigates the human condition from love to loss, birth to death, creating a '*comédie humaine*' in the manner of Honoré de Balzac or Emile Zola. He addresses the reliability of biography and plays on a widespread trust in the veracity of apparently objective printed matter. The personal artefacts he presents function, like Flaubert's parrot, to facilitate a direct connection with the character through the aura of personality we imagine these objects retain. By concentrating on this aspect, Corillon side-steps the question of authenticity, emphasising instead the impression of a real encounter. His use of fiction is not a way of escaping the real, but of reclaiming it.

Oskar Serti's House (*La Maison d'Oskar Serti*) (1997) is a series of darkened spaces, each representing a different room in Serti's house. Visitors can listen to episodes from Serti's history while imagining themselves in the rooms in which

these took place. Corillon accentuates the minor details of daily life, investing them with a Proustian significance. He has made Oskar Serti an artist *manqué*. An exiled Romantic, condemned to a life of perpetually missed opportunities, Serti exists in the interstices of history, just out of reach of fame or notoriety.

Catherine de Sélys is one of the characters encountered through Serti. Their fated romantic liaison is played

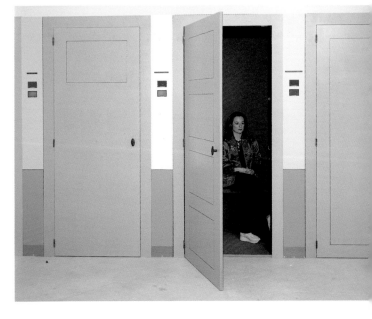

Patrick Corillon

out through a number of works. *At the Station* (*À la gare*) (1994) reconstructs a rendezvous between the lovers that is thwarted by mistaken appearances. Corillon evokes, with irony, a number of literary and cinematic counterparts, from *Anna Karenina* to *Brief Encounter*. The images of Serti and de Sélys, or their doubles, are painted onto screens, but like a seaside photography booth their faces are missing, and visitors can adopt either role.

The Flowers (*Les Fleurs*) (1988) is a children's nonsense botany in the manner of Edward Lear, for the plants require impossible situations in order to grow. Storytelling becomes more sinister in *Last Moments* (*Derniers moments*)

(1996). This sequence of texts details the last thoughts, hopes, dreams, memories, words and wishes of an unnamed protagonist. The work makes a public display of the inner voice of distress and despair. Corillon's installation *The Ticket Gates* (*Les Portillons*) (1993) examines public behaviour and personal choice. An accompanying text relates how Serti has observed the patterns of behaviour of those who approach such an obstruction on a daily basis, leading us to question our own life choices. TB

He comes to my room every day. He looks hard at me, then he sits down at the foot of the bed and turns his back on me. He is short of breath. Small puffs of warm air escape spasmodically from his mouth and cling to the window panes in front of him. He lifts his finger to one of the panes and draws something. I don't see what he draws because he is between me and the glass. He never turns around to face me. When he has finished drawing he waits a long time. Then he gets up and leaves the room. On the glass, the steam has had time to condense into tiny droplets which run off the drawing, blurring it. I only just have time to recognize the features of my face. The drops join together around what was my neck, making a small waterfall which flows down onto my bed. The rest of my face is quickly swallowed up in the flow. Soon there is nothing left at all. I wake with a start. My sheets are drenched with perspiration, but my limbs are too heavy and I have neither the strength nor the courage to get out of bed.

The Flowers 1988 (no.6)

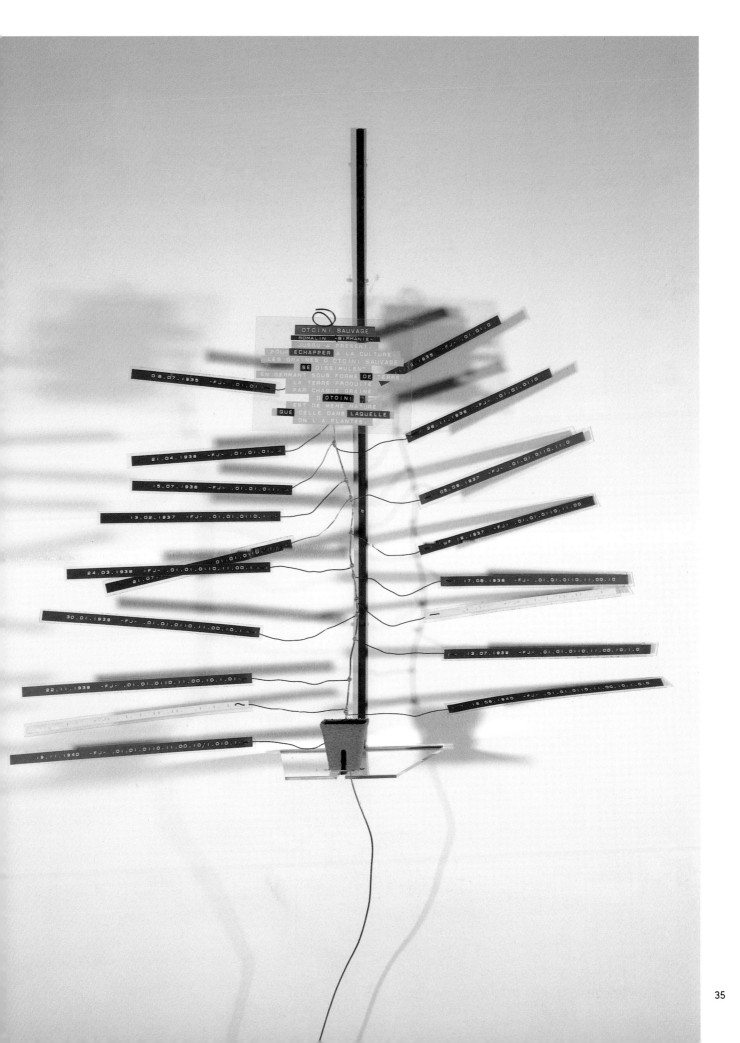

35

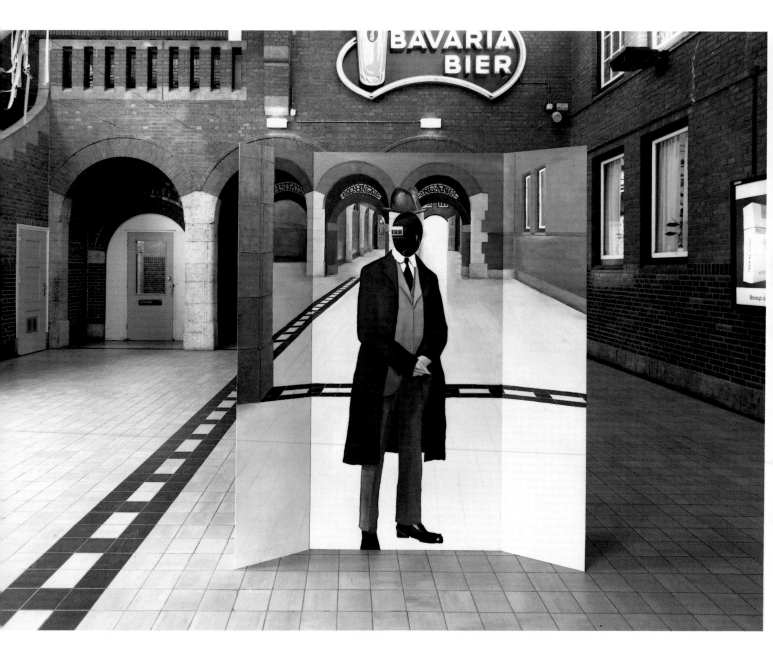

At the Station 1994 (no.5)

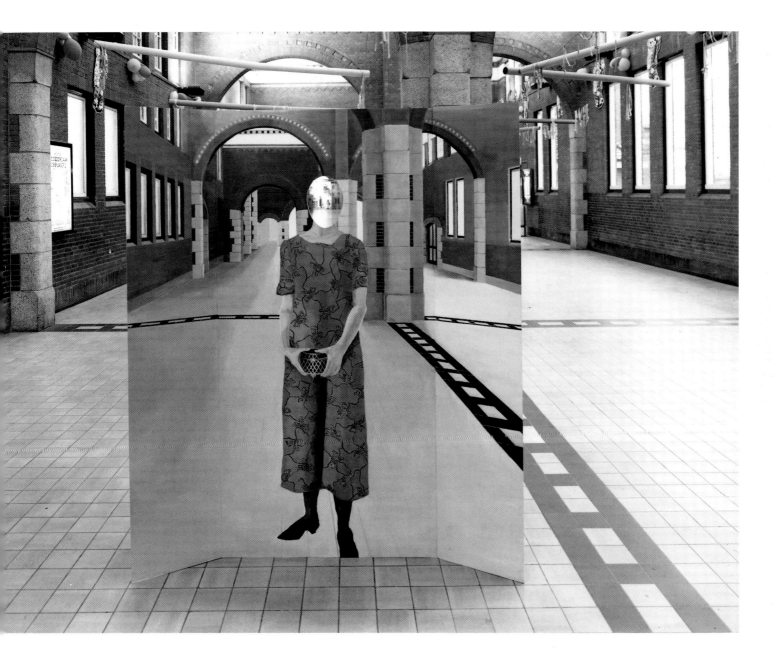

'I remember having mentally constructed — appearance,
behaviour, character and personal history — a number of
imaginary characters who were every bit as visible and present
to me as the things born from what we call, improperly
sometimes, real life.'* Patrick Corillon

Detail of *The Loop* 1996 (no.23)

ERIC DUYCKAERTS was born in 1953 in Liège, Belgium. A qualified philosopher, lawyer and artist, Duyckaerts has pursued a dual career of academic study and art projects, which include performance, sculpture, painting and video. Since 1998 he has been teaching at the Ecole nationale des beaux-arts in Dijon, France. Duyckaerts's work has been exhibited in Europe, Japan and New York; group exhibitions include: *Viennese Story* (1993), Wiener Secession, Vienna; *Self-determination* (1995), Gemeentemuseum voor moderne kunst, Arnhem; *On Board*, Aperto '95, Venice, and FRAC Languedoc-Rousillon, France; *Coïncidences* (1997), Fondation Cartier, Paris; and *Exogen* (1997), Institute of Mathematics, Copenhagen. Solo performances and exhibitions include: Espace 251 Nord, Liège (1984); Galerie Perrotin (1993, 1997); Fondation Cartier, Paris (1994); and Espace Croisé, Lilles (1995). Duyckaerts has published a book called *Hegel ou la vie en rose* (1992) and written numerous articles, both on the arts and philosophy. He lives and works in Paris and Dijon.

Bibliography
Eric Duyckaerts, *Hegel ou la vie en rose*, Paris 1992
'Citizen quoi?', interview by Vincent Bergerat, *Citizen K*, no.3, 1993, pp.26–7*
Patricia Brignone, 'Eric Duyckaerts, portrait de l'artiste en conférencier', *Artpress*, Apr 1996
Clarissa Hahn, 'Les Démonstrations mutationnelles d'Eric Duyckaerts: entretien avec Clarissa Hahn', *Blocnotes*, no.14, 1997, pp.75–8**

Many of Duyckaerts's art works reflect his career as an academic, drawing upon his research in subjects ranging from philosophy and law to mathematics and genetics. He questions the process of academic learning and inquiry, suspicious of the authority of intellectual discourse, which all too often takes refuge in rhetoric and remains unchallenged. For *Magister* (1989) Duyckaerts filmed a series of humorous improvisations in which he parodies different pedagogical styles based on the 'pop' science or psychology programmes found on television. He lectures on the subject of art, but the constant switch between conflicting academic registers confuses all points of reference. Similarly *How to Draw a Square* (1999) deconstructs and reconstructs the didactic process. It brings together a projection of a lecturer speaking and the chart onto which he has drawn his diagrams. Like one of Wittgenstein's language games, this work merges the explanatory drawing, the lecturer's gestures and the spoken word, physically exposing the 'spaces' between word and deed, idea and expression.

The Loop (*La Boucle*) (1996) is the first of a series of works, *Chains of analogies*, in which Duyckaerts examines the function of analogy, a key mechanism in his investigation of systems of thought. The principle of analogy forms the basis for hypotheses such as 'A is to B as C is to D as E is to F' and so on. This open and potentially endless structure has been regarded with suspicion by philosophers and logicians, wary that analogy appears to validate connections between entirely disparate objects or ideas, through a kind of *reductio ad absurdum*. Duyckaerts has arranged the objects into the form of an infinity symbol (∞), using this open structure to test the boundaries between the valid connection and a descent into the absurd. Obvious connections are placed next to abstruse ones, begging questions about the relationship between the various juxtaposed objects.

Eric Duyckaerts

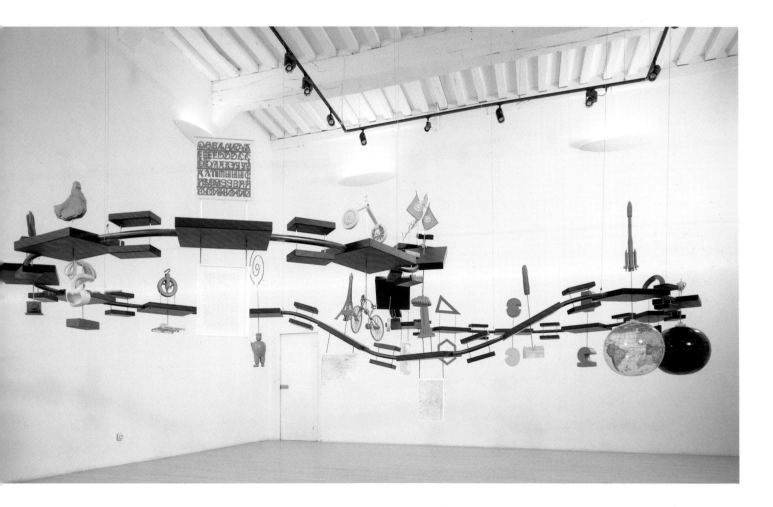

The Loop 1996 (no.23)

The Two Thumbed Hand series proposes a new evolutionary development. In these works, which include drawings, paintings, video and sculptural objects, Duyckaerts presents his hypothesis of fantastical evolutionary mutation, whereby the body grows a second axis of symmetry in the form of a single arm which has two thumbs and four fingers. Once again parodying scientific orthodoxy, Duyckaerts discusses the merits of this genetic miracle. He argues that it would produce artistic perfection, not only through the incredible dexterity of a two-thumbed limb, but also by resolving the art historical problem of absolute symmetry. Exploding the cultural prejudices of 'left' and 'right', this special limb would unite the brain's chiasmic structure, with which the left half of the body is ruled by the right hemisphere and vice-versa. Duyckaerts harnesses scientific discourse to explore the imaginary and absurd, suggesting that 'truth resides less in logic than in paradox'. JM

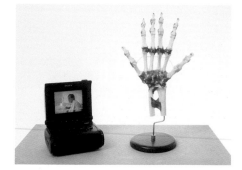

'The symmetry that exists between two hands, which I call actual hands – hands with five fingers – is a very particular symmetry. A mirror symmetry which is called enantiomorphic. This means that two objects, the left hand and the right hand, cannot be superimposed onto one another. If one makes a mould of the left hand, one would never be able to slip the right hand, if one were to turn it around, into the interior of this mould. The hypothesis of the hand with two thumbs, with four middle fingers, was my way of envisaging a symmetrical hand, not one which is enantiomorphic. I have worked a lot on symmetry and it seems to me that from a slightly ironical perspective, I have raised a consistent problem in art history – the question of symmetry, which I now think is resolved in a manner both elegant and funny.'*

Eric Duyckaerts

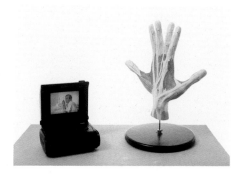

Scissors (a) 1994 (no.18)
Scissors (b) 1994 (no.19)
Fossil 1997 (no.17)
Screw Hypothesis 1994 (no.21)
Base 12 1993 (no.12)

BASE 12

'I have been struck by the omnipresence of analogy in the arts of representation. Analogy is inscribed in the depths of our being, independent of artistic questions.'**

Eric Duyckaerts

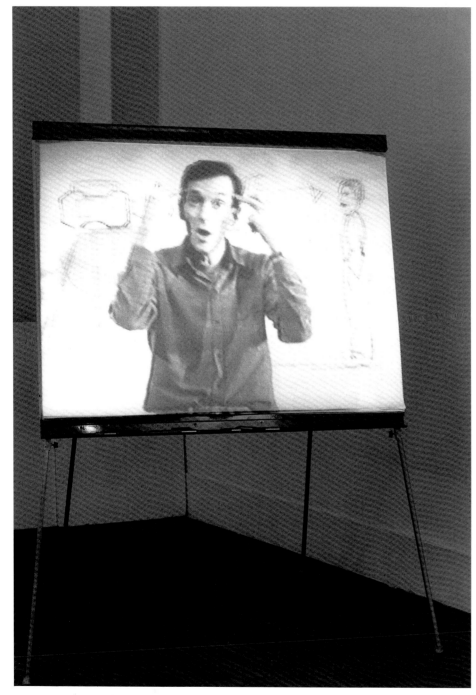

depth (en profondeur)
waves (ondulaire)
particles (particulaire)
surface (superficiel)

Space between Things (L'Espace entre les choses) 1994
(French version of *How to Draw a Square* 1999 (no.24))

KEITH EDMIER was born in Chicago in 1967. He attended the California Institute of the Arts (1986). Before becoming an artist, Edmier worked on prosthetic special effects in the American film industry and created horror-movie effects for *Leatherface: The Texas Chainsaw Massacre 3* (1989) and *Exorcist III: Legion* (1990). His work was included in *Human/Nature* (1995), New Museum, New York; and *Gothic* (1997), Institute of Contemporary Art, Boston. Solo exhibitions include: University of South Florida Contemporary Art Museum, Tampa (1997); Metro Pictures, New York (1998); and Douglas Hyde Gallery, Dublin (1998). He has shown regularly at Friedrich Petzel Gallery, New York. In Europe he has shown at Neugerrimschneider, Berlin (1995), Galerie Paul Andriesse, Amsterdam (1997) and debuted in Britain at Sadie Coles HQ, London (1998). Edmier lives and works in New York.

Bibliography
Simon Schama, *Landscape and Memory*, London 1995
Keith Edmier, exh. cat., University of South Florida Contemporary Art Museum 1997
Gothic: Transmutations of Horror in Late Twentieth Century Art, Institute of Contemporary Arts, Boston 1997
Keith Edmier, exh. cat., Douglas Hyde Gallery, Trinity College Dublin, Ireland 1998

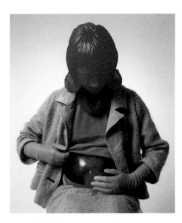

Beverly Edmier 1967 1996

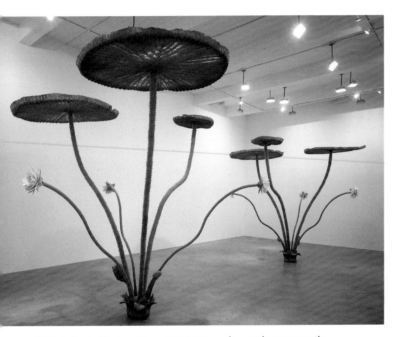

Victoria Regia (First and Second Night Blooms) 1998 (nos.25 & 26)

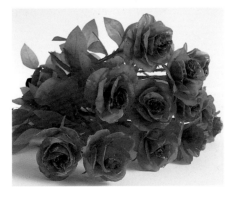

A Dozen Roses 1998

In many ways Edmier is a child of the 1970s. His work blends highly personal memories with the collective experiences of the first truly mass-media generation. He has fused historic events with intimate experience in *Beverly Edmier 1967* (1998), a sculpture of his mother when she was aged 22 and pregnant with him. The figure is shown cradling her stomach and the unborn artist can be seen through her transparent skin. She is dressed in a pink suit similar to that worn by Jackie Kennedy in 1963 when President Kennedy was shot dead. The work resembles a *pietà*, the enduring symbol of motherhood and mortality. *A Dozen Roses* (1998), an accompanying work, is a cast of a bouquet like that carried by Jackie. Edmier's work is often compared to Pop art; he emerged from the context of Chicago Pop in particular. Unlike the artists of the 1960s, however, for whom the world of mass media was new and strange, Edmier absorbed popular culture as part of his upbringing. As a prosthetics special effects artist, Edmier dealt in extreme images from the world of pulp fiction, fantasy literature, computer games and the Internet. These are areas of modern imagination that have been consistently marginalised within the realms of mainstream culture and high art. At the same time, Edmier reveals a concern for sculptural form that embraces the work of such figures as Jeff Koons and Robert Gober.

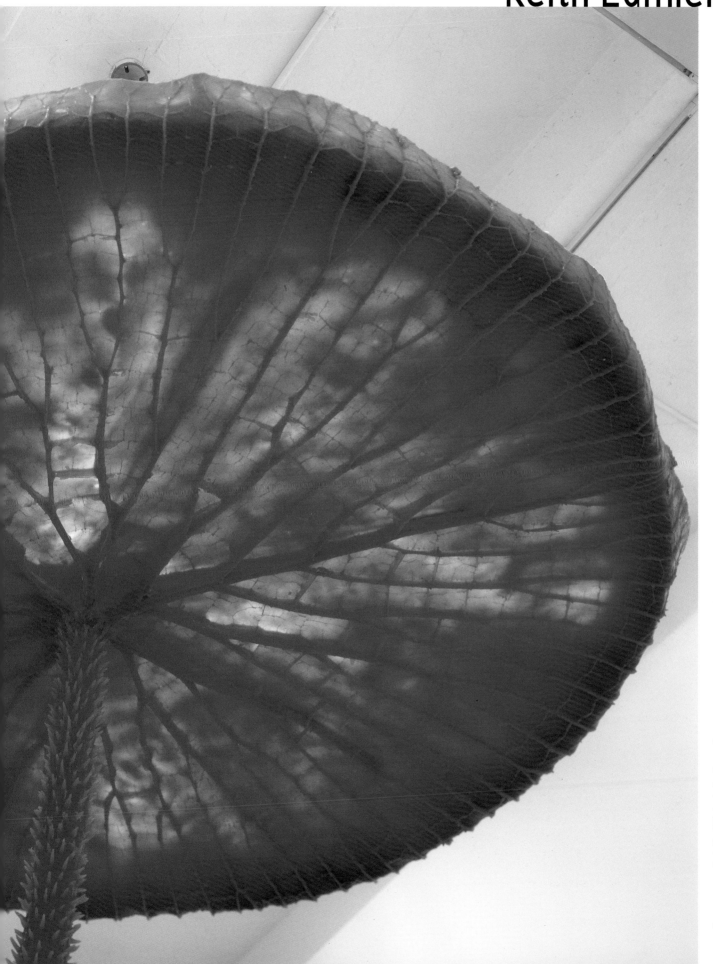

Keith Edmier

Victoria Regia (First Night Bloom) (1998) and *Victoria Regia (Second Night Bloom)* (1998) are two fantastical simulacra, cast from a species of giant water-lily that bears male and female blossoms on alternate nights. Edmier's sculptures show both the white bloom of the first night and the fully expanded pink flower of the second. The viewer approaches the plants as if from a sub-marine perspective, looking up at the veined underside of the leaves.

Edmier's sculptures engage with iconic nature and the idea that the defining national monuments of the United States are the natural phenomena celebrated in nineteenth-century American landscape painting and, later, in American cinema. They all express a relationship with nature defined by scale, awe and fear. Giant redwood trees were seen as natural equivalents to the immense Gothic cathedrals of Europe and a symbol of national stature. Likewise, Edmier's lilies are the embodiment of a 'heroic botany'. In cinema the American popular imagination has often embraced the more sinister, flip-side of nature: the unruly Sublime replaced by aberrant nature, a channel for the supernatural. Edmier has cast the gargantuan plants in a startling, fleshy pink resin, reminiscent of dental plastic or bubble-gum. The sculptures appear unreal, the products of an overactive imagination or an early 1960s' science-fiction film like *The Little Shop of Horrors* or *The Day of the Triffids*, both of which feature incredible killer-plants. TB

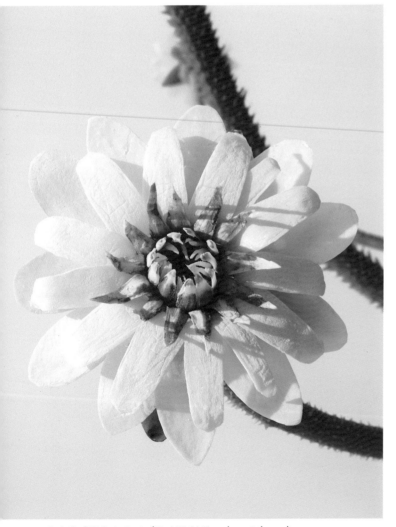

Detail of *Victoria Regia (First Night Bloom)* 1998 (no.25)

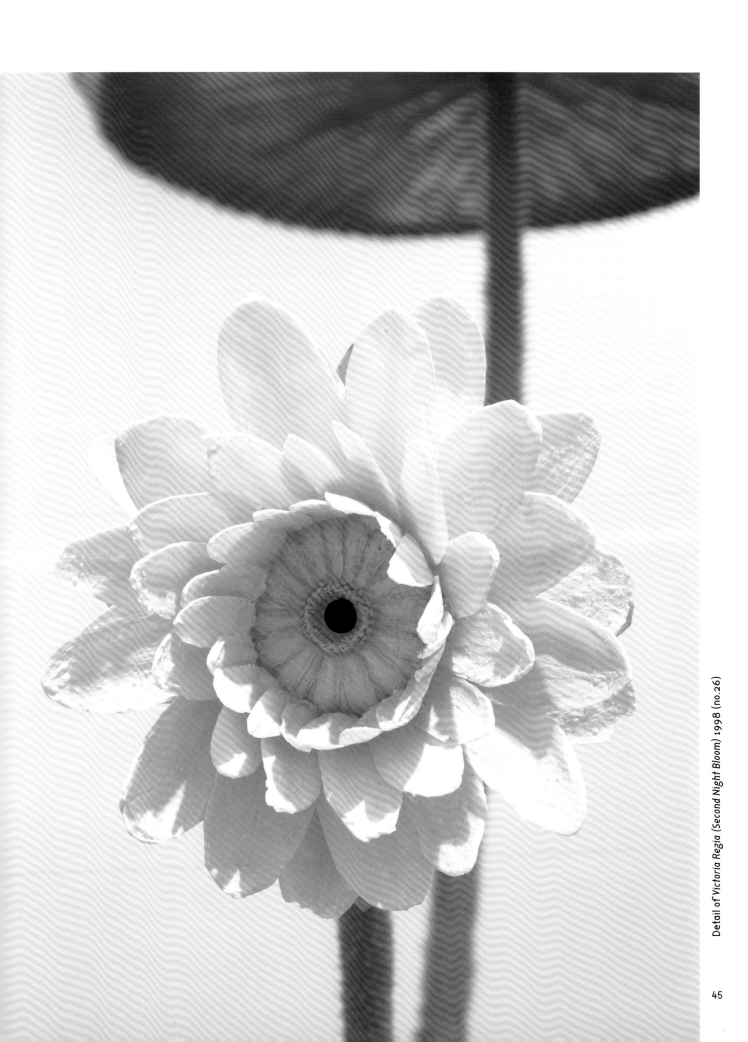

Detail of *Victoria Regia (Second Night Bloom)* 1998 (no.26)

MARIE-ANGE GUILLEMINOT was born in 1960 at Saint-Germain-en-Laye, France. After studying for five years at the Villa Arson in Nice, she gained her Diplôme Nationale Supérieur d'Expression Plastique in 1985 and then moved to Paris, where she now lives and works. Guilleminot has participated in many important exhibitions across the world: *Fémininmasculin – le sexe de l'art* (1995), Centre Georges Pompidou, Paris; *Manifesta 1* (1996), Rotterdam; *Belladonna* (1997), Institute of Contemporary Art, London; *L'empreinte* (1997), Centre Georges Pompidou, Paris; *De Genderisme* (1997), Setagaya Art Museum, Tokyo; *Skulptur. Projekte* (1997), Münster; and *Premises* (1998), Guggenheim Museum Soho, New York. She also exhibited at the Venice Biennale in both 1995 and 1997. As well as her many performances and interventions across the world, Guilleminot has had solo exhibitions at Galerie Chantal Crousel, Paris (1995, 1997); Israel Museum, Jerusalem (1995); Masataka Hayakawa Gallery, Tokyo (1998); and capc Bordeaux (1998).

Bibliography

Marc Pottier (ed.), *Avant-garde Walk a Venezia 1995 II*, Italy 1996*

Ariella Azoulay, 'Marie-Ange Guilleminot: A Lexicon', in *Skulptur. Projekte*, Münster 1997

Ann Wilson-Lloyd, 'Reactionary Transactions', *Sculpture*, no.9, Nov. 1997**

Guilleminot creates art objects that engage the spectator in a physical, and occasionally intimate, relationship. Her works often set up discreet challenges which are both threatening and exciting: to dip one's feet into a dark hole, spy through a tiny peep-hole, or slip on an unusual garment. Performance plays a crucial role in activating her works; each handling or manipulation of an object releases a new form or function and in this way it is constantly reborn.

The Life Hat (*Le Chapeau-Vie*) (1993–9) is a long tube of knitted fabric that can be stretched from a hat over the head and down the body into a pullover or dress. Guilleminot has done many public performances with this piece worldwide: 'As these experiences accumulate, I become more and more one with *Le Chapeau-Vie*. It helps me to define my own space as well as the space that separates me from others, in an intimate social relationship.'* *Life Hat* was originally conceived 'to make life more bearable'. It acts as a protective barrier from the outside world, but it also offers a new experience of self: its flexibility allows it to shape and in turn be shaped by its wearer.

A sweet and sticky candy skin envelopes the amorphous form suspended from a rudimentary contraption in *The Rotary Machine* (*La Rotateuse*) (1995), Guilleminot's response to the works of Marcel Duchamp. A cross between an enormous tongue and a stockinged human form (perhaps Guilleminot wearing the Life Hat), this awkward hybrid spins jerkily on its axis like an out of control acrobat. Once again Guilleminot uses motion to bring her work to life, but here the violent, lurching movement creates tension between the still object and the object in motion; it can neither be fixed as a still image, nor reach a sustained rhythm. Instead this manifestation of the *informe*, or formless, generates an atmosphere of frustration and anxiety.

The *My Dresses* (*Mes Robes*) (1992–6) have also developed from a number of performances by the artist, which range from wearing the dresses for practical and personal use to walking through public streets at night or lying on display

Dress no.4. Roller Dress 1992 (no.27d)

46

Marie-Ange Guilleminot

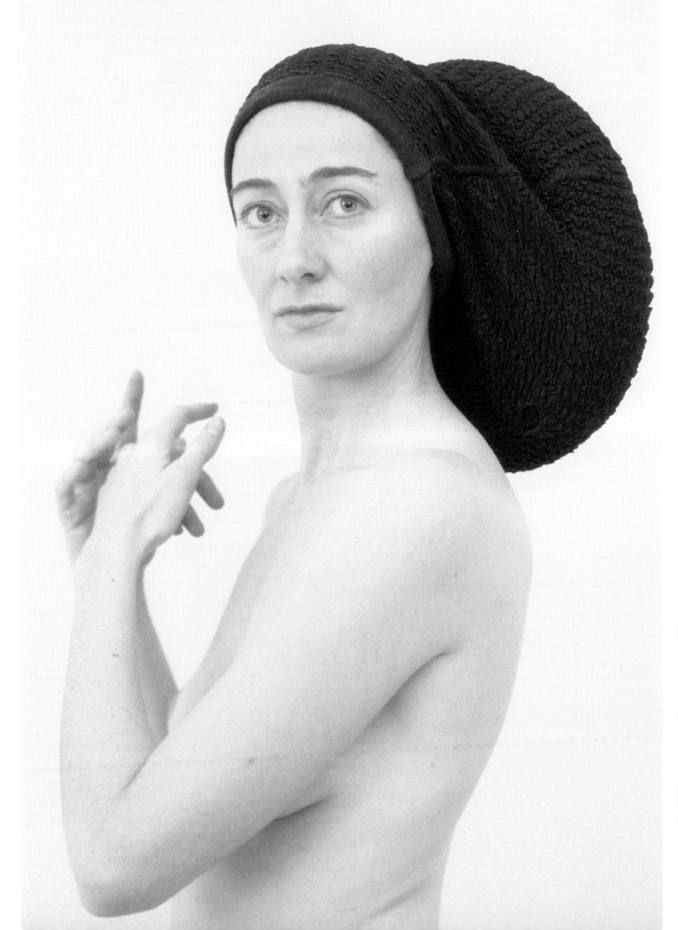

The Life Hat 1994 (no.28), worn by the artist

in a shop window overnight. The dresses, which can be worn by men or women, question assumptions about the transformative powers of fashion, occupying a middle ground between the functional and the fantastic. Referring to the rituals of dress, the codes of what can and cannot be seen, *Red Emotion Dress (La robe à emotion rouge)* (1996) uses livid colour and rusched fabric to suggest not only the flesh that lies beneath the fabric, but the internal organs within. Like the magic cloaks of fairy-tales, the dresses both disguise and expose their wearer. Guilleminot's works can be seen as ambiguous gestures, each offering a contribution to what she describes as her 'transformational lexicon': a personal vocabulary which suggests not only the *reinterpretation* of the art object within each new context, but also its *reformulation*. JM

'For me the work is also about formlessness, because the form or the object is not fixed. It just supports a way to communicate and transform. It's not about the object. This is also very important to me – to find a way to create my own economy in the art world. I want to make a culture of offering things.'**

Marie-Ange Guilleminot

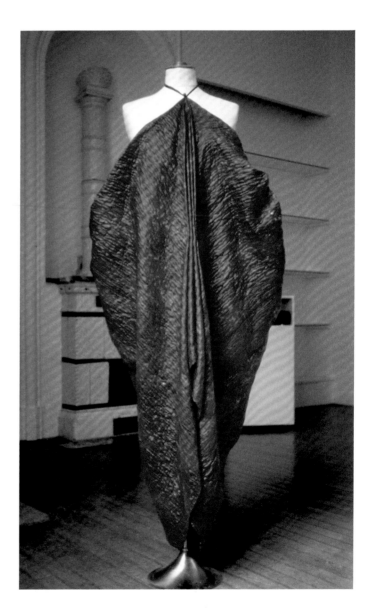

Dress no.12. Red Emotion Dress 1996 (no.27k)

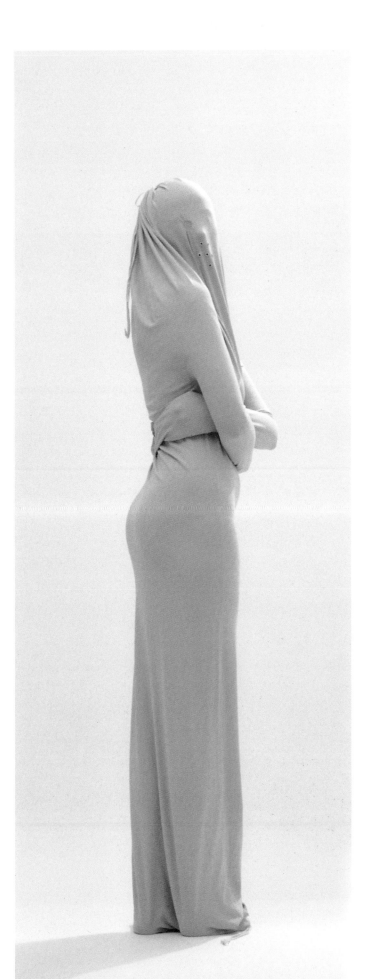

My Dresses 1992–6 (no.27)

'In 1992 I began to have the idea for a series of dresses, made according to my own measurements. Their shape followed the same pattern, covering the whole body with the exception of the head and hands. Some of the dresses impose a constraint upon my body implying a dependence upon each other. The dresses, today at the number of ten, were each made for specific actions.' Marie-Ange Guilleminot

Dress no.9. Bag Dress 1992 (no.27h)

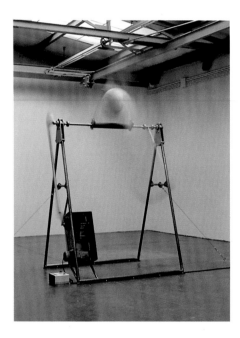

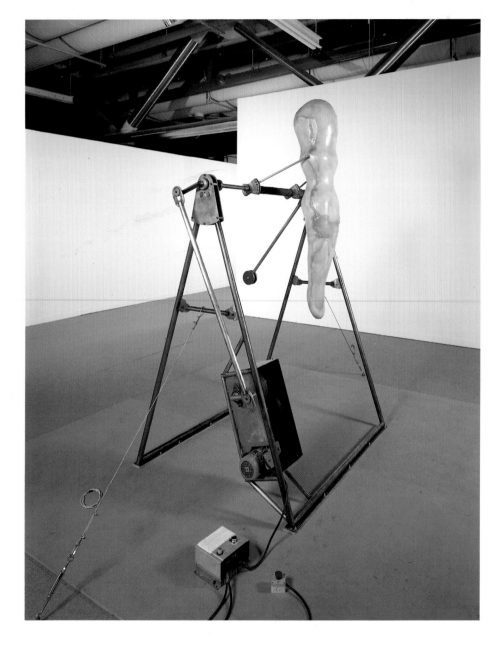

The Rotary Machine 1995 (no.30)

My Dresses (1992-6) (no.27), worn by the artist and her friends

51

EMMA KAY was born in London in 1961. She studied Fine Art at Goldsmiths College in 1980-3 and then again for an MA in 1995-7. She has participated in a number of group exhibitions, including *Recent British Multiples* (1997), Art Metropole Gallery, Toronto; *Thoughts* (1997), City Racing, London; *A–Z* (1998), Approach Gallery, London; *New Contemporaries* (1998-9), Tea Factory, Liverpool, travelling to London and Newcastle; *What difference does it make?* (1998), Cambridge Darkroom; *Surfacing* (1998), ICA, London; *In the Beginning* (1998), Murray Guy, New York; *Transfiguration* (1998), Bronwyn Keenan Gallery, New York; *Family* (1998), Inverleith House, Edinburgh; *Infra Slim Spaces* (1999), Birmingham Museum of Art, Alabama; *Cognitive Landscapes* (1999), Dorothée de Pauw Gallery, Brussels. Her first solo exhibition, showing *Shakespeare from Memory*, was at The Approach, London, in 1998. Emma Kay is a member of Cubitt, and artist-run organisation. She lives and works in London.

Bibliography

Emma Kay, *Paperback*, artist's book, Art Metropole Gallery, Toronto 1997

Bev Bytheway and Sacha Craddock (eds.), *New Contemporaries 1998*, London 1998

David Musgrave, 'A – Z', *Art Monthly*, July 1998, pp.29-30

Laura Moffat, 'Emma Kay', *Art Monthly*, no.222, Dec.-Jan. 1998-9, p.42

Emma Kay, *Worldview*, artist's book, Book Works, London 1999

Simon Morley, 'Surfacing Contemporary Drawing', *Contemporary Visual Arts*, no.21, p.72

In the beginning was the Word, and the Word was GOD, and GOD was the Word. And GOD created the Earth and the seven seas in seven days, and on the seventh day he rested, and was pleased with what he had done.

The Earth was created to hang between Heaven and Hell, where before there was only a terrible blackness. GOD gave the Earth land and water so that living things could flourish and then he created a man and called him Adam. (One of his reasons for doing this was to prove to the Devil that goodness would always triumph over evil). Heaven was populated by angels, and those angels that were not good enough in GOD's eyes were banished to hell forever. These were known as 'Fallen Angels'. When the Devil noticed what GOD was trying to

Detail of *The Bible from Memory* 1997 (no.31)

Emma Kay's work challenges the homogeneity and authority of the printed page. Through her manipulation of published texts and, more recently, a series of works based on her own memory, she draws attention to the conventions supporting different types of narrative. Kay's memory, as much as the devices she uses to prompt and frame it, is the real subject of her work.

In 1997 Kay reduced the entire contents of a selection of books, including works of pulp science fiction and pornography and Tolstoy's *War and Peace*, to a typeset catalogue of inanimate objects for each text, true to the sequence in which they appear. These works test the imagination of the viewer who inevitably attempts to reconstruct the original narrative, but can rely only on the imperfect combination of memory, preconception and a bald material inventory.

Kay also uses digital typesetting in her works based on existing texts but written entirely from memory. She is scrupulous in matching typeface and layout to her source. For *The Bible from Memory* (1997), the six-column layout of which resembles a page from an authorised version, Kay reconstructed what she could remember from Genesis to the Book of Revelation in 7,500 words without reference to any edition. Other related works include two maps drawn by the artist, *The World from Memory* I and II (1998), and *Shakespeare from Memory* (1998), for which Kay reproduced the twenty-six Shakespeare plays she could recall. For some plays she was able to give quite comprehensive accounts, but for others she could remember only the title.

Worldview (1999) is another large text-work written entirely from memory. It attempts to tell the history of the world and again presents the futile effort in an authoritative form. The work refers to the printed page,

In the beginning was the Word, and the Word was GOD, and GOD was the Word. And GOD created the Earth and the seven seas in seven days, and on the seventh day he rested, and was pleased with what he had done.

The Earth was created to hang between Heaven and Hell, where before there was only a terrible blackness. GOD gave the Earth land and water so that living things could flourish and then he created a man and called him Adam. (One of his reasons for doing this was to prove to the Devil that goodness would always triumph over evil.)

Heaven was populated by angels, and those angels that were not good enough in GOD's eyes were banished to hell forever. These were known as 'Fallen Angels'. When the Devil noticed what GOD was trying to do, he saw to it that humans who failed to be good ended up in hell. These lost souls were condemned to Eternal Damnation in Purgatory, which was a horrible place burning with hellfire.

Adam was placed in a beautiful and verdant garden that GOD had made especially for him, called Eden. Eden was like paradise, in fact it was an Earthly Paradise (although most of the Earth was like this at the time). It was also known as the Garden of Earthly Delights. Adam ran around naked, eating fruit and vegetables, and playing with the animals, in a state of innocence. But because Adam was not an animal and had the power of speech, he became bored and wanted someone to talk to. So GOD removed one of Adam's ribs while he was asleep and from it he fashioned Eve, a woman. Eve was just like Adam except for some particular physical features. Their sexual (or reproductive) organs were what differentiated them, in fact made them opposites, although Adam and Eve didn't realise this because they didn't know what these organs were for.

For a while these Adam and Eve were very happy and spent most of their time discovering what was around them, eating fruit and stroking the other creatures who were their friends. But they soon began to weary of their perpetual state of innocence and bliss. They became dissatisfied with their lot, and wondered why they should always do GOD's will.

There was a tree in the garden that GOD had told them not to touch. It was called the Tree of Knowledge, and on no account were they to pluck its fruit. Eve was most curious to know what the fruit of this tree would taste like and one day a beautiful and seductive serpent persuaded her that GOD would never find out. The fruits were called apples. Adam was horrified, but Eve persuaded him to pick just one, and have a taste. So they bit into the apple.

In an instant the sky turned black, and a storm blew up. Thunder roared, lightning flashed and the wind howled, terrifying Adam and Eve, who had never experienced bad weather and had no idea what was happening to them. Cowering together, the voice of GOD told them that they had given in to the forces of evil and picked the Forbidden Fruit from the Tree of Knowledge. They lost their innocence for ever and would spend their lives yearning for what they had lost. They pleaded with him to make the storm stop, saying that they were sorry and would never disobey him again, but he said his decision was irrevocable, and they would have to live with their mistake forever. He said that they had committed the Original Sin, and that this is what they would always be famous for – the event would henceforth be known. This first sight Eden wasn't enough for them, GOD had determined that unless they did what he asked for the rest of their lives, the would not join him in Heaven but would be consumed in the fires of Hell. This put the 'Fear of GOD' in them.

After this terrible catastrophe, GOD banished them from Eden for ever. Distraught and repentant, Adam and Eve were now at the mercy of the weather, which was often bad where before it had always been lovely. Significantly, they often felt extremely guilty, which was a new and confusing feeling. Furthermore, they had realised that their bodies were different, and became both fascinated and repelled by each other. They were embarrassed by their nakedness and covered their genitals with fig leaves. In short, they discovered sexual desire, and they had sexual intercourse which resulted in Eve giving birth to a child. Thus the human race began to multiply, and everyone was descended from Adam and Eve.

Humans had to eat, and so they learned how to make food by cultivating the land and killing animals. They developed an instinct for survival, and even learned to kill each other. Hunted by humans, the animals became shy and developed new habits, like hiding and running away. Being hunted also altered the hierarchy of the animals, or beasts, although unlike Adam and Eve they retained their innocence. None of this would have happened if Adam and Eve had not tasted the Forbidden Fruit, but in fact, it was all part of GOD's master plan. His plan ensured that they would know the difference between good and evil and always be motivated to have faith in him.

Humankind carried on reproducing, farming, fighting and building, spreading out over more and more of the Earth until they were relatively sophisticated. They developed cities, industry, economics, agriculture and entertainment. To regulate all this they constructed laws, moral values, armies, and territories. They had even begun to try and describe and explain the place Earth on which they lived, or to work out how they got there, and what would happen to them after they died. They knew that they had a Creator, who appeared to be a man and was called the

The people of the Earth had become blasé about the existence of GOD, since it seemed that they could do no wrong in his eyes. Sex was one of their favourite pastimes, and they had begun to fornicate all the time, not necessarily with the purpose of producing children. They stole from each other and were becoming obsessed with material possessions and power. They treated each other badly, and they no longer saw themselves as equal to each other and to the animals. But on the whole they knew the difference between good and evil. Those who had seen GOD or been spoken to, had been given advice about how people should behave if they wanted to get to Heaven. These people were usually men, and the most Holy were known as the

Prophets. Events in their lives are described in the Bible to illustrate important lessons from GOD.

The story of Ruth used to glean corn (picking up what is left in the fields after the harvest). She attracted the attention of a rich man called Boaz, and there's a whole book in her name. Certainly she was the daughter of a prophet or some similarly well known man. Cain and Abel were the sons of Isaac. They had an argument which resulted in the accidental murder of Abel by Cain, who threw a rock at his head. Cain was forever scarred by this event, and the Mark of Cain, whether real or metaphorical, came to be symbolic.

The Prodigal Son left the family home because his father divided up his land between his three sons, and he wasn't happy with his lot. He went off to seek his fortune in the world, which nearly broke his father's heart. In his absence, the other stay at home brothers squabbled over the third share of land, and became greedy, idle and lazy. Although they had at first seemed to care more about their father, because they had stayed at home, the farm went to rack and ruin. Meanwhile the Prodigal Son didn't fare any better than he would have done if he had stayed at home and worked his plot of land. So he returned to claim it back. His father forgave him for leaving. This is known as the 'Return of the Prodigal Son'.

There was also a king who was asked to adjudicate over a maternity dispute. Two mother's were claiming the same baby. He declared that the only way to settle the problem was to cut the baby in half, wisely realising that the real mother would rather give the baby up, than let it die. When she did so, he restored her child to her, since her care for the child's had been proved to be greater than her desire to keep it for herself.

Daniel was an important leader, who was unfortunately thrown into a lion's den. He managed to avoid being eaten by talking to the lion calmly. Jonah was also persuasive – he ended up in the belly of a whale after being swallowed, but persuaded the whale to open its mouth and let him walk free.

Moses is the most famous person in the Old Testament, followed by Abraham, Noah, Elijah (who was once fed by ravens when he was starving), Solomon, and David. They were all leaders of tribes, mostly in Egypt and Israel, and often direct descendants of each other.

Moses achieved numerous and incredibly important things for his people, helped by GOD. He began life as an abandoned child, and was found floating in a basket, stuck in some bulrushes on the river Nile. He grew up to be precociously intelligent and wise, and became a prophet and a religious leader of his tribe. He could see that things were going seriously wrong with the human race and this worried him gravely.

Moses, like other prophets, was prone to seeing strange things which were made to appear to him by GOD. The spontaneous combustion of the Burning Bush is a dramatic example. These visions made him all the more faithful to GOD, since they were so incredible. So when GOD asked him to climb to the top of a mountain in the desert, he didn't hesitate. He fasted while he was up there (the idea of fasting was to get closer to GOD by ignoring the demands of your mortal body.)

GOD revealed to Moses ten rules for his people to live by, and instructed him to have these Commandments engraved on stone tablets so that everyone could read them. They were: Thou shalt not kill, thou shalt not steal, thou shalt not covet thy neighbour's possessions, thou shalt not commit adultery, thou shalt not take the Lord's name in vain, thou shalt not worship graven images, thou shalt love thy neighbour as thy would thyself, thou shalt honour thy father and mother, and there were two more.

These formed the base for the establishment of a group of followers called the Chosen Few. Many joined them because they felt that things were going from bad to worse, and they wanted something to believe in. They were afraid of dying and going to Hell and the promise of Heaven comforted them. The fear of GOD's wrath was the lynchpin of the belief system. GOD was known to be good, and only to be feared if his Commandments were disobeyed. He told them to Moses to make it easier for people, giving them the incentive of a life in Heaven.

At this point the people began to fall into two camps – those that followed Moses and the other prophets, and those that decided that if this GOD were invisible to them, he probably didn't exist. Therefore they chose their own deities and made statues and pictures to represent them. Since the Bible is about a particular GOD and how to carry out his wishes, obviously it does not specify any other GOD who is worthy of worship. One of the Ten Commandments forbids the worship of graven images, and this is how the Jew came to have no representations of GOD. The Words of GOD were enough to represent him.

The story of the Writing on the Wall – during a feast in a temple, some anonymous automatic writing appears on the wall, which strikes terror into the hearts of those that see it.

GOD told his people not to make offerings to him, only to pray and to make sacrifices of animals. There is lots of sacrifice in the Bible, usually involving lambs, rams, and calves. GOD even asked Abraham to sacrifice his own son, Isaac, to prove his faith. Abraham knew that GOD would not ask this without good reason, so he complied with the request, prepared an altar, and had his son placed on it, ready for the sacrificial sword. While the knife was poised above his son's heart, Abraham had a vision of GOD, and before his very eyes his son was turned into a lamb, and he killed the lamb instead. Abraham had passed the ultimate test of faith – to love GOD more than his own flesh and blood.

Sinners against GOD's word in thought (very important) and deed, began to make him very uneasy. He showed his anxiety and displeasure in various ways, the most notable being the plagues, pestilences, famines and disasters, which were sent by GOD to devastate the land. The Nile was dried up, all the fish died, and then its waters turned to blood. Crops failed, a

plague of frogs and then of locusts ate every green thing for miles. Contagious diseases were introduced. Prophets made it clear that these things were all signals of GOD's disapproval, and that the only way to avoid the wrath of their LORD was to live good lives.

When some tribes were starving in the desert, GOD showed his mercy by providing them with food. Overnight fine flakes fell from the sky, which were like bread when eaten in quantity. At dawn a heavy dew was deposited and this was sweet to taste like honey. Flocks of quails were all around. The people ate the quails, the honeydew and the flakes, which were called manna – this is known as the story of the Manna and Quails.

A great famine was prevented by Joseph, the son of Jacob, a Canaanite, (who was the son of Esau) and the head of a tribe. (Jacob had an eventful life – he was sleeping in a field one night, resting his head on a stone, and dreamt he saw a ladder reaching up to a cloud. In addition, at some point in his life he had to wrestle with some angels.) Joseph was one of twelve sons, of whom the youngest was called Benjamin. But Joseph was the favourite. His father had given him a beautiful 'Coat of Many Colours', which made his brothers very jealous. They were also irritated by the fantastic dreams he had. So they resolved to get rid of him, and somehow they did. Joseph ended up working as a baker in the palace of a rich man called Potiphar. Word got around that he could interpret dreams, and eventually he became Potiphar's right hand man. All Joseph's dream interpretations proved correct, and by paying attention to them Potiphar managed to amass considerable wealth. Unfortunately, Joseph caught Potiphar's wife's eye and she tried to seduce him. Potiphar found out and thought that Joseph had been the seducer. He had him thrown into a dungeon.

Even from prison Joseph's interpretative talents stood him in good stead. He interpreted his fellow prisoner's dreams, and when Pharaoh got word of his talents, he summoned him to his palace. He had a dream which really worried him in which seven thin cows ate seven fat cows, but didn't derive any nourishment from them. Joseph predicted seven years of bumper harvest followed by seven years of famine. He advised the king to stock pile food in the good years and then ration in the bad years. Sure enough, the predictions were correct, the people followed Joseph's advice, and no one starved. His position as the Pharaoh's advisor was secured.

However Joseph's good-for-nothing brothers in Canaan were not so lucky. They had not heeded the warning and were going hungry. In the end they went to Egypt to throw themselves at the mercy of the Pharaoh. They were received by Joseph, and didn't realise he was their long lost brother, although he recognised them. He had a dream in which he saw eleven stars bowing down to his star, and had interpreted this to mean that the brothers did feel remorse for their sins. Before he gave them food, Joseph decided to play a trick on them, to see if they had an ounce of goodness in their hearts.

He planted a silver cup or something in the bag of the youngest, Benjamin, whom he loved the most. Then he accused all ten of them of stealing the cup, and it was found. The brothers tried to clear his name, and insisted that they be punished instead of him – feeling retrospective guilt for what they had done to their other brother. They said it would break their father's heart to lose another son. Joseph, satisfied, pardoned them, and revealed his true identity. They were incredulous and he showed them his multi-coloured coat.

David the Giant killer was the son of Solomon or the other way around. He was to become king of his people, who lived in Israel and were amongst GOD's Chosen Few. When his people were being terrorised by a giant, David fought the giant and killed him with his slingshot, earning himself the name 'giant-killer'.

Another tale of how weakness can overcome strength is that of Samson the strong man. He succumbed to the charms of a woman named Delilah who was fascinated by his fabled strength. In an unguarded moment he revealed to her that his strength was only preserved if his long hair was left uncut. One night when he was asleep she cut off his hair. Samson was awoken by the shouts that the temple was collapsing. He could have held up the main supporting beams and saved the temple, but his strength had been taken from him by Delilah. His faith had lapsed, momentarily, but fatally. The temple collapsed and crushed those that were in it to death.

God's general opinion of human kind had not changed. The cities of Sodom and Gomorrah gave him most cause for despair. These were sinful places, full of fun palaces, dens of iniquity and vice. Anyone with any moral fibre was bound to leave, as did Lot. But Lot's wife wanted to stay, and was so difficult to persuade, that once he did get her on to the road out of town, Lot made her promise not to look back, thinking that she would be too tempted to return. Temptation did indeed get the better of her, and she was turned into a Pillar of Salt. Those that remained had the idiot of building a tower to reach Heaven, where they were convinced even greater delights than the sins of the flesh awaited them. The Tower of Babel was a magnificent folly, with steps spiralling up the exterior and lots of windows. It was the highest building in the world, and it really tried GOD's patience. He didn't destroy it, but he gave all the different races in the city different languages, so that communication and thus the building project, was impossible. The cacophony of voices coming from the tower came to be known as 'babble'. The tower never reached heaven.

It wasn't just Lot who was looking for a better place to live. Noah had been told by GOD to build a boat, and he obeyed, for he could see that the people of Sodom and Gomorrah were on a slippery slope. He started construction of the huge vessel, assisted by Mrs Noah, his sons Shem, Ham and Japhet and their wives. People would come just to see the extraordinary spectacle of a ship built without a sea to sail on. They laughed at the eccentric Noah, but he took no notice, convinced that GOD had something in mind, and immune to the taunts of these libertines.

The ship was known as the Ark, and it was barely finished when GOD's patience finally ran out. Despairing of an improvement amongst the sinners, he opened the Floodgates of Heaven, unleashing a rainstorm of unprecedented scale. For forty days and nights it rained in torrents and the land was flooded as far as the eye could see. The water level continued to rise until all living and breathing things were drowned. Noah, meanwhile, on GOD's instruction, had loaded a breeding pair of every species of creature on to the Ark, two by two, and he and his family were floating safely on the floodwaters. They drifted around for ages, until one day Noah sent a Dove to find out if there was any dry land. The dove returned carrying an Olive Branch in its beak, which was a sign of hope. Eventually the Ark came to rest on the top of what had been Mount Ararat. The Ark was unloaded, and the animals went forth to increase and multiply.

This is how GOD started again – Noah's sons and their wives became the ancestors of a new people. They were very grateful to GOD for sparing them, and their faith in him increased. As the waters receded, the Ark was left high and dry, and fertile land uncovered, so that Noah and his descendants could grow plenty of food. There is an unfortunate postscript to this story – Noah abused one of his granddaughters, and was found out. He was confronted by the rest of the family and had to repent. After this new beginning, GOD took a firmer hand in the destiny of his people. He wanted them to establish a homeland and centre for his worship. He promised his 'Chosen Few' lands of their own, which they called the Promised Land. They were nomadic tribespeople, living in the desert in Egypt. The Promised Land turned out to be there, and fight Egypt for it. Moses and Abraham, King David, and Solomon were all leaders at various times. Several generations later they reached their goal, and became known as the Israelites.

A historic episode took place – that of the Parting of the Waves, also known as the Red Sea Crossing. The Chosen Few were travelling in the desert and had run out of food. Their route lay through the wilderness, and their morale was very low. Egyptian troops were closing in on them and they were cornered. GOD told Moses to hold his staff aloft and the waters of the Red Sea would part, opening the way to safety. Moses did this and the sea rose up, forming a towering canyon with walls of water, and the sea bed was dry. They began the long crossing, but were pursued by the Egyptians. When the Egyptians reached the middle of the sea bed, GOD turned it to mud, so that their progress was slowed and they couldn't catch up with Moses and his people. Once the Chosen Few were safely on the other side, in Jordan, GOD allowed the waters to close over the Egyptians and every single one of them was drowned.

The founding of Jerusalem, or Zion, City of GOD, is described at great length in the parts of the Old Testament that are devoted to economics, laying down of laws, the division of land, and establishment of a political hierarchy. Battles were frequent, the Battle of Jericho being particularly famous. Joshua signalled the attack with trumpets made from ram's horns, and the Walls of Jericho were pulled down. Further stories are told in Deuteronomy, Judges, Leviticus (named after Levi), and Ecclesiastes [?] were numbers, scribes, and money lenders all played their part in the life of the city. David was a major player, he was at this point a king and his son was called Solomon (who had a wife called Bathsheba). Solomon was known for his wisdom (the Wisdom of Solomon), and there is a whole book devoted to a long lament about Jerusalem and the journey to the promised land, called the Song of Solomon, or Song of Songs. It tells of sitting by the river of Babylon and weeping for the memory of Zion. Babylon, which was destroyed by GOD, was a city dedicated to pleasure, and it had one of the seven wonders of the world, the Hanging Gardens. It came to represent what people couldn't have, or could have had if they'd been better people. Jerusalem was the holiest place for the Israelites, but they weren't permitted to build temples or worship there, as their rulers did not recognise their new religion.

Rituals and rules were established, and sacred places and objects began to emerge. Some men wore a small box tied to their foreheads, called a phylactery. It would have contained a bit of scroll. A bunch of marjoram might be used as a brush and dipped in blood, to daub the front door of a house for some reason. Soil was often used in some kind of vessel, as were scrolls.

The best sacred vessel by far is the Ark of the Covenant. The Convenant is the dead sea scrolls, or some other part of the first writing down of the Old Testament. GOD required Moses to have this made at the same time as he dictated the Ten Commandments. It was a portable chest with shoulder rests, and had a golden angel on each of the four corners. The Ark was carried around by Moses and wherever it came to rest was a most sacred and holy spot. It was like a portable temple, and it ended up (in the Old Testament at least) in the temple in Jerusalem.

The end of the Old Testament has the Israelites waiting for the birth of the Messiah, the son of GOD, who will be sent to save them from themselves.

The story begins with Joseph, a carpenter who lived on the shores of Lake Galilee. He had a wife, Mary, but they were childless. In fact Mary was a Virgin. One day an angel called Gabriel appeared to Mary, and he had wings like drifted snow and fiery eyes. He may actually have appeared to her as a dove. Gabriel told that she was with child, her (this event is usually referred to as the Annunciation), and that the child was very special, because he was the Son of GOD, a manifestation of GOD on Earth. He was to be called Jesus when it was born and he had been sent to Earth by GOD to take away the sins of the Earth. This is known as the Miraculous Conception, and Mary became the Blessed Virgin, the Mother of GOD.

Those with strong faith were aware that something amazing was about to happen and they began serving signs in the sky and making predictions. Herod had insisted that all Galileans make a journey for some

reason, so Mary and Joseph set off on their donkey. It was winter and Mary was nine months pregnant. All the inns they tried were full, however one inkeeper, seeing Mary's condition, offered them his stable in Bethlehem, and that is where Jesus was born. Mary wrapped him in swaddling clothes and laid him in a manger.

The shepherds and the kings arrived at the stable just after Jesus had been born. He was sitting in Mary's lap, and she was dressed in blue. Joseph and the ox and ass that lived in the stable were staring at the child in adoration. The newborn child had a powerful and precocious influence over all who set eyes on him. The shepherds and kings prostrated themselves before him, and laid their gifts at his feet. The shepherds brought lambs as gifts. Lambs are very important symbols in the Bible. Soon the glad tidings of great joy spread, and crowds of people came to the stable in Bethlehem to worship Jesus. Cherubim and seraphim (small childlike angels) hovered above the stable.

Jesus grew up a carpenter like his father. He was always a special child and as soon as he was old enough he began to travel around, making friends and telling stories. It was clear that he had extraordinary powers of perception, and these soon made him famous in Galilee. He gathered a band of followers who became known eventually as the Apostles, the Disciples, or simply, 'The Twelve'.

Jesus was always trying to make good people feel the power of GOD, and to have more faith and believe in themselves: 'you are the light of the world/salt of the Earth', 'don't hide your light under a bushel' and 'if your slate is clean, then you can throw stones', were some of his favourite sayings. But what really got people excited and increased his following was his ability to achieve the impossible. All his life he performed what became known as Miracles. The most mundane of these occurred at a wedding at Cana, when there was no wine, so Jesus had them fill several barrels with water, which flowed out as wine, this is referred to as the 'Water into Wine' miracle. More dramatic was the Feeding of the Five Thousand – an occasion where five thousand of his followers had gathered to hear him preach, but there was nothing to feed them with except one loaf and one fish. Jesus bade people to look in their baskets and lo! there was fish and bread for every one (also known as Loaves and Fishes). Along the same lines he told a farmer, whose crops had failed, to sow his barren field with pebbles instead of corn, and have faith in GOD. Sure enough the stones grew into fat ears of corn which thrived.

Medical miracles were even more amazing – people were constantly coming to be healed of their ailments by Jesus (The miracles only worked if people had true faith). A man who had never walked got up from his bed and walked unaided. A blind man regained his sight. Most impressive was the Resurrection of Lazarus, who was actually dead and in his tomb until Jesus arrived, when he rose form the dead and breathed again. But surely the best miracle was the Walking on Water. When they were out fishing one day, to prove to a doubting disciple that GOD was really acting through him, Jesus stepped out of the boat and simply walked on the surface of the sea.

The miracles were really tests of faith and love – if had to prove his own loyalty to his Father. Naturally his tests of faith were harder to endure. His forty days in the desert with the Devil were the worst ordeal (apart from the final days of his life). The Devil took him flying over the desert and showed him some truly fabulous things. He tempted him with riches and power beyond all imagining, and doubtless in more subtle and devious ways. But Jesus resisted everything, content to walk around in simple robe and sandals and get food where he found it.

The disciples were Matthew, Mark, Luke, John 'the Baptist', Peter 'the Rock', Paul, Simon, James, and three others. Because some of them were fishermen by trade, and they went around converting people to the faith preached by Jesus, they were known as 'fishers of men'. The fish is thus an important Biblical symbol, and actually symbolises Christianity itself. Ritual tonsal immersion in water was the method used to welcome people into the faith. This was called baptism. The disciple called John did most of this baptising, for which he was known as John the Baptist.

Baptism was usually done in a river – John was often to be found up to his waist surrounded by waiting crowds performing a mass baptism. He had long hair and a beard, like Jesus. Because of John's active role, Herod thought he was a threat and had him thrown into jail. Herod had a mistress called Salome, with whom he was so besotted that she could ask anything of him. Her famous 'Dance of the Seven Veils' only fanned the flames of his desire for her. Salome provoked Herod's jealousy trying to seduce John in his prison cell. She was fascinated by his piety, and saw it as a challenge. He, of course, resisted all her advances but Herod was so jealous that when Salome, angry that John had spurned her, asked Herod for his head on a plate, he acquiesced. When Salome received the head she kissed its lips and declared that she had possessed John at last.

Just as John was seen as dangerous by Herod, so Jesus was attracting the attention of both Herod and Pontius Pilate of Jerusalem, for being called the King of the Jews. His power over the rabble was increasing, and it was beginning to look as though it might lead to riots. Herod interrogated Jesus and asked him how he dared to call himself the King of the Jews, but Jesus said, 'it is you who call me that'. Herod thought this very insolent, and said that he would leave it to Pilate to deal with. It is implied that he was a little afraid of, or in awe of Jesus.

In Jerusalem Jesus had two enemies among the high priests, especially the one called Caiaphas. However, he knew that he had to go there, and his entry into the city one Sunday was triumphant. He rode on a donkey, having declined a horse, and the crowds put palm leaves down in the road before him. When they heard that Jesus of Nazareth was on his way to the city, the high priests plotted to ensure his arrest. They earmarked Judas as being susceptible to a bribe and weak in his faith. They

offered him forty pieces of silver merely to identify Jesus so that they could arrest him. Judas eventually agreed (he had some grudge against Jesus), but at least he refused to take the money.

Jesus knew that his time on Earth was nearly over. He summoned his Disciples to the Last Supper. They all bathed each other's feet. Mary brought a bottle of expensive myrrh oil and anointed Jesus' feet using her hair as a brush. Judas, feeling guilty, objected angrily, saying that Mary (who was a prostitute) was not worthy of doing this for Him. Jesus told him that he should only throw stones if his own slate was clean – a hint that he knew what was going to happen. Judas said that the money spent on the ointment could have gone to the poor and at this Jesus got even angrier. He told the Disciples that despite the sufferings of the poor, they should still be grateful for the good things in life. He urged them not to argue but to make the most of the evening and what little time he had left.

Jesus passed round some bread and a cup of wine, which he wanted everyone present to share with him. He asked that they remember him when they eat and drink, saying that the bread will represent his Body and the wine his Blood. This ritual became known as the Sacrament. The disciples were incredulous when Jesus said he was going to leave them. Jesus became impatient with them, for they were all a bit drunk. He told them that not only was he to die in next few days, but also that very night, one of the twelve would deny ever having known him, and another would betray him. Peter, he said, would deny him three times before the cock crows, and Judas would betray him with a kiss.

Jesus wanted them all to stay awake and pray with him in the garden of Gethsemane, but one by one the wine got the better of all of them and he was alone in his final hours of freedom. He knew that this was GOD's will. In the night Pilate's soldiers accompanied by Caiaphas came to arrest him and Judas marked him out with a treacherous kiss on the ear. When the others awoke it was too late and they too were dragged off for questioning. Peter eventually denied that he knew Jesus and just as he repeated this for the third time, the cock crowed and he realised what he had done.

Jesus was taken to see Pilate, who questioned him about his motives and offered him freedom if he renounced his GOD. Pilate was rather struck by such a charismatic man and perhaps felt inclined to let him go, even trying to pass the responsibility back to Herod, who was the ruler of Galilee, where Jesus was born. But egged on by Caiaphas and his supporters, Pilate was persuaded that only the emperor Caesar could be a religious ruler, and that Jesus must therefore be condemned to death. The fickle crowd were baying for blood and when Pilate offered to pardon one prisoner, they demanded that it be Barrabas, a robber, rather than Jesus. Pilate gave the order for Jesus to be crucified. He called for a bowl of water and publicly washed his hands of the guilt.

On a Friday Jesus was taken to be crucified. He was made to wear a purple robe and a crown of thorns and to carry the cross on his back. The route to the Mount of Olives was lined with people and several times he collapsed with exhaustion. The disciples, Mary Magdalen and his parents were gathered there and a man named Joseph of Arimathea. They endured the sight of Jesus and two thieves being nailed to crucifixes. Jesus had a nail driven through each hand and one through both feet. There was a sign pinned to the cross above him with four letters on it – which spelt 'King of the Jews'.

Jesus's time on the cross is known as the Crucifixion, or the Passion (in other words his pain). Jesus asked for water and one of the guards gave him a sponge soaked in vinegar instead. He never complained or cried out, but he asked GOD why he had forsaken him. A soldier pierced his side with the point of his lance and blood flowed to the ground. Eventually Jesus 'gave up the ghost'. As he breathed his last, he said 'Father, forgive them, for the know not what they do. Unto thee I commend my spirit.' And his spirit left his body and ascended to Heaven – this is referred to as the Ascension.

The next day, Saturday, his friends took Jesus's body down and the two Marys wrapped him in a linen shroud for his burial in a cave. A large boulder was rolled in front of the entrance. On the Sunday, the disciples went to visit the tomb and discovered that the stone had been rolled away, and the body was gone. Only the shroud remained. At first they thought the tomb had been robbed, but then Jesus appeared to them and told them that he had gone to Heaven, where he would sit forevermore on GOD the Father's right hand. 'I am the Resurrection and the Life', he said. Although his mortal body was no more his spirit (or Holy Ghost) had merged to be one with GOD, and was with them on Earth. This combination of the Father, the Son, and the Holy Ghost became known as the Trinity, or Three in One and One in Three. The disciples, he said, must carry on his work on Earth and found the Christian Church. Peter was given this task and was to be the Rock on which the Church was founded. This final return to Earth is known as the Resurrection.

Once the Church was founded, the disciples were kept busy writing the gospels, and preaching in the name of the Lord. These activities are documented in Paul's and Peter's letters to the Ephesians and the Corinthians.

The final word in the New Testament goes to John, in the book which describes the Revelations made to him about the fate of the world after Jesus. This is not written by John the Baptist, but by a hermit who lived in a cave and who saw very clearly that the end of the world was nigh. The book of Revelations is guaranteed to strike the fear of GOD into people's souls. It tells people how to recognise the Devil, who may often walk amongst them in disguise: he will bear on his body the letters 666 – the mark of the Devil. The most important thing is never to forget the sacrifice that Jesus made. Those who are good will be saved, pardoned for their sins and will lead a better life in the hereafter.

The Bible from Memory 1997 (no.31)

but as Kay points out, it suggests a book that would be 'encyclopaedic in ambition, but fantastically fallible'. She stresses that her attempts to remember and put into chronological order all she knows of the world from memories of school lessons, books, films, TV documentaries, current affairs and her travels have been completely genuine. The gaps, the missing parts of history, the warping of time and the lost centuries are as important to the work as the recollections themselves.

Kay's orderly use of printed texts, lists of objects, and memory maps appears to connect her with the text- and time-based Conceptual art of the 1970s, for example the Herculean hand-writing projects of the German artist Hanne Darboven. At the same time, Kay's reliance on her own memory brings her close to artists who have used personal inventories to prompt a series of complex and associative responses in the viewer, for example Christian Boltanski or Susan Hiller. Through self-imposed restraint and reliance on an unpredictable and fragile process, she presents a world view that is simultaneously inaccurate and truthful. CK

Details of *The World from Memory* II 1998 (above and opposite)

'When I am writing I always imagine myself in some kind of virtual computer environment and think of my memory works as hypertexts. The associative and cognitive links people make are the very ones which computers try to emulate, and even represent. Hypertext is an apparently objective attempt to impose order over chaos and to get to grips with vast resources, though its subjectivity is inescapable. It seemed to me to be interesting to represent this attempt visually.' Emma Kay

VIK MUNIZ was born in 1961 in São Paulo, Brazil. After studying academic drawing and sculpture, he moved to the United States in 1983 and settled the following year in New York, where he now lives and works. At first Muniz spent several years doing odd jobs and portraits to make a living. He later took up making sculptural objects before concentrating upon photography. He now teaches photography and drawing, and is associate editor of *Blind Spot* magazine. Muniz has exhibited widely and in 1998 he represented Brazil at the São Paulo Biennale, Brazil. Selected solo exhibitions have taken place at: Galeria Camargo Vilaça, São Paulo (1995); Rena Bransten Gallery, San Francisco (1998); International Center of Photography, New York (1998); and Museum of Contemporary Photography, Chicago (1999). Group exhibitions have included: *Life Size: Small, Medium, Large* (1992), Museo D'Arte Contemporaneo Luigi Pecci, Prato; *Panorama Da Arte Contemporanea Brasileira* (1995), Museu de Arte Moderna, Rio de Janeiro; *Inclusion/Exclusion* (1996), Steirischer Herbst, Graz; *Le Donné, le fictif* (1998), Centre National de la Photographie, Paris; and *The Museum as Muse* (1999), The Museum of Modern Art, New York.

Bibliography
Silence Please!: Stories after the Works of Juan Muñoz, ed. Juan Muñoz, Louise Neli and James Lingwood, Dublin 1996
Andy Grundberg, 'Sweet Illusion', *Artforum*, Sept. 1997
Mark Alice Durant, 'When the duck's beak becomes the rabbit's ears: Vik Muniz and the Alphabet of Likeness', *Vik Muniz: Seeing is Believing*, Santa Fe 1998, p.142
Vik Muniz, *Vik Muniz: Seeing is Believing*, Santa Fe 1998*

It is not surprising that a key image in Vik Muniz's series *Pictures of Chocolate* (1997–9) is of Jackson Pollock with one of his 'drip' paintings. Hans Namuth's famous photographs of the artist at work drew attention to Pollock's belief that painting was the material embodiment of action. Muniz's work also focuses on the process of image-making, but he is less interested in the creative act than in deconstructing the mechanics of representation. The *Pictures of Chocolate* hover between flatness and three-dimensionality: what at first appear to be simple tonal portraits suddenly break up into the glossy dribbles of chocolate syrup. This chocolate syrup was coincidentally the same brand that Alfred Hitchcock used as blood in the 'shower scene' in his film *Psycho*. Muniz is fascinated by the layers of fakery which contribute to making an image look 'real'. Influenced by the visual games and devices employed by Dada and Surrealist artists, he also enjoys playing optical tricks. However, his low-tech illusions and *trompe l'oeil* techniques mask a serious interest in the process of vision as a sophisticated, yet fallible filter of the external world. Muniz does not attempt to disguise his complex fabrication process, but like a magician revealing the workings of his trick, he encourages the viewer to deconstruct the image. In doing so we become aware of the complex way we receive, filter and digest visual information.

The series *Aftermath* (1998) is another of Muniz's experiments in *trompe l'oeil*, where he masterfully depicts street children out of carnival detritus. These images hint at the extremes of poverty and wealth in Brazil's capital, particularly during the Rio Carnival. Yet the assemblages paradoxically allow the children to break through the detritus with which they are customarily identified, and form their own image or identity. The use of unusual materials (chocolate, sugar, dirt and rubbish) allows

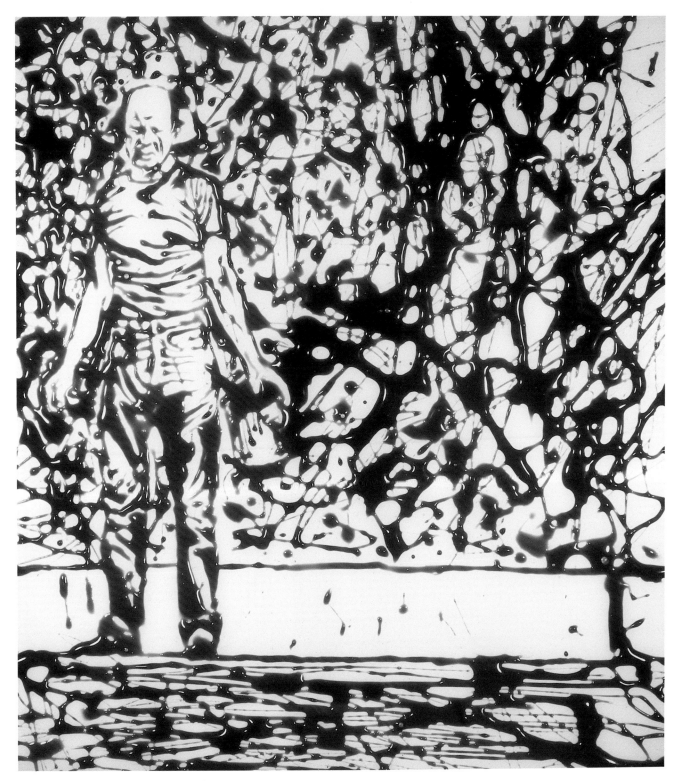

Action Painter (after Hans Namuth) 1999 (no.34b)

Vik Muniz

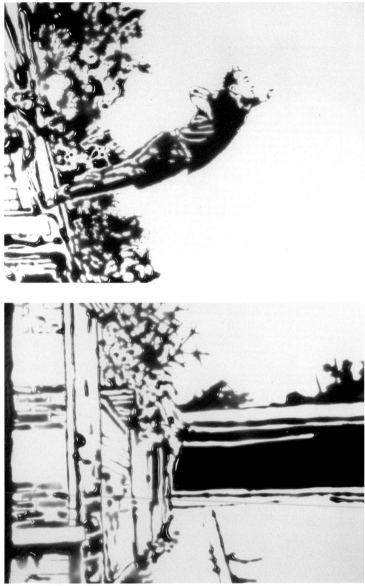

Leap into the Void (after Yves Klein) 1999 (no.34c)

Muniz to engage the viewer's automatic use of analogy and metaphor to make sense of the visual image. He is fascinated by our instinctive ability to form extraordinary links within a collective visual syntax.

In his earlier work *Personal Articles* (1995–9) Muniz disseminated in public a series of amusing fake press reports, inspired by the extraordinary images in science journals: 'They mean absolutely nothing, but in the context of this fictional apparatus that surrounds them, they become meaningful … I just wanted to make them barely convincing, but when you have these elements — you see the paper, you see coherent blocks of text — you believe in it.'* *Personal Articles* raises questions concerning the credibility of visual information and the authority of printed text, just as Muniz's photographic works destabilise photography's traditional claims to authenticity. Amongst the games, Muniz demonstrates a profound sense of wonder at the complexities of human perception, and our relentless capacity to absorb and transform the image-saturated world around us. JM

'I want to make the worst possible illusion that will still fool the eyes of the average person … Illusions as bad as mine make people aware of the fallacies of visual information and the pleasure to be derived from such fallacies. These illusions are made to reveal the architecture of our concept of truth. They are meta-illusions.'* Vik Muniz

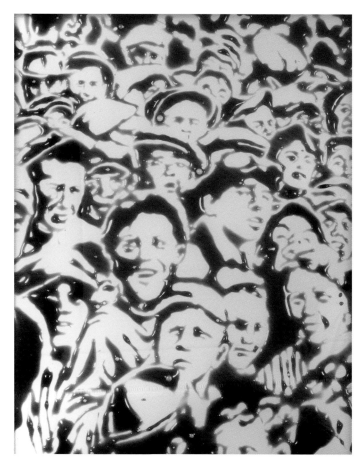

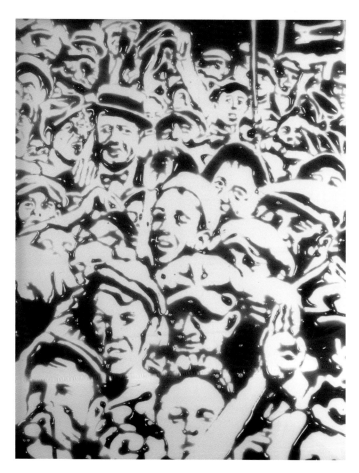

Babe 1998 (no.34a)

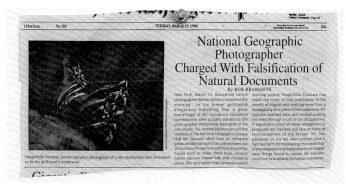

Personal Articles 1995–9 (no.33)

'Something happens when you experience an optical illusion that exchanges the experience of an object for the experience of vision itself.'* Vik Muniz

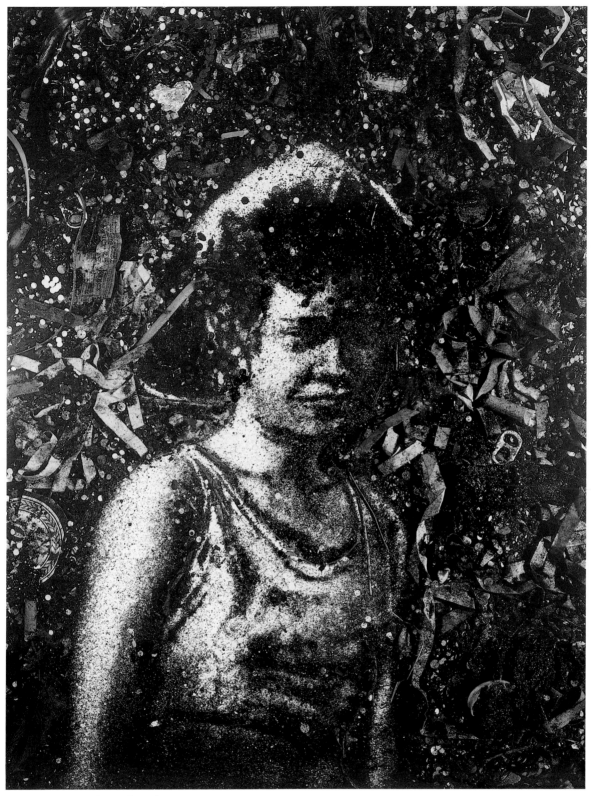

Aftermath (Aparecida) 1998 (no.35)

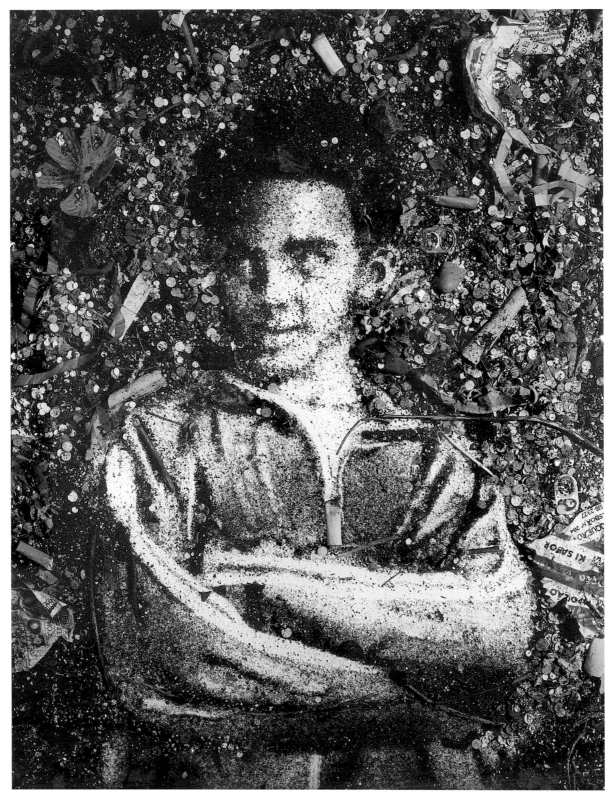

Aftermath (Emerson) 1998 (no.36)

PAUL NOBLE was born in Northumberland in 1963 and grew up in Whitley Bay. He attended Sunderland Polytechnic and the Humberside College of Higher Education. In 1986 Noble moved to London and became one of the founders of City Racing, an artist-run gallery in Vauxhall; his work was included in its final exhibition, *The Last Show* (1998). He has exhibited frequently in Europe where his work has been seen in London, Bremen, Frankfurt, Hanover, Oslo, Eindhoven and Paris. He first exhibited in New York in 1997, at Jay Gorney Modern Art, with American artists Allen Ruppersberg and Paul McCarthy (1998). Large-scale drawings of his imaginary town 'Nobson' were exhibited at the Chisenhale Gallery, London (1998), followed by the related *'Welcome to Nobpark'* at Interim Art, London (1998-9). Group exhibitions in London include *Belladonna* (1997), Institute of Contemporary Arts; *'A-Z'* (1998), The Approach; *Surfacing, Contemporary drawing* (1998), Institute of Contemporary Arts. Noble curated the group exhibition *Sociable Realism* (1998), Stephen Friedman Gallery, London. He lives and works in London.

Bibliography
Brett Ballard, 'Funny Business', interview with Paul Noble, *Everything*, Spring 1995
Carl Freedman, *Frieze*, no.30, Sept.-Oct. 1996, p.88
Belladonna, exh. cat., Institute of Contemporary Arts, London 1997
Matthew Higgs, 'Paul Noble' in *Cream*, London 1998
Paul Noble, *Introduction to Nobson Newtown*, Cologne 1998*
Paul Noble, *Nobson Newtown*, Cologne 1998
Helen Sumpter, 'Art with nobs on', *The Big Issue*, no.271, 16-22 Feb. 1998

Paul Noble, who has been described as working with 'bed-sitter introspection' has produced paintings, drawings, photographs, constructions, installations and book-jackets. He works mostly in open-ended series and his major project since 1995, 'an exercise in portraiture via town planning',* has centered on the imaginary and dystopian 'Nobson Newtown' and its environs. The town's twin mottos, 'no style only technique' and 'no accidents only mistakes', comment ironically on late twentieth-century town planning and perhaps also on some recent art. Noble's social satire has been seen in the tradition of Swift, Dickens and Mervyn Peake, and it is conveyed in a meticulous style that combines the obsessive and critical focus of the Neue Sachlichkeit with the bathos and robust humour of underground comics.

Noble has presented an overview of 'Nobson' in a series of large oblique projection drawings. Groups of buildings, based on a geometric font designed by the artist, spell out their particular functions — Nobslum, Nobpark, Nobjobclub. The artist also produced a small guide book,* written in an appropriately upbeat style, which describes how the planners decided that the town centre should become 'an un-centre wasteland'. It also records that places of worship had been excluded, by popular request, in favour of a central shopping mall. 'Perhaps inspired by Nicolai Ceaucescu's single-mindedness in rebuilding Bucharest, Nobson Newtown was … built in the same knock-it-down-and-start-again spirit.' Aspects of this evocative urban archetype, with its provision for decline, violence and the dumping of waste, have been extrapolated with greater detail in works such as *'Welcome to Nobpark'* (1998).

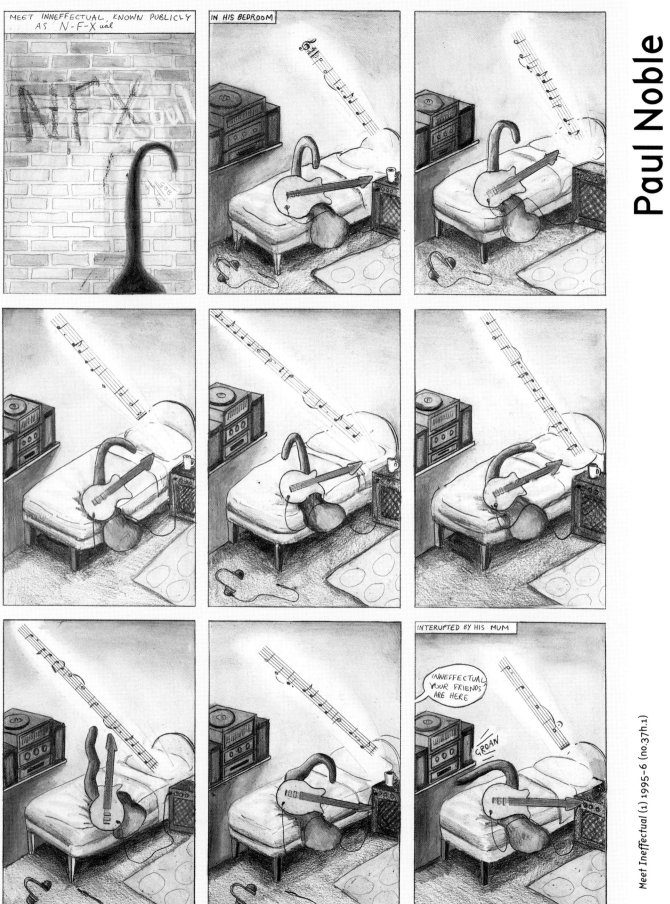

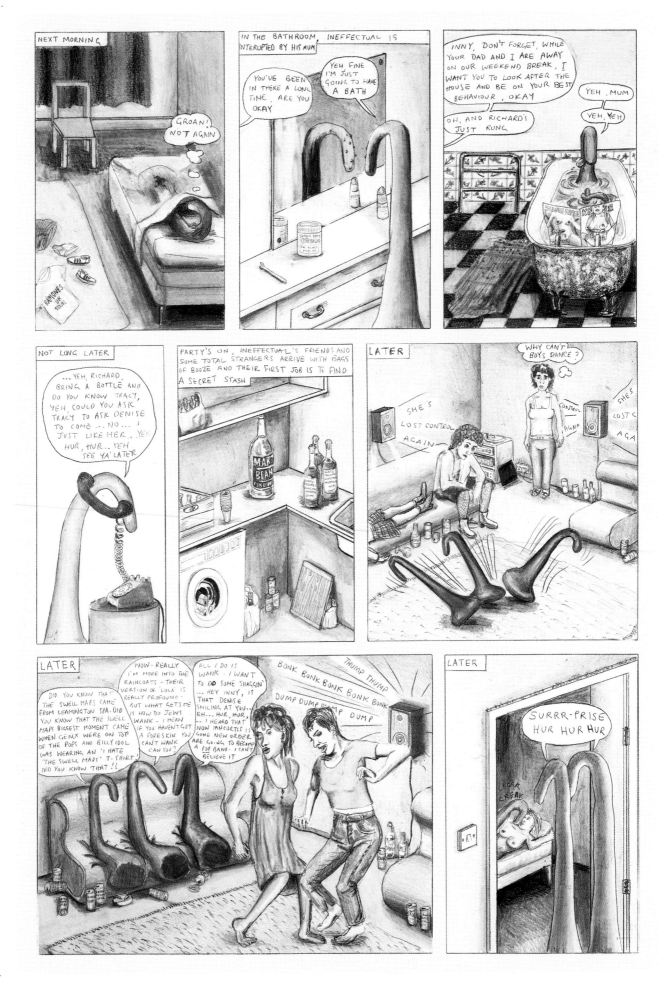

Meet Ineffectual (2) 1995-6 (no.37h.2)

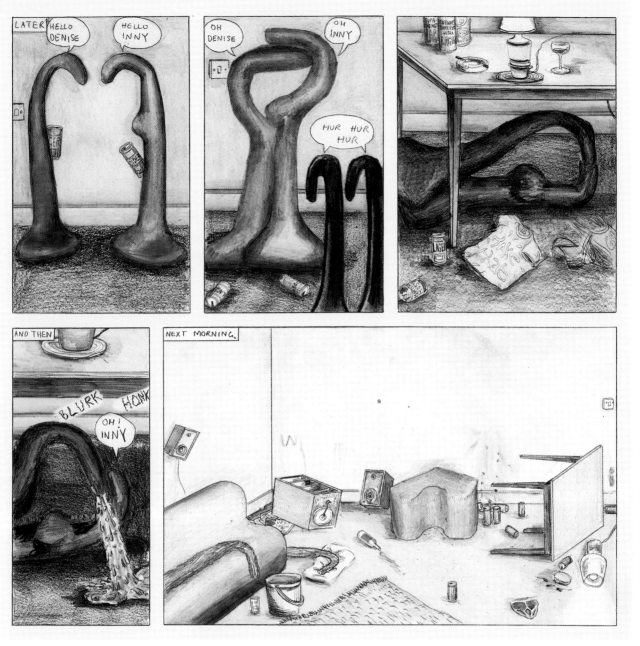

Meet Ineffectual (3) 1995–6 (no.37h.3)

Last Orders 1995–6 (no.37h.8)

Doley (1995–6) is a game true to the spirit of Nobson's bunker-like unemployment office, whose architects, according to Noble, 'did not really have any idea what actually happens in such a place'. It has been likened to 'a modern monopoly for the hopelessly dispossessed' and relates to the artist's experience of eleven years on the dole. Noble pragmatically describes it as 'a functioning duration piece', gauged on loss rather than gain. Accompanying drawings and a set of rules describe aspects of the game's characters, whose personae players must adopt in order to play. Their amorphous appearance reinforces the hopelessness of their names: Oblivious, Aimless, Formless, Ineffectual and Burnt Out. Players are required to put on a series of props in order to resemble the character each has adopted. According to Noble, the props are there to add a theatrical element and distract players from the fact that 'there is no space for skill when playing *Doley*'. Like its subject, *Doley* can be played for long periods of time … CK

The Doley Game 1995-6 (37a) during play

Extracts from *Doley: The Rules* (no. 37b)

'A game for three or more players over the age of sixteen. Before the game can begin players must choose one of the board characters. There are five supplied, each with their own persona. These are: Oblivious (& Other-worldly), Burnt Out, Formless & Misshapen, Ineffectual and Aimless. If more than five people want to play Doley at the same time make extra counters with whatever is at hand.

You are now a player in Doley. This is what happens to you. Once every two weeks you sign on and then, a couple of days later, your giro comes. Sometimes the giro comes in the second post which means hanging around, watching the letterbox, waiting for the postman before your fortnightly life can begin again. Sometimes the giro doesn't come in the second post either and you are forced to write the day off.

The game is *You are drawing the dole!* Doley cannot be won, but if the players follow the rules desperation may be avoided.

The game may now begin. Players must position their personae in the 'Spend the Day in Bed' station. Having decided amongst yourselves who is to lead, the dice is thrown.

Move your counter the amount of spaces indicated by the dice and follow instructions given on the square that you land on. Some stations are self-explanatory. For example, if you were to land on 'Spend the Day in Bed' this is the place your character can rest and stay out of harm's way. Not a bad place to be!

Some stations are more complex and may require the new character to spend some time getting used to the details of the rules; for instance 'Sign On' and 'Get Giro': Signing on and getting giro can be very easy indeed, but often as not proceedings are complicated by a 'Letter from the Dole'.

'Sign On' is the station where the character declares a fortnight of unemployment. It is necessary to have *not* worked in order to get your giro. In fact, even if you have done some cash-in-hand (see 'Painting and Decorating') it is best not to mention it. Signing on is the thing you do before you can get your giro. It is not necessary to stop on 'Sign On' to receive your giro – as long as your character passes over 'Sign On' directly en route to 'Get Giro' then everything is okay ... *unless* ... your character lands on 'Sign On' by *throwing a six*. This is the game's equivalent to a 'claimant' arriving at the dole office with paint-spattered hands, a pencil behind the ear, a tool belt around the waist and the works van parked up at the front doors! This means that you are not eligible for this cycle's benefit. Do not collect any money when you pass 'Get Giro'.'

FERNANDO SÁNCHEZ CASTILLO was born in Madrid in 1970. He studied at the Universidad Complutense, Madrid, and in 1995 he completed a Master's in Philosophy and Aesthetics at the Universidad Autónoma, Madrid. Sánchez Castillo's first solo exhibition, *Desde el cuarto de estar*, was held at the Galería Marta Cervera, Madrid, in 1996. Sánchez Castillo has taken part in several group exhibitions in Spain, including: *Uno cada uno* (1994), Galería Juana de Aizpuru, Madrid; *XII Muestra de Arte Joven* (1996), Salas de Exposiciones del Ministerio de Cultura, Madrid; *Germinations 97* (1997), Instituto de la Juventud, Madrid. He was represented by Galería Marta Cervera at ARCO, La Feria Internacional de Arte Contemporáneo (1997, 1998) in Madrid. In 1995 he participated in *Walking behind the Glass* at the International Center for Photographic Studies, Los Angeles. He lives and works in Los Angeles and Madrid.

Bibliography

Friedrich Schiller, *On the Aesthetic Education of Man*, Oxford 1982*

Fernando Castro, 'Artistas para al proximo milenio', *Diario*, no.16, June 1996

Ana Alfageme, 'Nuevas Propuestas', *El Pais Dominical*, Aug. 1997

Juan Botella, *Muestra de Arte Joven*, exh. cat., Salas de Exposiciones del Ministerio de Cultura, Madrid 1997

Miguel Fernandez Cid, ARCO 97, *ABC de las Artes*, exh. cat., ARCO, Madrid 1997

Fernando Huici, 'De cuerpo y en efigie', *Que ha pasado en mi cuarto de estar*, exh. cat., Comunidad de Madrid, Madrid 1997

Project for the End of the World 1996

Sánchez Castillo's works are experiments in controlled chaos. Inspired by German Romantic poet Friedrich Schiller's observation that 'A man is truly a man when he is playing',* Sánchez Castillo makes objects which explore the notion of play. In the series *Small Toys* he made miniature constructions and habitats reminiscent of children's playthings, architectural maquettes or flimsy television sets. The objects are activated by simple electronic or mechanical devices: a puppet figure repeatedly gets up and sits down; and an assemblage of tiny household goods moves randomly about the floor operated by a 'bump and go' system. These repetitive and random movements provoke humorous, yet hazardous, scenarios in which the spectator is forced to dodge careering objects. Sánchez Castillo draws attention to humour and play as experiences which are double-edged; locked in frustrated motion, these 'toys' become torturously monotonous and potentially dangerous. The artist links his interest in binary oppositions — laughter/fear, chaos/containment, inside/outside — to Jacques Derrida's notion of *différance* and Frederic Jameson's discussion of the 'dark origins of culture'. He also cites the influence of Theodor Adorno, Max Horkheimer and Sigmund Freud.

Several works in the same series refer to Sánchez Castillo's experience of growing up in the wake of Franco's dictatorship in Spain. *Tribune* (1993) is a small aluminium podium which spins rapidly around the floor, while from inside the droning voice of General Franco endlessly repeats the Fascist dictum: 'Country, religion, family …'. The structure resembles certain Constructivist works, in particular El Lissitzky's *Lenin Podium* (1924). But while Sánchez Castillo may have been influenced by the

Fernando Sánchez Castillo

Explosion Simulator (Casa Desencantada) 1998 (no.38)

'I want to refer to the symbolic function of art as a conciliator
needed between the psychological reality of the individual and
the world of a community. The piece of art creates a common
place and articulates a language.' Fernando Sánchez Castillo

technological dynamism embodied in this work, he states: 'I don't trust the power of art as a tool that is able to change the world of the "real" like previous generations did.' Adopting Derrida's concept of play as a destabilising mechanism, Sánchez Castillo once again parodies the modernist monolith with the humorously titled *Monument to Revitalise Old Heroes* (1993), a toy statue of a horseman on a plinth which shakes violently. In contrast to the Constructivist ethos of creating art works not only in public service but for the public sphere, these works are determinedly small-scale, domestic and irreverently fun.

Explosion Simulator (Casa Desencantada) (1998) relates to a recent series of works which experiment with the creation of micro-civilisations and the possibility of building a society. Among them Sánchez Castillo constructed a self-contained living unit and in *Guided Direction Project* (1999) he created a cylindrical fishtank for studying the primary behaviour of goldfish. These microcosmic constructions resemble modern-day dioramas; however, Sánchez Castillo always introduces an agent of change or disruption. In *Explosion Simulator (Casa Desencantada)* the miniature 'middle-class family house' is intermittently shaken by a simulated earthquake which upturns all the furniture, producing a violent noise and clouds of smoke. This work undermines the bourgeois attachment to material objects and also raises questions about the need to adapt to a continually changing environment. In his attempt to combat the 'nostalgia of art' Sánchez Castillo avoids the fixed art object and instead makes works which embody a constant struggle: they are always in a state of becoming or undoing. JM

Tribune 1993

Monument to Revitalise Old Heroes 1993

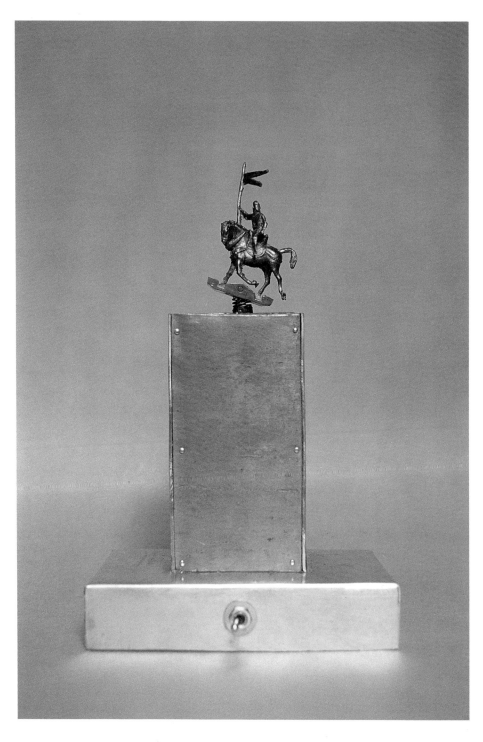

'I want to refer to the symbolic function of art as a conciliator between the psychological reality of the individual and the world of a community. The piece of art creates a common place and articulates a language.' Fernando Sánchez Castillo

KATY SCHIMERT was born on Grand Island, New York, in 1963. After graduating from Philadelphia College of Art in 1985, she went on to complete a Master's in Fine Arts at Yale University in 1989. Schimert's solo exhibitions include *Dear Mr. Armstrong* (1995), Janice Guy Gallery, New York; AC Project Room, New York (1996); David Zwirner Gallery, New York (1998); and Theoretical Events, Milan (1999). Her acclaimed *Oedipus Rex: The Drowned Man* at The Renaissance Society, University of Chicago (1997) was subsequently shown at the 1997 Whitney Biennial, New York. She has participated in group exhibitions across the United States, including: *Critical Mass* (1994), Yale University Art Gallery, New Haven; *The Lie of the Land* (1996), California University Art Museum, Santa Barbara; *Heart, Mind, Body and Soul* (1997), Whitney Museum, New York; and *New Work: Drawings Today* (1997), San Francisco Museum of Modern Art. Schimert has previously shown in the UK in *Belladonna* (1997) and *Surfacing. Contemporary Drawing* (1998) both at the Institute of Contemporary Art, London. Schimert lives and works in New York.

Bibliography

Michael Rees, 'Yale Sculpture', *Flash Art*, vol.26, no.170, May/June 1993

Alan G. Artner, 'She's so literary', *Chicago Tribune*, 16 Mar. 1997*

Olga Zdanovics, 'Katy Schimert', *New Art Examiner*, vol.24, June 1997, p.39

Lynne Cooke, 'The Draftsman's Contract: Seeing Blind' in *Katy Schimert*, exh. cat., The Renaissance Society at the University of Chicago, Chicago 1998

Katy Schimert's work is haunted by a cast of archetypal characters whom she has adopted to create a new, evolving mythology: Oedipus, Sir Lancelot, Ophelia, Icarus and Neil Armstrong. These iconic figures, ancient and modern, provide points of reference and departure from which Schimert invents new intertextual fictions. Like the extravagant staged fantasies of her contemporary Matthew Barney, Schimert looks at ways to break down the historical, temporal and linear constraints of conventional narrative. Instead she uses symbolism, analogy and metaphor to weave complex threads which interconnect and reverberate from one work to another.

In several works Schimert has drawn upon the tropes of Romantic literature, exploring the theme of idealised, unrequited love and evoking a highly sensual, metaphorical landscape. The relationship between exterior and interior worlds is the subject of *Oedipal Blind Spot* (1997), one of several pieces that make up *Oedipus Rex: The Drowned Man* (1997), a body of work which includes text, drawings, video and ceramics. *Oedipal Blind Spot* refers to Sophocles' famous drama of incest and patricide, and its subsequent adaptation by Sigmund Freud in his examination of the mechanics of desire. Schimert breaks down the narrative into key symbolic moments which she has mapped onto a schematic landscape made of tin-foil, thread and pencil drawings. A mountain range is the central axis between the cities, which mark the different stages of Oedipus' life and his development of self-knowledge. The artist's notational drawings for these cities resemble eyes, suns and orifices, which float in orbit around the mountains. The shapes suggest links between Oedipus' blinding of himself (through which he gains 'inner' sight), the sun as the bearer of light and thus sight, and Freudian sexual fixations.

The sun and its inverse the moon are recurrent symbols in Schimert's work. The gleaming ceramic *Sun*

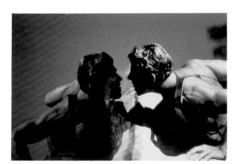

Sir Lancelot 1995

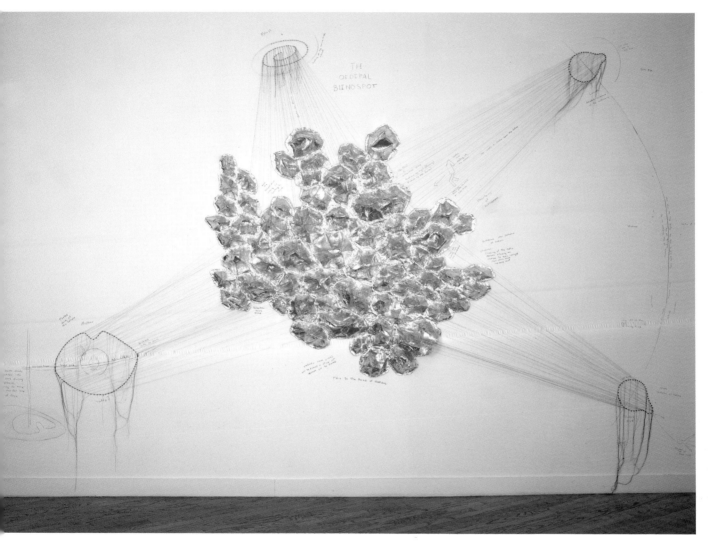

Oedipal Blind Spot 1997 (no.40)

Katy Schimert

Spots (1998) and the dazzling cellular configuration in *The Sun* (1998) form part of a recent body of work that relates to the myth of Icarus. Icarus was the son of the inventor Daedalus, who devised a way to escape captivity on the island of Minos by fabricating wings out of feathers and wax. But in his enthusiasm and hubris, Icarus flies too high and the sun melts his wings, plunging him to his death in the sea below. This death by drowning recalls Schimert's short film in *Oedipus Rex: The Drowned Man* (1997), in which a languorous youth is dragged to the ocean floor by heart-shaped weights. Just as the sun is potentially both healer and destroyer, so the water, whose viscosity suggests amniotic fluid, becomes tomb and womb.

Schimert's circle of glowing yellow blown-glass in *The Sun* simultaneously resembles a vast cosmology and a cluster of minute cellular structures. The shifting perception from macrocosm to microcosm (and vice versa) is an analogy that can be applied to Schimert's work as a whole: her complex layering of references implies that the search for meaning is endless; each insight simply yields another.

JM

Untitled 1997 (no.41)

Untitled 1997 (no.42)

Untitled 1997 (no.43)

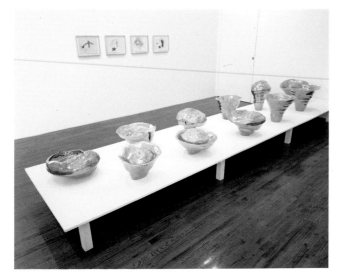

Sun Spots 1998 (no.46)

Untitled 1997 (no.44)

'I think Romanticism is important in general. It's very much about having conflict, about believing and knowing at the same time and knowing that what you believe may not be true yet still being able to believe in it. To me that coincides with love and fate.'* Katy Schimert

The Sun 1998 (no.47)

PIERRICK SORIN was born in 1960 in Nantes, France, where he studied at L'Ecole Nationale des Beaux-Arts (1938-8). He started making short films at the age of 12, and in 1989 he began to use video. His 'autofilmings' were followed by works he calls 'trap-devices', involving spectator participation. In 1993 he began making narrative video installations and the following year created a series of works for French television. Since 1995 he has been producing 'virtual mini-spectacles', combining real environments with 'virtual' protagonists on video. Sorin has participated in the biennales at Venice (1993), Istanbul (1995) and São Paulo (1998). Other group exhibitions include: *Hors Limites* (1994), Centre Georges Pompidou, Paris; *Acting Out* (1994), Royal College of Art, London; *Longing and Belonging* (1995), Site Santa Fe; *L'Effet cinéma* (1995), Musée d'art contemporain, Montréal; *In/conclusive States* (1996), Fruitmarket Gallery, Edinburgh; and *Traffic* (1996), CRDC, Nantes. Solo exhibitions include: *Pierrick Sorin, Films, Videos and Installations 1988-1995* (1995), capc Musée d'art contemporain de Bordeaux; Kunsthaus, Zurich (1996); *Pierrick Sorin: Artiste solitaire, stupide et trop agité* (1996), Shiseido Gallery, Tokyo; *Les Soirées Nomades* (1997), an intervention with Pierre Bastien at the Fondation Cartier, Paris; Galerie des Beaux Arts, Nantes (1998); and *The Onlookers* (1999), Centro de Arte Reina Sofía, Madrid. Sorin also exhibits regularly at Galerie Rabouan Moussion, Paris. He lives and works in Nantes.

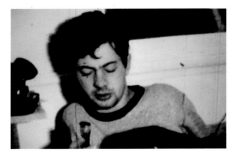

Pierrick Sorin's work in film and video embraces the ambivalent, farcical spirit of silent cinema comedy. He deliberately employs low-tech processes, including accelerated motion effects and fixed position cameras. Influenced by cinematic comedians from Charlie Chaplin and Jaques Tati to Woody Allen, Sorin's role as the sole protagonist in his work is to represent the 'Everyman', coping with the hazards of daily life. His slapstick sketches explore the boundary between the comedic and the tragic and exploit the sense of empathy these situations generate; we may laugh but we are essentially laughing at ourselves.

In *Awakenings* (*Réveils*) (1988) Sorin records the moment of rousing on successive mornings, as he repeatedly describes his fruitless attempts to go to bed earlier and get enough sleep. The film recalls the ennui of Goncharov's *Oblomov* and the inertia attributed to *Generation X*. The sentiments may seem banal, but through them Sorin expresses the human desire for rejuvenation and renewal. As citizens of a 24-hour, global culture, sleep has become an obsession for us all.

I have kept my slippers on so that I can go to the bakery (*J'ai même gardé mes chaussons pour aller à la boulangerie*) (1993) is a multiple screen work. Addressing the camera, the artist describes, in a deliberately awkward and rambling manner, an unspecified personal problem. Meanwhile a torrent of books rains down on him: the 'fool' is showered with sources of knowledge inaccessible to him. Sorin presents himself as victim whilst simultaneously being the author of his own humiliation. He shows himself adrift in an unrelenting world, but he is as much at the mercy of his own failings as of exterior forces.

A Wonderful Show (*Un spectacle de qualité*) (1996) is a complex video installation that presents the spectator in a 'virtual mini-spectacle'. On looking into the work, an image of the viewer is projected onto the scene of a domestic bathroom. The effect is derived from an eighteenth-century stage trick in which mirrors were used to produce ghostly apparitions. A toy-like image of the artist also appears and performs a series of inane entertainments and pranks. Life is presented as one great amusement, *le grand cirque humain*, in which we are all both actor and spectator.

In *Pierrick is Cutting Wood* (*Pierrick coupe du bois*) (1997) the artist plays two characters simultaneously: one in drag, holding a video camera; the other dressed in only a pair of boxer shorts and socks, wielding an electric power-saw. Both alter egos are superimposed onto other images, where they make ineffectual attempts to cut up a plank of wood. Sorin is addressing the language of art as well as joking about the process of art making. He quotes the writer Emile Cioran: 'faced with the complexity of the world the only thing we can do is wear a silly smile.'* TB

Bibliography
Acting Out - The Body in Video: Then and Now,
 exh. cat., Royal College of Art, London 1994
In/conclusive States, exh. cat,. Fruitmarket Gallery,
 Edinburgh 1996
Pierrick Sorin: Artiste solitaire, stupide et trop agité,
 exh. cat., Shiseido Gallery, Tokyo, in conjunction
 with Musée d'art contemporain, Lyons 1996*

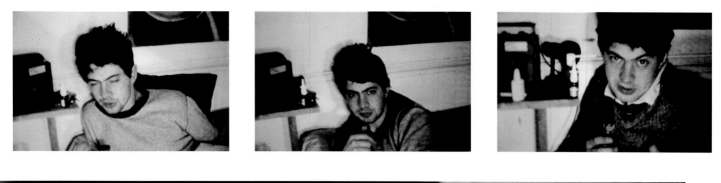

Awakenings 1988 (no.48a)

Pierrick Sorin

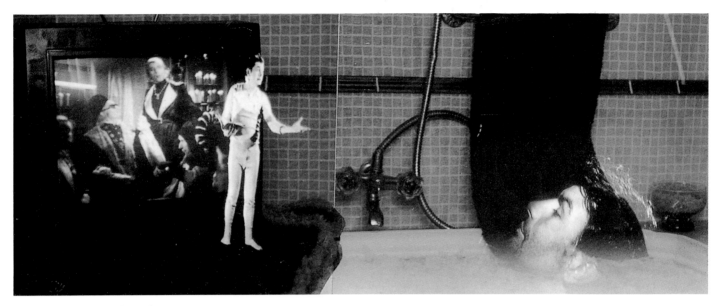

A Wonderful Show 1996 (no.50)

'I loved slapstick comedy films when I was a child. Besides I still think that the magic of the cinema was already there in those silent movies. But it is more the very style of those films which is important to me, the fixed camera, visual gags, the fragile, jerky pictures — all that is more important for me than the actors' personalities.'* Pierrick Sorin

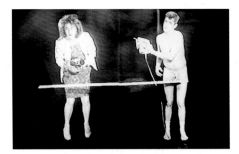

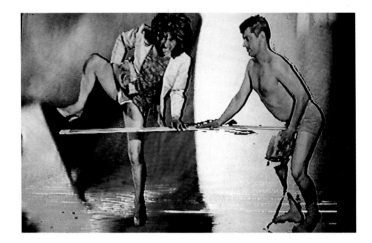

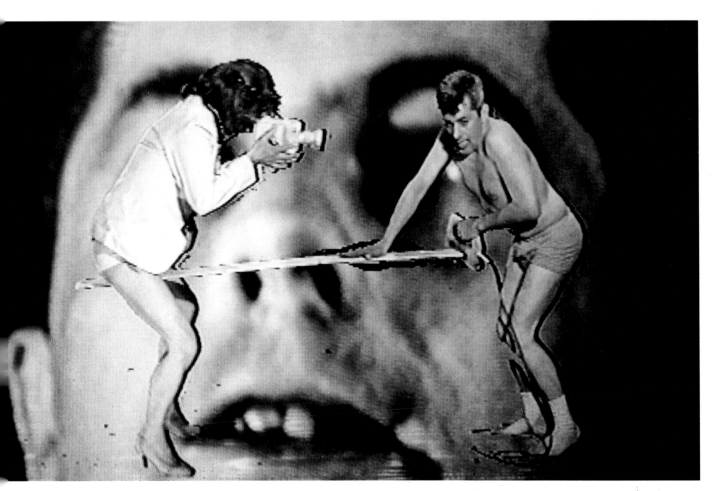

Pierrick is Cutting Wood 1997 (no.51)

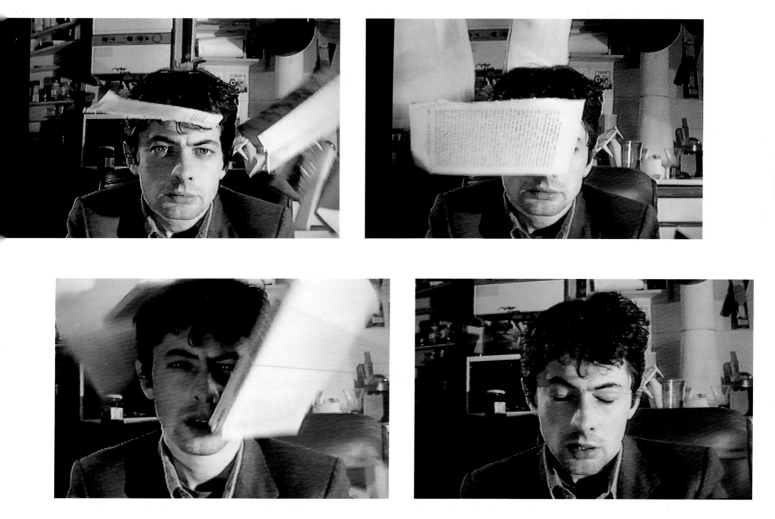

I have kept my slippers on so that I can go to the bakery 1993 (no.49)

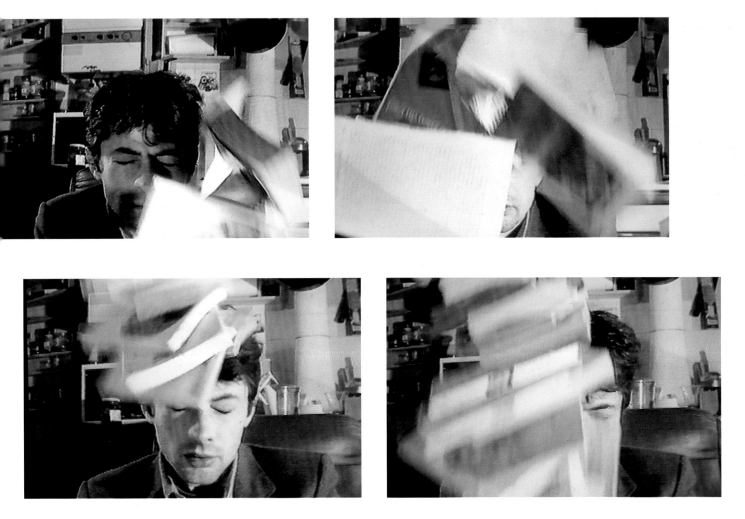

'The writer Cioran (b.1911) said that faced with the complexity
of the world the only thing we can do is wear a silly smile.
The stupidity of my character is of that order. Along with his
solitude, his stupidity has something fundamental about it:
it is the stupidity of man in general, his inability to grasp the
truth of the world.'* Pierrick Sorin

MOMOYO TORIMITSU was born in Tokyo, Japan, in 1967. She graduated from Tama Art University, Tokyo, in 1994 and two years later moved to New York where she attended the International Studio Program at PS1 during 1996-7. In 1998 Torimitsu had her first solo exhibition in New York at Momenta Art, which followed three solo exhibitions at Gallery MYU, Tokyo (1994, 1995, 1996). Since graduating her work has concentrated upon sculptural objects using highly sophisticated technology, in particular cartoon-style simulated animals and birds. Torimitsu's work has been seen in Europe in *Zones of Disturbance* (1997), Steirischer Herbst, Graz, and in a recent group exhibition *Where I Am* (1998), Galeria da Mitra, Lisbon. She has participated in several group exhibitions in New York and Japan, including *Morphe '95 City Crack* (1995), Mizuma Art Gallery, Tokyo; *Art × ∞ =* (1996), Sam Museum, Osaka; *Expansion Arts* (1997), Artanative Museum, New York; *Contact* (1999), Jack Tilton Gallery, New York; and *Spiral TV* (1999), Spiral Gallery, Tokyo. She continues to live and work in New York.

Bibliography

Rainer Ganahl, 'Business as Un-Usual', *zing magazine* 3, Spring 1997

Jennifer Higgie, 'Zones of Disturbance', *Frieze*, no. 38, Jan.-Feb. 1998

Barbara U. Schmidt, 'Steirischer Heibst 98', Art/Text, Feb.-Apr. 1998

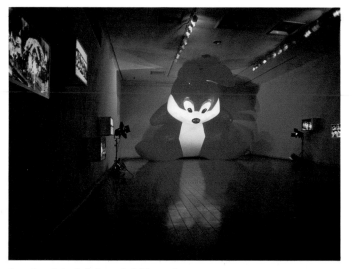

Somehow I don't feel comfortable 1996

Momoyo Torimitsu's crawling robot, *Miyata Jiro* (1994), looks exactly like an ordinary Japanese businessman. His name is a common Japanese name and his clothing the typical business uniform. The striking thing about this humanoid robot is that he cannot stand up, but is condemned to drag himself along the ground in an eternal Sisyphean crawl. The work was created for performance in public places around Tokyo; dressed as a nurse Torimitsu assists Mr Miyata on his crawl amongst the fascinated crowds, occasionally performing the operation of changing his batteries. Describing the robot as 'a soldier of the Japanese corporate empire ... who invades foreign economies for the motherland', the artist intended the work to be a criticism of the effects of the post-1960s' economic boom on Japanese society. The grovelling businessman humorously comments upon the strict observance of convention integral to the Japanese work ethic, but also hints at the subculture of karaoke, movies and the sex industry that represents after-hours business activity. The three-channel video installation features *Miyata Jiro* in a series of spoof commercials wittily advertising the accessories of the business world: an energising tonic, 'Mellow Lights' cigarettes, business suits and insurance. Examining the human desire for conformity, Torimitsu uses image doubling to create a phalanx of Mr Miyatas; as the camera retreats from the crawling businessman, he is seen to be one of millions who get smaller and smaller until they appear like a swarm of ants. In direct contrast to the prevalent culture of individualism, here it is the power of anonymity and uniformity that is ironically presented as attractive. Torimitsu's work *Pleasure of Destruction — Merry Go Round* (1995), which is composed of two crawling girls and two goats placed in symmetry on a pedestal table, raises similar questions about imitation and simulation. The identically dressed girls in twin sailor suits suggest not only the binds of social codes, but also, emphasised by the sophisticated technology involved in the making of these objects, the possibilities of human cloning.

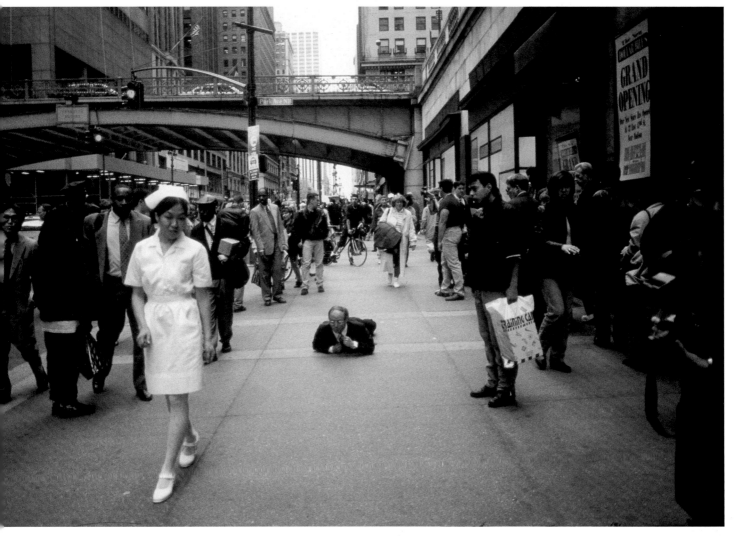

Miyata Jiro 1994 (performance in New York, 1997) (no.52)

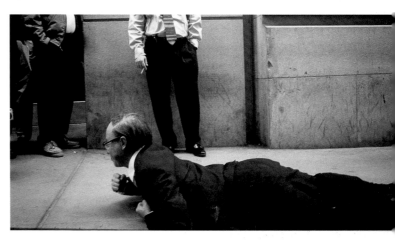

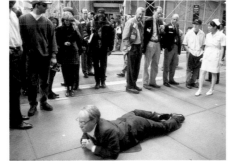

Momoyo Torimitsu

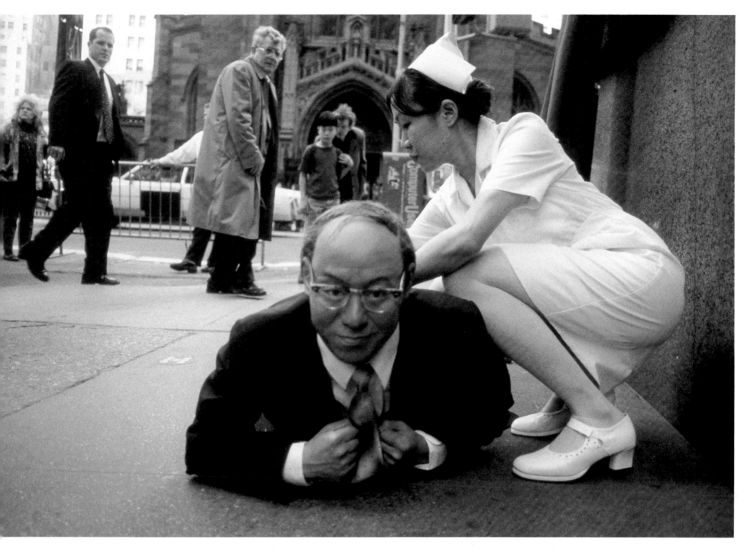

Miyata Jiro 1994 (performance in New York, 1997) (no.52)

Since her arrival in the United States Torimitsu has come to see Miyata Jiro as a universal 'Everyman', and her interest has shifted to his role as both a figure who can be identified with and perceived as an image in itself. Imitating the omniscient international media with its concomitant claims to authenticity, the three video monitors each present different images of the robot's integration into 'real' life. Amidst the increasingly complex array of signs in today's high-tech society, Torimitsu explores her belief that daily life 'consists of a reality in which one never encounters anything "authentically real"'. JM

'One of the main focuses of my work is the tension between "reality" as it is perceived via the senses, and that experience which we recognize as physically or objectively real.'
Momoyo Torimitsu

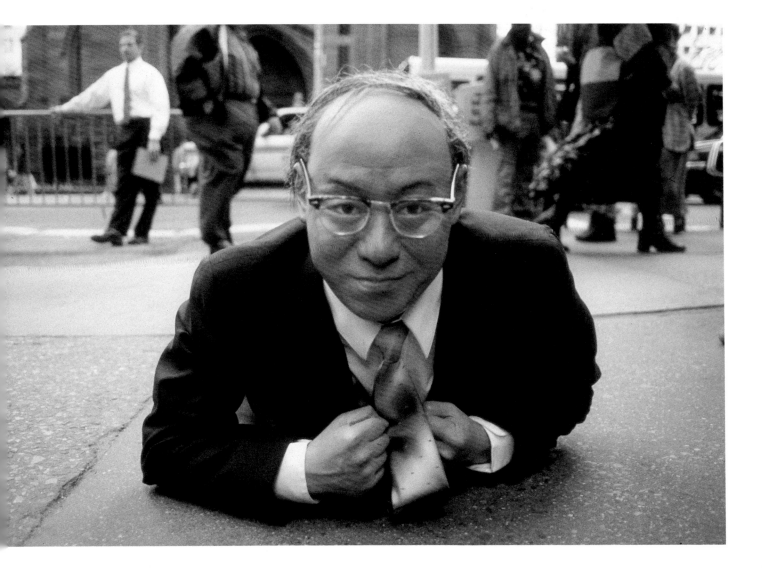

PATRICK VAN CAECKENBERGH was born in Aalst, Belgium, in 1960. He trained as an undergraduate at the Académie des Beaux-Arts, Aalst, and the Ghent Academy during 1980-4. He spent the following year at the Ecole Supérieure d'Architecture in Eindhoven. Among Van Caeckenbergh's many solo exhibitions are: Gallery Zeno X, Antwerp (1987, 1989, 1991, 1995, 1998); Fundacio La Caixa, Barcelona (1993); White Cube, London (1995); and Galerie des Archives, Paris (1998). He has participated in numerous group exhibitions including: Kunst, Europa (1991), Kunstverein, Düsseldorf; Aperto, Venice Biennale (1993); Hors Limites (1994), Centre Georges Pompidou, Paris; Laboratoires (1995), Galerie Art et Essai, Rennes; Manifesta I (1996), Rotterdam; Berechenbarkeit der Welt (1996), Bonner Kunstverein, Bonn; and Natural Habitat (1997), The Tannery, London. Van Caeckenbergh lives and works in Sint-Kornelis-Horebeke, Belgium.

Bibliography

Patrick Van Caeckenbergh, *Abracadabra, Recueil Artistique de Photographies Documentaires* inédites 1992

Bert Jansen, 'Patrick Van Caeckenbergh's Oeuvre, A Funnel not a Cornucopia', *Kunst & Museumjournaal*, vol.5 no.4, 1994, pp.8-14

Clem Neutjens, *De Vruchtbare Ruïne, Een Creatie van Patrick Van Caeckenbergh* (*The Productive Ruin, The work of Patrick Van Caeckenbergh*), Middelburg 1995

Laboratoires: pour une expérience du corps, Rennes 1995

Ali Baba 1997 (no.58b)

Patrick Van Caeckenbergh is an omnivorous collector and inventory-maker. His extraordinary hybrid assemblages, collection cabinets and elaborate pseudo-scientific drawings reflect the human need to create systems and structures as a way of negotiating order out of chaos. However Van Caeckenbergh emphasises that any attempt to rationalise is futile: systems themselves are simply the arbitrary products of an eclectic world. JM

Cardinal Pöïäüüo 1997 (no.58h)

'What I have been doing up until now represents itself in highly baroque forms, held together in extremely complex and intimate genealogical tracks (the genealogist being someone who draws connections between living structures). I lose myself exploring these connections within the boundaries of my own created nest (like a domestic animal). This pure, everyday spot is the ideal place to explore and reinforce my inner island.

I am looking for the extreme pleasure of moments when thought exists purely within itself. I cherish these short-lived moments, formed as bubbles – a fraction of immense beauty until it bursts against a tiny bit of reality. These are moments when all thoughts are completely without control, function or communication. The life of a thought extends to the edge of words; there it stiffens and dies. To put it more plainly, I speak in terms of censorship. To communicate with words is to censor.

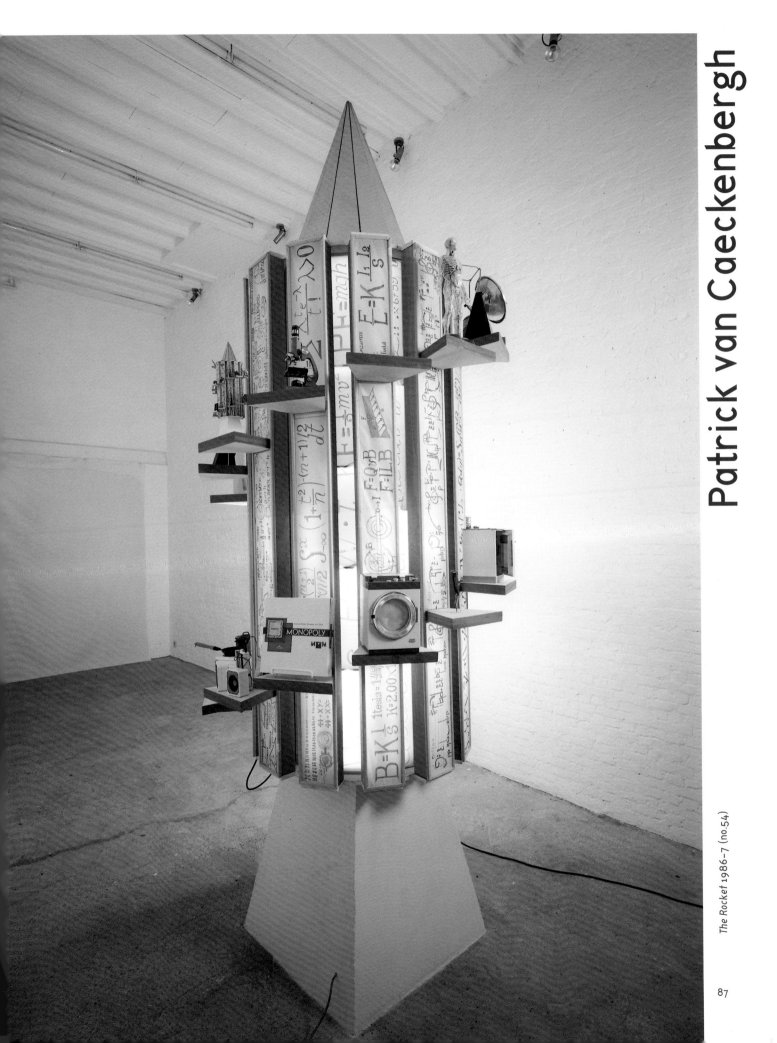

The Rocket 1986–7 (no.54)

'Until now I have been working on three major bodies of work:

A = *Un Pied d'Oeuvre* (1978–84) (a little shed knocked together at the feet of a building site): a delirious experiment trying to accumulate as much as possible knowledge about some fundamental questions like, 'Why are we made out of flesh?'

B = *ABRACADABRA* (1984–90): a search for the ideal magic charm to understand the world. As an anthropologist in the field, awake before everybody, alert until the night falls. Nothing is evident; everything is in a permanent state of accusation.

C = *The Very Life* (1990–8): an exhaustive search to the roots of my fatal instinctive behaviour as a domestic animal. Developed as a sort of long and laborious journey through my living room and its specific internal organisation, the digestive system.
I = (1990–3): 'I spoke with Quadrupeds, Birds and Fishes until…'
II = (1993–6): 'Allow the whole, while continually stirring, to simmer gently until…'
III = (1996–8): 'Be careful, my boy!'
IV = (1990–8): 'I am sitting under the ground and deep huddled I slept the whole winter long until…'

'Drawn up to resemble a family tree, the results of these activities lead to a dilemma, a duel where drama and pleasure face each other. The results provoke, on the one hand, an absolute desire for more, and on the other hand, a continuous return to zero, the point where everything needs to be reconstructed, and where everything can then be torn down again. Ruins constitute the most appropriate location for stimulating memory and creativity. The never-ending parable of spinning around the productive ruin. The only thing left is to observe and inspect the whole, time and again.

I use the metaphor of the digestive system. I eat and eat but my own body takes out all the necessary elements to survive and the remains abandon the body. These ruins, concentrated within a little ball of manure, fall down onto the platform of reality – in this reality, contemporary art is the only platform on which I am tolerated.' Patrick Van Caeckenbergh

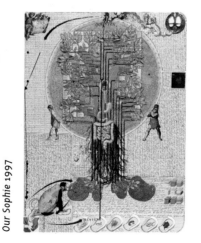

Our Sophie 1997

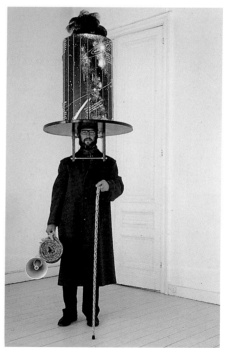

Hat! 1989. (no.55) worn by artist

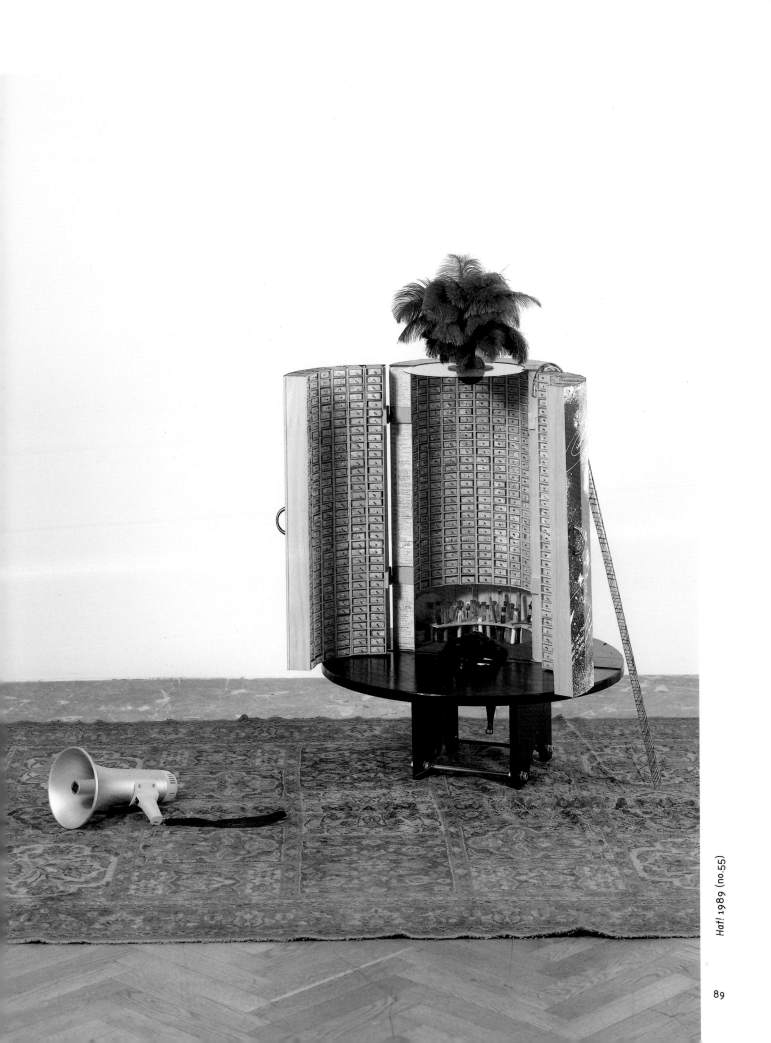

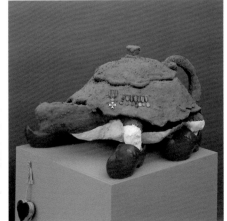

Our Sophie 1997 (no.58k)

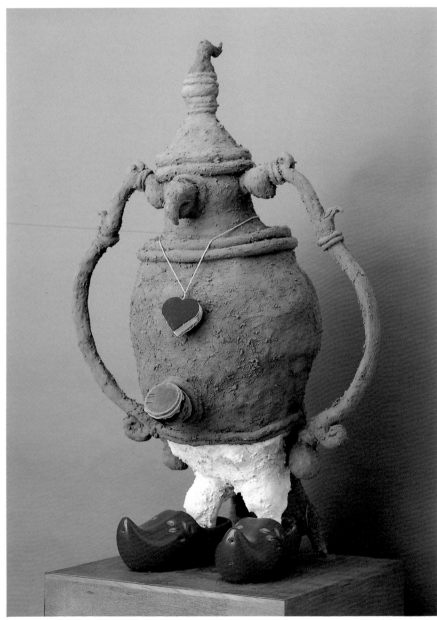

Mr Teste 1997 (no.58i)

90 PATRICK VAN CAECKENBERGH

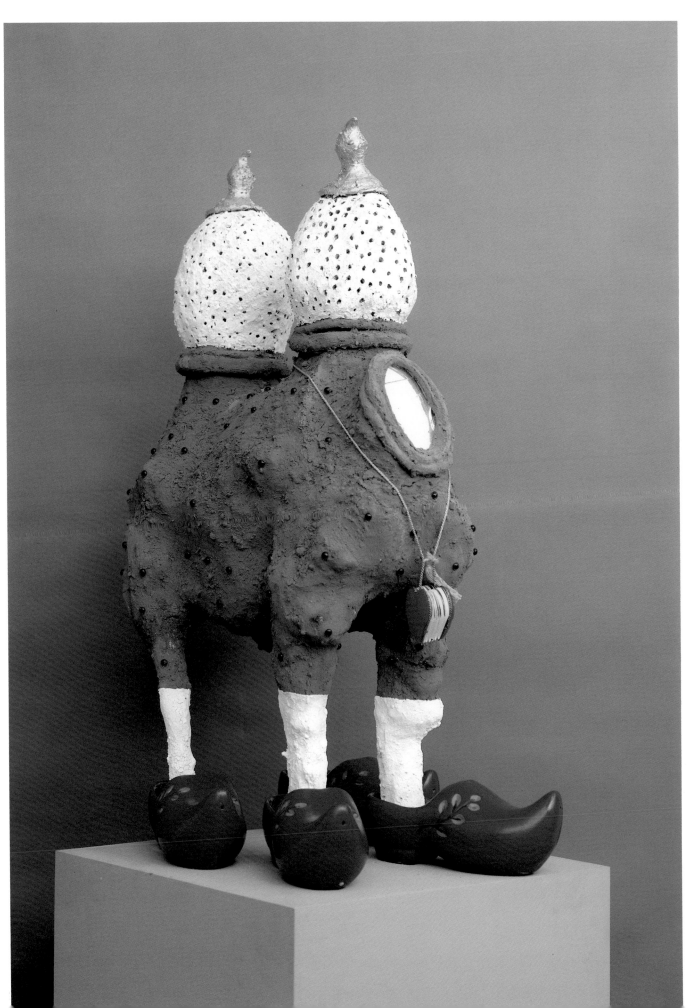

Prince Myschkin 1997 (no.58m)

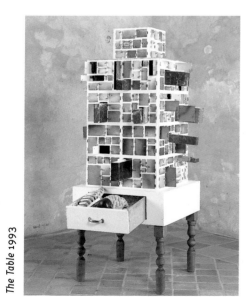

The Table 1993

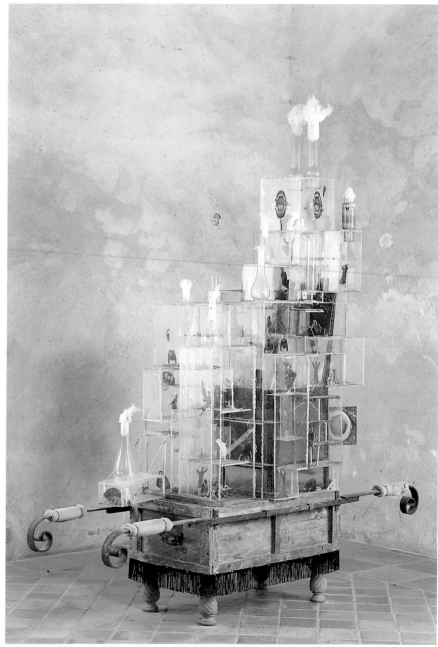

The Potty Chair 1993 (no.57)

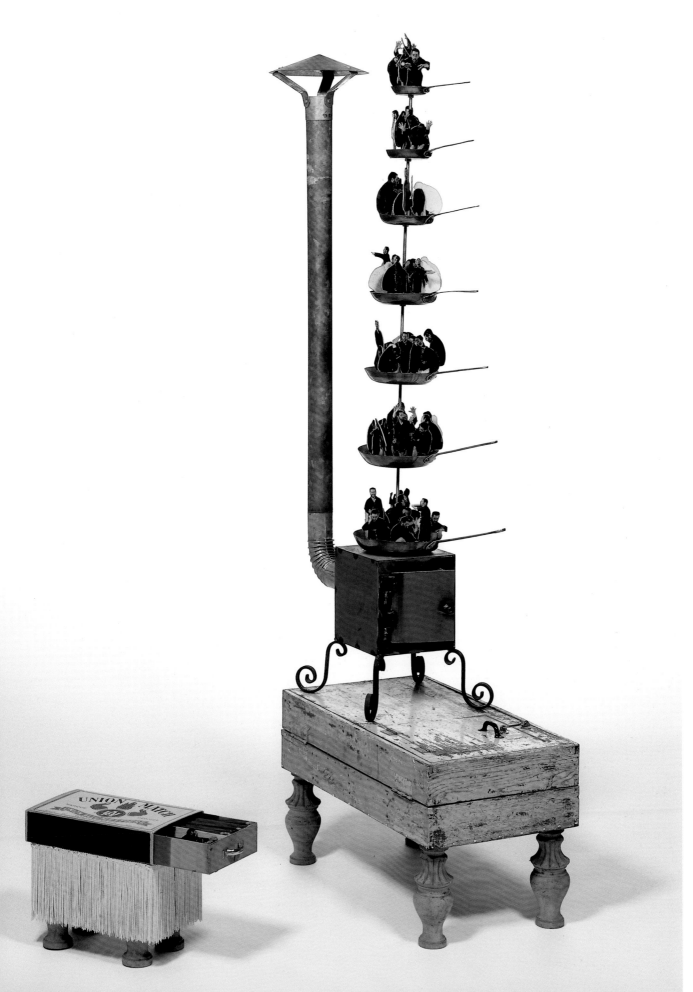

XAVIER VEILHAN was born in Lyons in 1963, and now lives and works in Paris. Veilhan has exhibited widely in France and his work has been included in a number of exhibitions in Europe and the United States. His first solo exhibition, *Un peu de biologie*, was at the Galeria Fac Simile in Milan in 1991. Since then he has exhibited at the Galerie Jennifer Flay, Paris (1994, 1996, 1998); Musée d'Art Moderne de la Ville de Paris (1993), Le Consortium, Dijon 1993; Centre de Création Contemporaine, Tours (1995); Sandra Gehring Gallery, New York (1995); Analix, Geneva (1995); Andréhn-Schiptjenko, Stockholm (1996); and Javier Lopez, Madrid (1998). Group exhibitions have included: *No Man's Time* (1991), Villa Arson in Nice; *Moral Maze* (1995) with Liam Gillick and Philippe Parreno, Le Consortium, Dijon; *Traffic* (1996), CAPC, Bordeaux; *L'Art du plastique* (1996), Ecole des Beaux-Arts, Paris. In 1998 Veilhan exhibited in *Racontes-moi une histoire*, Magasin, Grenoble; *Cloth-Bound*, Laure Genillard Gallery, London; and *Premises* (1998), a major survey of French art at the Guggenheim Museum, New York.

Bibliography

Marie-Ange Brayer, 'L'Image générique', *Art Press*, no.171, Jul.–Aug. 1992, pp.39–42

Olivier Zahm, 'Dangerous Games: Xavier Veilhan', *Artforum*, vol.31, no.4, Oct. 1992, p.71

Xavier Veilhan, exh. cat., Centre de Création Contemporaine, Tours; FRAC Languedoc-Roussillon, Montpellier; Consortium, Centre d'Art Contemporain, Dijon; Editions JRP, Geneva 1993

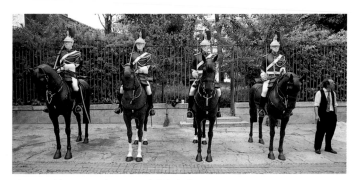

The Republican Guard 1995, exhibited at FRAC, Languedoc Roussillon (no.59)

Veilhan has been described as 'a conceptual object maker'. He trained as a painter and, like many artists of his generation, has used his work to examine the conventions of representation. His earliest paintings isolate single objects, out of context, against monochrome backgrounds. Taking his images from the natural world, history, culture, industrial design and architecture, he engages in an encyclopaedic attempt to recode common objects into systems of representation. While reducing familiar things to simplified archetypes, Veilhan tries nevertheless to identify areas of singularity and difference. By altering scale and colour, simplifying detail or devising new contexts for traditional themes, he challenges assumptions about the world that he appears to replicate.

Veilhan has worked with a range of media, including sculpture, painting, video, performance and, more recently, life-size photographic works. The artist refers to his three-dimensional work as 'statuary' because he wishes to present a recognisable genre, but one that has lost its narrative and symbolic character. 'I think the most important distinction between statuary and sculpture is the obligation of statuary to be effective. I am trying to rehabilitate the political dimension of art works … in terms of the idea of commemoration and legitimization implied by statuary.' *The Republican Guard* (*La Garde Républicaine*) (1995) puts the viewer in an ambiguous position. Veilhan's life-size mounted guardsmen seem to embody the impersonal authority of the state while remaining approachable — ideal subjects for tourist photography. The artist has previously shown the guards

Xavier Veilhan

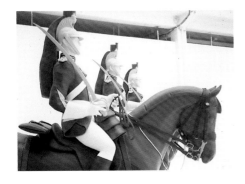

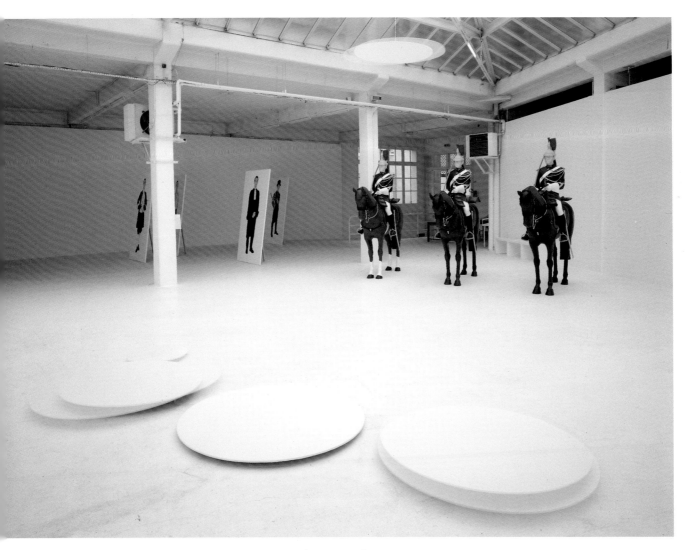

The Republican Guard 1995 and *Spinning Machines* 1995 (nos.59 & 60)

Untitled (The Demonstration) 1997 (no.62)

'The exhibition space inevitably removes an equestrian statue, for example, from its everyday environment and places the spectator in a fictitious space — a space which is that of fiction by definition. As the onlooker moves about on an abstract pedestal, he himself becomes an object of representation, in the same capacity as other components of the work ... What this implies is that the exhibition is a fiction of the same order as the work of the artist. Art is a subset of reality. In essence the only part of reality that is understandable is that which can be expressed, reproduced, replayed — that which can be simulated.' Xavier Veilhan

in a variety of appropriate public spaces, where they have exercised a particular fascination. Each of the figures has been separately carved, implying individuality despite the uniform.

The artist has described his *Spinning Machines* (1995) as deliberately disruptive tools, intended to make people more aware of the space in which they are standing. These are placed very near to the ground and 'their slow and eccentric rotations introduce an aspect of temporality into the viewing process, something from which the spectator is usually distanced.' While some of the discs of the machine remain stationary, two move very slowly on a side axis at approximately one revolution per minute.

Veilhan's large laminated photographic works are also paradoxical, reminiscent of hyperrealist painting rather than photography. He describes them as *tableaux* in order to emphasise their theatricality, and uses digital imaging and printing to cut and paste figures into various scenarios. These composites often start life as photographs of the artist and his friends wearing home-made costumes, taken in the small courtyard of his Paris studio. Dressed in stiff skirts and beards that give them the look of dervishes or figures from an ancient frieze, they star-gaze, weight-lift or march against simplified landscapes or dull contemporary interiors, their activities ritualised and banal. Seen together, they suggest a dreamlike world where dynamic action is constantly attempted but repeatedly frustrated. CK

Untitled (The Astronomers) 1997 (no.61)

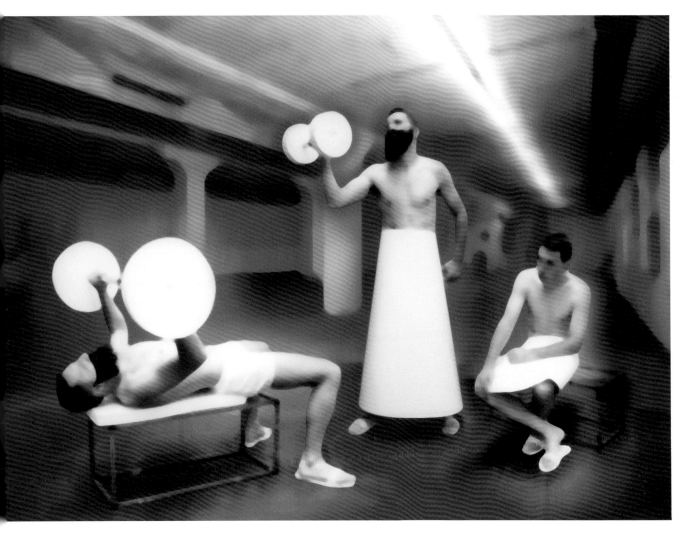

Untitled (The Weightlifters) 1997 (no.63)

BRIGITTE ZIEGER was born in Neuhofen, Germany, in 1959. She moved to Paris in 1979 where she later attended the Ecole des Beaux-Arts. Zieger has shown widely in Continental Europe, particularly France. Solo exhibitions include *Spareparts* (1995), Institut Français, Thessaloniki, and *Ready to Take Care of You* (1996), Galerie Chez Valentin, Paris. In 1997 her work was seen in two exhibitions in New York: *Face Value*, PS 122, and *Prop Fiction*, White Columns. Other group shows include *Les Révues parlées* (1998), Centre Georges Pompidou, Paris; *Grenzgäenge* (1998), Film Foyer, Winterthur, Switzerland; and *Festival Cinema/Video* (1998, 1999), Musée d'art contemporain Lyons. Her videos *Playback* I and II were exhibited at the Galerie des Archives, Paris, in 1998. Together with Christine Melchiors and Véronique Hubert, Zieger founded *[B&B UNLIMITED]]|* (1997), a mobile gallery conceiving exhibitions for alternative and private spaces. Its most recent manifestation, *24H Deluxe* (1999), Hotel Scribe, Paris (where Marcel Proust and the Lumières brothers once stayed), presented a series of installations and events that could be visited over a continuous period of 24 hours. Zieger continues to live and work in Paris.

Bibliography

Brian Holmes, 'L'Art du demontage', *Brigitte Zieger*, exh. leaflet, Institut Français de Thessalonique 1994

Emmanuelle Gall, 'Propositions', *Journal des Expositions*, May–June 1995, p.11

Jeanne Susplugas, 'Renee Kool, Brigitte Zieger', *Art Press*, Sept. 1998, p.xii

Brigitte Zieger examines real and imaginary spaces, originals and copies. Her work is gently subversive and suggests the presence of 'virtual' zones where anything might happen. Working with performance, film, sound and installation, she discloses a fascination with science-fiction films and texts. *Playback* (1997), first presented in a private flat, features the recorded voice of an actor who reads from a science-fiction novel by Philip K. Dick. Simultaneously she is seen mouthing the same text slightly out of synch, so that she appears to echo the recording. Her clothing and bearing suggest that she is a replica, perhaps the character in a film or cyberspace, and the recorded voice-over is the authentic experience.

In the video *Venus* (*Vénus*) (1997), Zieger wears a prosthetic brain modelled in plasticine and reminiscent of the special effects in low-budget science-fiction films. Against a soundtrack typical of that genre she untangles the soft grey matter and arranges it into a chic hair-style. Having literally 'straightened out her brain' she then proceeds to cover it with silver radiator paint until she resembles some exotic futuristic creature. Zieger's repetitious actions — straightening, smoothing, painting — are both humorous and disconcerting. *Venus* may be seen as a playful homage to Bruce Nauman's four *Art Make-Up* films of 1967–8, in which he applies layers of coloured make-up to his bare torso and face. As the title suggests, he is both covering and re-inventing himself.

Zieger acknowledges a number of other important influences, including Pop art and the obsessive polymorphous, cartoon-like work of Öyvind Fahlström; the pioneering British architectural practice Archigram; and the performance work of Gilbert & George. A work by David Hammons, *Bliz-aard Ball Sale* — part temporary sculpture, part performance, and focused ironically on the art market — holds a particular importance for her. Hammons performed it in New York during the winter of 1983 in an area where many new galleries had recently opened. Alongside other street vendors, he sold passers-by different sizes of snowball, destined to melt. Likewise, Zieger bases her works on familiar everyday images and objects. However, her works have less to do with the commodities they represent than with 'the cultural networks that piece them together and articulate them in larger wholes, conditioning their manufacture, their distribution, their use.'

Playtime (1998) consists of large replicas of the parts of several types of gun, laid out on a ground sheet, as if in the process of being assembled. In the accompanying video a man dressed as an over-grown child is seen in a domestic interior, studying instructions and then painstakingly assembling an M16 rifle from one of the outsized cardboard 'kits'. On completing his task, he 'fires' the gun out of a window. The scene is made all the more disturbing by its apparent domesticity and the playfulness that challenges its latent violence. CK

Venus 1997 (no.65) (opposite)

Playtime 1998 (no.64) (pp.100-1)

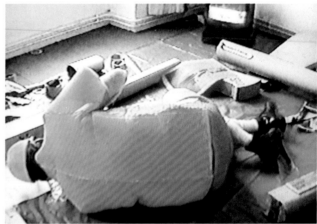

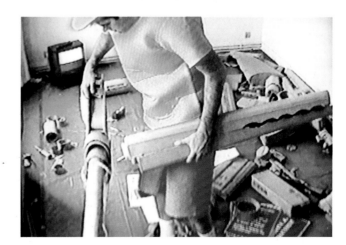

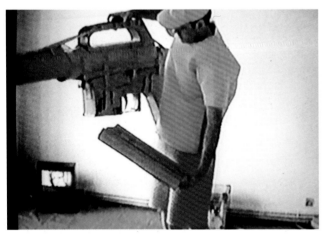
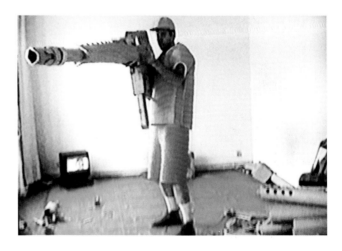

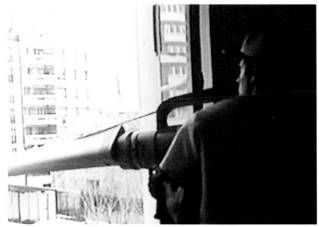

'Masses of images are delivered every day, manufactured identities and attitudes overtake us, sweeping us along ... We shall consider reality a moving thing, fluctuating between the virtual broadcast, life, production, promotion and documentary.'
Brigitte Zieger

Playtime 1998 (no.64)

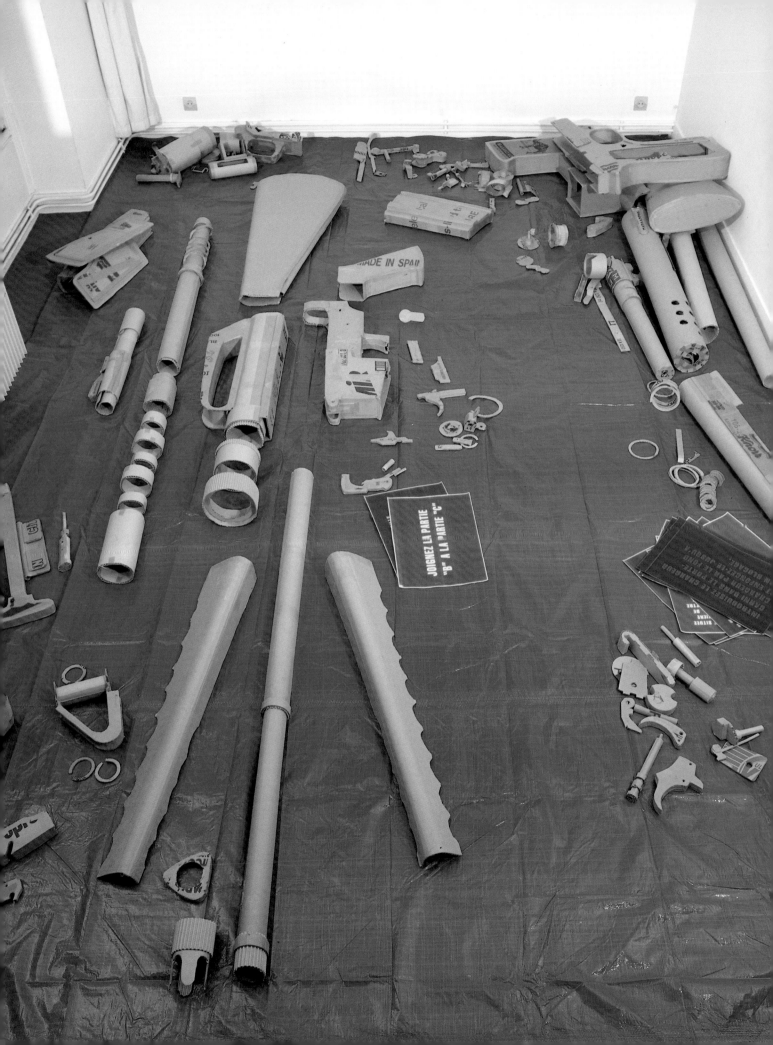

LENDERS

Private collections

Advokatfirman Vinge, Sweden 34a
Akzo Nobel Art Foundation, Netherlands and Friedrich Petzel Gallery, New York 25
Miranda Brooks 41
Collezione Cellula and Galleria Massimo de Carlo 1
Philippe Cohen, Paris 22, 29
M.V., Belgium 56, 58k–l
Patrick Corillon 5–8
Magnus and Charlotte Dahlhjelm 37g.5
Mr and Mrs de Backer-De Wolf, Belgium 54
The Dikeou Collection 52
Martin and Rebecca Eisenberg 43
Flick Collection. Courtesy Galerie Hauser and Wirth, Zurich 40
Galerie Jennifer Flay, Paris 60
Gilles et Marie Françoise Fuchs 20–1
Sandra Gering, New York, and Javier Lopez, Madrid 61
Marie-Ange Guilleminot 27k–27l
Susan and Michael Hort 37d, 47
Emma Kay and The Approach 32
Le Roy-Koenders, Belgium 58c–d
Fabienne Leclerc, Paris 18
Monsieur Bruno Mottard 13
Galerie Jacqueline Rabouan Moussion 51
Maureen Paley/Interim Art 37a–b
Maureen Paley/Interim Art, London, and Gorney, Bravin and Lee, New York, 37c, f, g.1–4, g.7, h
Galerie Emmanuel Perrotin 24
Nancy and Joel Portnoy 37c
Re Rebaudengo Sandretto 2
A.G. Rosen 37g.6
Brent Sikkema Gallery, New York 33
Pierrick Sorin 48a–c
Momoyo Torimitsu 53
Zeno X Gallery 55, 58b, 58e–j, m–n
Brigitte Zieger 64–5
David Zwirner, New York 39
David Zwirner, New York, and Katy Schimert 42, 44
Count Zu Solms-Rödelheim 17, 19
Private Collections 10, 12, 26, 34b–c, 35–6, 45–6, 58a

Public collections

Tate Gallery, London 31
Fonds Régional d'Art Contemporain Provence-Alpes-Côte d'Azur, Marseille 27d, 28
Fonds Régional d'Art Contemporain des Pays de la Loire, Nantes 50, 57
Caisse des Dépôts et FRAC Languedoc-Roussillon, Paris 59
Centre Georges Pompidou, Paris. Musée national d'art moderne/Centre de création industrielle 9, 30, 49
Fondation Cartier pour l'art contemporain, Paris 63
Fonds national d'art contemporain. Ministère de la Culture, Paris 11, 14–16, 27a–c, 27e–j
Fonds Régional d'Art Contemporain Champagne – Ardenne, Reims 23
Fundacion Arco. Centro Galego de Arte Contemporánea, Santiago de Compostela 38
Musée d'Art Moderne et Contemporain de Strasbourg 62
Castello di Rivoli Museo d'Arte Contemporanea Rivoli-Torino, Turin 3–4

PHOTOGRAPHIC CREDITS

Akzo Nobel Art Foundation, Netherlands and Friedrich Petzel Gallery, New York
Fundacion Arco. Centro Galego de Arte Contemporánea, Santiago de Compostela
Joel Bloquet
Galleri Lars Bohman
Casse des Dépôts et FRAC Languedoc-Roussillon Paris
Fondation Cartier pour l'art contemporain, Paris
Castello di Rivoli Museo d'Arte Contemporanea Rivoli-Torino
Collezione Cellula and Galleria Massimo de Carlo
Sadie Coles
Marc Domage
Galerie Jennifer Flay, Paris
Fonds national d'art contemporain. Ministère de la Culture, Paris
Fonds Régional d'Art Contemporain Champagne – Ardenne, Reims
Fonds Régional d'Art Contemporain des Pays de la Loire, Nantes
Fonds Régional d'Art Contemporain Provence-Alpes-Côte d'Azur, Marseille
Sandra Gering, New York, and Javier Lopez, Madrid
Philippe de Gobert
Marian Goodman Gallery, New York
Gorney Bravin and Lee, New York, and Maureen Paley/Interim Art, London
Didier l'Honorey
Alan Kane
Kleinefenn
Peggy Leboeuf
Pierre Leguillon
Philippe Magnon
Paolo Pellion, Turin
Galerie Emmanuel Perrotin
Friedrich Petzel Gallery
Centre Georges Pompidou, Paris. Musée national d'art moderne/Centre de création industrielle
Re Rebaudengo Sandretto
Kim Ri-Hye
Pjerpol Rubens
Brent Sikkema, New York
Musée d'Art Moderne et Contemporain de Strasbourg
Felix Tirry
Etienne Van Slain/Gregor Ramaliers, Maastricht
Piet Ysabie
Zeno X Gallery
David Zwirner

Text figures

Courtesy of De Appel (Photo: Niels den Haan)
Mainline Pictures/Ronald Grant Archive
Martijn van Nieuwenhuyzen
Paramount/Ronald Grant Archive
Redferns Music Library (Photo: Donna Santisi) (Photo: Leon Morris)
Courtesy of Stedelijk Museum Bureau Amsterdam (Photo: Hans van der Boogaard) (Photo: Renée Kool)
UIP/Ronald Grant Archive

List of Works

Measurements are given in centimetres,
followed by inches in brackets,
height before width before depth.

Where no measurements are given,
this is because installation size varies.

MAURIZIO CATTELAN

1 *Stadium* 1991
Wood, iron and glass
120 × 700 × 70 (47 $^1/_2$ × 275 $^5/_8$ × 27 $^1/_2$)
Collezione Cellula and Galleria Massimo
de Carlo
Illustrated on pp.26–7

2 *Bidibidobidiboo* 1996
Taxidermic squirrel and mixed media
50 × 58 (19 $^5/_8$ × 22 $^7/_8$)
Re Rebaudengo Sandretto
Illustrated on p.30

3 *Twentieth Century (Novecento)* 1997
Taxidermic horse with leather harness
200.7 × 270.5 × 69.9
(79 × 106 $^1/_2$ × 27 $^1/_2$)
Castello di Rivoli Museo d'Arte
Contemporanea Rivoli-Torino
Illustrated on p.31

4 *Charlie don't surf* 1997
Mixed media
111.8 × 71.1 × 69.9 (44 × 28 × 27 $^1/_2$)
Castello di Rivoli Museo d'Arte
Contemporanea Rivoli-Torino
Illustrated on pp.28–9

PATRICK CORILLON

5 *At the Station (À la gare)* 1994
Painted wood and printed text
200.5 × 136 × 40 (78 $^7/_8$ × 53 $^1/_2$ × 15 $^3/_4$)
The artist
Illustrated on pp.36–7

6 *The Flowers (Les Fleurs)* 1988
Wire, perspex and dynamo tape
16 pieces: 120 × 59.7 × 29.9
(47 $^1/_4$ × 23 $^1/_2$ × 11 $^3/_4$) each
The artist
Illustrated on pp.34–5

7 *The Ticket Gates (Les Portillons)* 1993
Painted wood and printed text
80 × 32 × 120 (31 $^1/_2$ × 12 $^5/_8$ × 47 $^1/_4$) each
The artist
Illustrated on p.33

8 *Last moments (Derniers moments)* 1996
Text mounted on wood panels with steel and chain
The artist

a *Last moments of one condemned-to-be-
thrown-on-a-fragile-raft-down-a-200-foot-
waterfall (Derniers moments d'un condamné-
à-être-lancé-sur-un-frêle-radeau-en-haut-
d'une-chute-de-soixante-quinze-mètres)*
Extract on p.34

b *Last moments of one condemned-to-a-fatal-
fall-down-the-steps-of-the-tower (Derniers
moments d'un condamné-à-la chute mortelle-
dans-l'escalier-du-donjon)*

c *Last moments of one condemned-to-be-tied-
to-a-post-at-night-in-a-forest-full-of-wolves
(Derniers moments d'un condamné-à-être-
attaché-de-nuit-à-un-porteau-dans-une-forêt-
infestée-de-loups)*

9 *Oskar Serti's House* 1997
(La Maison d'Oskar Serti)
Mixed media. 5 parts: 214.6 × 99.7 × 120
(84 $^1/_2$ × 39 $^1/_4$ × 47 $^1/_4$) each
Centre Georges Pompidou, Paris:
Musée national d'art moderne/
Centre de création industrielle dépôt
de la Caisse des Dépôts et Consignations
Illustrated on p.32

ERIC DUYCKAERTS

10 *Searching Researcher (Chercheur cherchant)* 1993
Plaster
40 × 19.7 × 19.7 (15 $^3/_4$ × 7 $^3/_4$ × 7 $^3/_4$)
Private collection

11 *X-ray (Radiographie)* 1993
Plaster and x-ray
Plaster: 39.4 × 19.7 × 19.7 (15 $^1/_2$ × 7 $^3/_4$ × 7 $^3/_4$)
X-ray: 43 × 22 (16 $^7/_8$ × 8 $^5/_8$)
Fonds national d'art contemporain
Minislère de la Culture, Paris

12 *Base 12* 1993
Plaster
45 × 19.7 × 19.7 (17 $^5/_8$ × 7 $^3/_4$ × 7 $^3/_4$)
Private collection, Paris
Illustrated on p.40

13 *Five Fingered Hypothesis* 1993
(Hypothèse à cinq doigts)
Pencil and pastel on colour photocopy
Framed: 49.5 × 64.8 (19 $^1/_2$ × 25 $^1/_2$)
Monsieur Bruno Mottard

14 *New Muscles (Muscles nouveaux)* 1993
Pencil and pastel on colour photocopy
Framed: 49.5 × 64.8 (19 $^1/_2$ × 25 $^1/_2$)
Fonds national d'art contemporain
Ministère de la Culture, Paris

15 *Old Versus New* 1993
(Ancien versus nouveau)
Pencil and pastel on colour photocopy
Framed: 49.5 × 64.8 (19 $^1/_2$ × 25 $^1/_2$)
Fonds national d'art contemporain
Ministère de la Culture, Paris

16 *Equivalence System* 1993
(Systèmes d'équivalences)
Pencil and pastel on colour photocopy
Framed: 49.5 × 64.8 (19 $^1/_2$ × 25 $^1/_2$)
Fonds national d'art contemporain
Ministère de la Culture, Paris

17 *Fossil* 1994
Bones, ligaments and wood
36.5 × 20 × 13.5 (14 $^3/_8$ × 7 $^7/_8$ × 5 $^3/_8$)
Count Zu Solms-Rödelheim
Illustrated on p.40

18 *Scissors (a) (Ciseaux (a))* 1994
Pastel on paper
Framed: 24 × 32 (9 $^1/_2$ × 12 $^5/_8$)
Fabienne Leclerc, Paris
Illustrated on p.40

19 *Scissors (b) (Ciseaux (b))* 1994
Pastel on paper
Framed: 24 × 32 (9 $^1/_2$ × 12 $^5/_8$)
Count Zu Solms-Rödelheim
Illustrated on p.40

20 *Scissors (c) (Ciseaux (c))* 1994-6
Pastel on paper
Framed: 24 × 32 (9 $^1/_2$ × 12 $^5/_8$)
Gilles et Marie Françoise Fuchs

21 *Screw Hypothesis* 1994
Resin, acrylic and wood
35 × 30 × 30 (13 $^3/_4$ × 11 $^3/_4$ × 11 $^3/_4$)
Gilles et Marie Françoise Fuchs
Illustrated on p.40

b *Action Painter (after Hans Namuth)* 1999
Cibachrome print
125.6 × 112.6 (49 $^1/_2$ × 44 $^3/_8$)
Private collection
Illustrated on p.57

c *Leap into the Void (after Yves Klein)* 1999
Cibachrome print
138.6 × 105.6 (54 $^1/_2$ × 41 $^5/_8$)
Private collection
Illustrated on p.58

35 *Aftermath (Aparecida)* 1998
Cibachrome print
151.6 × 115.6 (59 $^3/_4$ × 45 $^1/_2$)
Private collection
Illustrated on p.60

36 *Aftermath (Emerson)* 1998
Cibachrome print
145.6 × 115.6 (57 $^3/_8$ × 45 $^1/_2$)
Private collection
Illustrated on p.61

PAUL NOBLE

37 *Doley*

a *The Doley Game* 1995-6
Board game, edition of 50
63.5 × 63.5 (25 × 25)
Maureen Paley/Interim Art
Illustrated on pp.66

b *Doley: The Rules* 1999
Lithograph, edition of 10
84 × 59.4 (33 $^1/_8$ × 23 $^3/_8$)
Maureen Paley/Interim Art
Extract on pp.67

c *The Back of My Front Door* 1996
Oil on canvas
69.9 × 48.3 (27 $^1/_2$ × 19)
Nancy and Joel Portnoy

d Oblivous's Stuff
Susan and Michael Hort

d.1 *Meet Oblivious (1)* 1995-6
Pencil on paper
70 × 50 (27 $^1/_2$ × 19 $^1/_2$)

d.2 *Meet Oblivious (2)* 1995-6
Pencil on paper
70 × 50 (27 $^1/_2$ × 19 $^1/_2$)

d.3 *Dream* 1995-6
Pencil on paper
70 × 50 (27 $^1/_2$ × 19 $^1/_2$)

d.4 *Meet Stukzip* 1995-6
Pencil on paper
70 × 50 (27 $^1/_2$ × 19 $^1/_2$)

d.5 *Oblivious Inn* 1995-6
Watercolour on paper
39 × 58 (15 $^3/_8$ × 22 $^7/_8$)

d.6 *Interior* 1995-6
Pencil on paper
53 × 73 (20 $^7/_8$ × 28 $^3/_4$)

d.7 *Oblivious out at night* 1995-6
Pencil on paper
48 × 68 (18 $^7/_8$ × 26 $^3/_4$)

d.8 *Oblivious out* 1995-6
Oil on canvas
40.6 × 50.8 (16 × 20)

e Burnt Out's Stuff
Maureen Paley/Interim Art and
Gorney Bravin and Lee, New York

e.1 *Meet Burnt Out (1)* 1995-6
Pencil on paper
70 × 50 (27 $^1/_2$ × 19 $^1/_2$)

e.2 *Meet Burnt Out (2)* 1995-6
Pencil on paper
70 × 50 (27 $^1/_2$ × 19 $^1/_2$)

e.3 *Dream* 1995-6
Pencil on paper
70 × 50 (27 $^1/_2$ × 19 $^1/_2$)

e.4 *Burnt Out in* 1995-6
Pencil on paper
81.3 × 69.9 (32 × 27 $^1/_2$)

e.5 *Burnt Out going out* 1995-6
Pencil on paper
85.1 × 54.6 (33 $^1/_2$ × 21 $^1/_2$)

e.6 *Burnt Out out* 1995-6
Oil on canvas
76.2 × 61 (30 × 24)

e.7 *Burnt Out Inn* 1995-6
Watercolour on paper
38.1 × 50.8 (15 × 20)

f Aimless's Stuff
Maureen Paley/Interim Art and
Gorney Bravin and Lee, New York

f.1 *Meet Aimless (1)* 1995-6
Pencil on paper
69.9 × 49.5 (27 $^1/_2$ × 19 $^1/_2$)

f.2 *Meet Aimless (2)* 1995-6
Pencil on paper
69.9 × 49.5 (27 $^1/_2$ × 19 $^1/_2$)

f.3 *Dream* 1995-6
Pencil on paper
69.9 × 49.5 (27 $^1/_2$ × 19 $^1/_2$)

f.4 *Aimless in* 1995-6
Pencil on paper
116.2 × 80 (45 $^3/_4$ × 31 $^1/_2$)

f.5 *Aimless out* 1995-6
Pencil on paper
76.2 × 69.9 (30 × 27 $^1/_2$)

f.6 *About* 1995-6
Oil on canvas
50.8 × 40.6 (20 × 16)

f.7 *The Aimless* 1995-6
Watercolour on paper
38.1 × 50.8 (15 × 20)

g Formless's Stuff
Maureen Paley/Interim Art and
Gorney Bravin and Lee, New York
(exc. g.5 and g.6)

g.1 *Meet Formless (1)* 1995-6
Pencil on paper
70 × 50 (27 $^1/_2$ × 19 $^1/_2$)

g.2 *Meet Formless (2)* 1995-6
Pencil on paper
70 × 50 (27 $^1/_2$ × 19 $^1/_2$)

g.3 *Dream* 1995-6
Pencil on paper
70 × 50 (27 $^1/_2$ × 19 $^1/_2$)

g.4 *The Formless Arms* 1995-6
Watercolour on paper
38.1 × 50.8 (15 × 20)

Sound and Vision a project by Matthew Higgs

100 RECORDS

ROBERT JOHNSON King Of The Delta Blues Singers (1937/61)
JOHN CAGE 4'33" (1952)
CHET BAKER Chet Baker Sings (1954)
BO DIDDLEY Bo Diddley (1955)
JOHN COLTRANE My Favorite Things (1961)
SUN RA The Heliocentric Worlds Of Sun Ra (1965)
ENNIO MORRICONE Original Motion Picture Soundtrack *The Good, The Bad and The Ugly* (1966)
BONZO DOG DOO-DAH BAND Gorilla (1967)
RAHSAAN ROLAND KIRK The Inflated Tear (1967)
RED CRAYOLA The Parable Of Arable Land (1967)
THE VELVET UNDERGROUND The Velvet Underground & Nico (1967)
THE BEATLES The Beatles ('The White Album') (1968)
CAPTAIN BEEFHEART Trout Mask Replica (1968)
13TH FLOOR ELEVATORS Easter Everywhere (1968)
2001: A SPACE ODYSSEY Original Motion Picture Soundtrack (1968)
MC5 Kick Out The Jams (1969)
THE STOOGES The Stooges (1969)
ART ENSEMBLE OF CHICAGO Certain Black (1970)
SYD BARRETT The Madcap Laughs (1970)
MILES DAVIS Bitches Brew (1970)
PERFORMANCE Original Motion Picture Soundtrack (1970)
CAN Tago Mago (1971)
MARVIN GAYE What's Going On (1971)
NICO Desert Shore (1971)
SLY AND THE FAMILY STONE There's A Riot Goin' On (1971)
CAN Ege Bamyasi (1972)

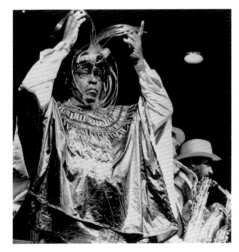

SUN RA Space Is The Place (1972)
FAUST The Faust Tapes (1973)
HERBIE HANCOCK Head Hunters (1973)
ROXY MUSIC For Your Pleasure (1973)
THE RESIDENTS Meet The Residents (1974)
LEONARD COHEN Best Of Leonard Cohen (1975)
LOU REED Metal Machine Music (1975)
PATTI SMITH Horses (1975)
TOM WAITS Nighthawks at the Diner (1975)

IGGY AND THE STOOGES Metallic K.O. (1976)
IAN DURY & THE BLOCKHEADS New Boots And Panties (1977)
JONATHAN RICHMAN & THE MODERN LOVERS Jonathan Richman & the Modern Lovers (1977)
SUICIDE Suicide (1977)
WIRE Pink Flag (1977)
ALTERNATIVE TV The Image Has Cracked (1978)
DEVO Q: Are We Not Men? A: We Are Devo! (1978)
STEEL PULSE Handsworth Revolution (1978)
PERE UBU The Modern Dance (1978)
PERE UBU Dub Housing (1978)
THE FALL Live At The Witch Trials (1979)
GANG OF FOUR Entertainment! (1979)
JOY DIVISION Unknown Pleasures (1979)
FELA KUTI I.T.T. (1979)
THE POP GROUP Y (1979)
PRINCE Prince (1979)
PUBLIC IMAGE LTD. Metal Box (1979)
THE SPECIALS Specials (1979)
THE SLITS Cut (1979)
DEXY'S MIDNIGHT RUNNERS Searching For The Young Soul Rebels (1980)
JOY DIVISION Closer (1980)
JAMES 'BLOOD' ULMER Are You Glad To Be In America? (1980)
KRAFTWERK Computer Love (1981)
THROBBING GRISTLE Greatest Hits (1981)
ESG Come Away With ESG (1983)
THE JESUS AND MARY CHAIN Psycho Candy (1985)
SCHOOLLY-D Schoolly-D (1986)
BOOGIE DOWN PRODUCTIONS Criminal Minded (1987)
HAPPY MONDAYS Bummed (1988)
PUBLIC ENEMY It Takes A Nation Of Millions To Hold Us Back (1988)
SONIC YOUTH Daydream Nation (1988)
ANTHRAX Persistence Of Time (1990)
ANGELO BADALAMENTI Music From *Twin Peaks* (1990)
FUGAZI Repeater (1990)
LEE 'SCRATCH' PERRY From My Secret Laboratory (1990)
PUBLIC ENEMY Fear Of A Black Planet (1990)
SCOTT WALKER Sings Jacques Brel (1990)

BUTTHOLE SURFERS piouhgd (1991)
MY BLOODY VALENTINE Loveless (1991)
PRIMAL SCREAM Screamadelica (1991)
SEBADOH III (1991)
SLINT Spiderland (1991)
BARRY ADAMSON Soul Murder (1992)
PALACE BROTHERS There Is No One What Will Take Care of You (1992)
PAVEMENT Slanted and Enchanted (1992)
STEREOLAB Transient Random-Noise Bursts With Announcements (1993)
TINDERSTICKS Tindersticks (1993)
APHEX TWIN Selected Ambient Works Volume II (1994)
BECK One Foot In The Grave (1994)
WEEN Chocolate And Cheese (1994)
NEIL YOUNG AND CRAZY HORSE Sleeps With Angels (1994)
THE SMITHS Singles (1995)
NICK CAVE & THE BAD SEEDS Murder Ballads (1996)
DAFT PUNK Homework (1996)
TORTOISE Millions Now Living Will Never Die (1996)
MOGWAI Young Team (1997)
LEE 'SCRATCH' PERRY Arkology (1997)
RADIOHEAD OK Computer (1997)
THE SIMPSONS Songs In The Key Of Springfield (1997)
AIR Moon Safari (1998)
THE BETA BAND The Three E.P.'s (1998)
NICK CAVE & THE BAD SEEDS The Best Of (1998)
MASSIVE ATTACK Mezzanine (1998)
STEVE MILLER BAND Greatest Hits (1998)
BONNIE 'PRINCE' BILLIE I See A Darkness (1999)

100 FILMS

L'AGE D'OR dir. Luis Buñuel, 1930
DR JEKYLL AND MR. HYDE dir. Rouben Mamoulian, 1932
FREAKS dir. Tod Browning, 1932
A NIGHT AT THE OPERA dir. Sam Wood, 1935
THE WIZARD OF OZ dir. Victor Fleming, 1939
FANTASIA dir. Ben Sharpsteen, 1940
THE LIFE AND DEATH OF COLONEL BLIMP dir. Michael Powell &
 Emeric Pressburger, 1943
THE PICTURE OF DORIAN GRAY dir. Albert Lewin, 1945
LA BELLE ET LA BÊTE dir. Jean Cocteau, 1946
BLACK NARCISSUS dir. Michael Powell & Emeric Pressburger, 1946
A MATTER OF LIFE AND DEATH dir. Michael Powell & Emeric
 Pressburger, 1946
JOUR DE FÊTE dir. Jaques Tati, 1948
THE FOUNTAINHEAD dir. King Vidor, 1949
ORPHÉE dir. Jean Cocteau, 1950
PANDORA AND THE FLYING DUTCHMAN dir. Albert Lewin, 1950
THE 5000 FINGERS OF DR T dir. Roy Rowland, 1953
ANIMAL FARM dir. John Halas/Joy Batchelor, 1954
THE HOUND OF THE BASKERVILLES dir. Terence Fisher, 1958
MON ONCLE dir. Jaques Tati, 1958
TOUCH OF EVIL dir. Orson Wells, 1958
VERTIGO dir. Alfred Hitchcock, 1958
THE REBEL dir. Robert Day, 1960
LAST YEAR IN MARIENBAD dir. Alain Resnais, 1961
THE EXTERMINATING ANGEL dir. Luis Buñuel, 1962
LA JÉTÉE dir. Chris Marker, 1962
THE BIRDS dir. Alfred Hitchcock, 1963

THE NUTTY PROFESSOR dir. Ernest D. Glucksman, 1963
DR STRANGELOVE: OR, HOW I LEARNED TO STOP WORRYING
 AND LOVE THE BOMB dir. Stanley Kubrick, 1963
THE GOSPEL ACCORDING TO ST MATTHEW dir. Pier Paolo Pasolini,
 1964
SCORPIO RISING dir. Kenneth Anger, 1964
ALPHAVILLE dir. Jean-Luc Goddard, 1965
ANDREI RUBLEV dir. Andrei Tarkovsky, 1966
FAHRENHEIT 451 dir. François Truffaut, 1966
THE GOOD, THE BAD AND THE UGLY dir. Sergio Leone, 1966
DANGER: DIABOLIK dir. Mario Bava, 1967

PLAYTIME dir. Jacques Tati, 1967
IF ... dir. Lindsay Anderson, 1968
THE ILLUSTRATED MAN dir. Jack Smight, 1968
ROSEMARY'S BABY dir. Roman Polanski, 1968
PERFORMANCE dir. Nicolas Roeg & Donald Cammell, 1970
THE PRIVATE LIFE OF SHERLOCK HOLMES dir. Billy Wilder, 1970
THE ABOMINABLE DR. PHIBES dir. Robert Fuest, 1971
A CLOCKWORK ORANGE dir. Stanley Kubrick, 1971
O LUCKY MAN! dir. Lindsay Anderson, 1973
WESTWORLD dir. Michael Crichton, 1973
ZARDOZ dir. John Boorman, 1973
DARK STAR dir. John Carpenter, 1974
LANCELOT DU LAC dir. Robert Bresson, 1974
THE TEXAS CHAINSAW MASSACRE dir. Tobe Hooper, 1974
BARRY LYNDON dir. Stanley Kubrick, 1975
LA BÊTE dir. Walerian Borowczyk, 1975
AI NO CORRIDA dir. Nagisa Oshima, 1976
FELLINI'S CASANOVA dir. Federico Fellini, 1976
THE KILLING OF A CHINESE BOOKIE dir. John Cassavetes, 1976
THE MAN WHO FELL TO EARTH dir. Nicolas Roeg, 1976
APOCALYPSE NOW dir. Francis Ford Coppola, 1979
THE DRILLER KILLER dir. Abel Ferrara, 1979
THE FOG dir. John Carpenter, 1979
STALKER dir. Andrei Tarkovsky, 1979
THE THIRD GENERATION dir. Rainer Werner Fassbinder, 1979
AIRPLANE! dir. Abrahams/Zucker/Zucker, 1980
ALTERED STATES dir. Ken Russell, 1980
THE ELEPHANT MAN dir. David Lynch, 1980
BLADE RUNNER dir. Ridley Scott, 1982
BRITANNIA HOSPITAL dir. Lindsay Anderson, 1982
E.T. dir. Steven Spielberg, 1982
LIQUID SKY dir. Slava Tsukerman, 1982
THIS IS SPINAL TAP dir. Rob Reiner, 1983
COCAINE (MIXED BLOOD) dir. Paul Morrissey, 1984
BRAZIL dir. Terry Gilliam, 1985
MISHIMA dir. Paul Schrader, 1985

PEE-WEE'S BIG ADVENTURE dir. Tim Burton, 1985
TROUBLE IN MIND dir. Alan Rudolph, 1985
DOWN BY LAW dir. Jim Jarmusch, 1986
FERRIS BUELLER'S DAY OFF dir. John Hughes, 1986
HENRY: PORTRAIT OF A SERIAL KILLER dir. John McNaughton, 1986
CRAZY LOVE dir. Dominique Deruddere, 1987

HOUSE OF GAMES dir. David Mamet, 1987
NEAR DARK dir. Kathryn Bigelow, 1987
BEETLEJUICE dir. Tim Burton, 1988
HEATHERS dir. Michael Lehmann, 1988
THE NAKED GUN dir. David Zucker, 1988
THE VANISHING dir. George Sluizer, 1988
ROGER & ME dir. Michael Moore, 1989
TWIN PEAKS dir. David Lynch, 1989
LIFE IS SWEET dir. Mike Leigh, 1990
THE ADDAMS FAMILY dir. Barry Sonnenfeld, 1991
BILL & TED'S BOGUS JOURNEY dir. Peter Hewitt, 1991
THE NAKED GUN 2$\frac{1}{2}$: THE SMELL OF FEAR dir. David Zucker, 1991
BRAINDEAD dir. Peter Jackson, 1992
ADDAMS FAMILY VALUES dir. Barry Sonnenfeld, 1993

GROUNDHOG DAY dir. Harold Ramis, 1993
NAKED GUN 33$\frac{1}{3}$: THE FINAL INSULT dir. David Zucker, 1994
NIGHTWATCH dir. Ole Bornedal, 1994
BABE dir. Chris Noonan, 1995
CRUMB dir. Terry Zwigoff, 1995
CRASH dir. David Cronenberg, 1996
GUMMO dir. Harmony Korine, 1997
THE BIG LEBOWSKI dir. Joel Cohen, 1998
THE IDIOTS dir. Lars von Trier, 1998

NOTES

1 (i) *Sound and Vision* considers two propositions:

If *Abracadabra* was a record collection, what might it contain?
If *Abracadabra* was a season of films, what might it include?

It represents my attempt to establish aural and cinematic equivalents for an art exhibition – something often considered to be a *primarily* visual experience. I was interested to see if *Abracadabra*'s mood and elusive atmosphere could be adequately 'translated', transcribed through the agency of other mediums, different disciplines. I was intrigued by the possibility that I might be able to establish a parallel argument for *Abracadabra*, an argument that might *allude* to the exhibition without necessarily referring directly to it. I had originally considered a possible third option – an attempt to determine the exhibition as if it was a 'library' but rejected this idea in favour of including instead the index from Charles Jencks and Nathan Silver's seminal 1973 book *Adhocism: The Case for Improvisation* (see pp.115–125).

(ii) *Sound and Vision* was compiled intuitively, and it should be 'read' in this spirit. It is not an attempt on my part to somehow explain *Abracadabra* (a task, it has to be said, more appropriately and ably performed by the exhibition's curators Catherine Grenier and Catherine Kinley in their respective contributions to this catalogue). Nor should *Sound and Vision* be interpreted as a way of saying something new *per se* about the exhibition. Rather I was more interested in trying to address (albeit obliquely) the inherent paradoxes and implicit contradictions, the conceptual complexities and visual discordances, that I saw as being central to the exhibition, 'discrepancies' that made *Abracadabra* – to my mind at least – such a compelling (and often frustrating) proposition.

(iii) What struck me immediately about *Abracadabra* – and continues to strike me as being significant – was that it assembled a far from predictable group of artists. Whilst individually a number of the artists are now regulars on the art world's international merry-go-round, the *grouping* – referred to elsewhere by Grenier as a 'phenomenon' as opposed to a 'movement' – collectively remains aloof, noticeably devoid of a unifying manifesto and consequently difficult to pin down. In the absence of

any one determining ideology and without a theoretical safety-net the work featured in *Abracadabra* deftly resists simplistic categorisation. This seemed to me essentially a good thing: for too long now we have been witness to the packaging of artists based on the sketchiest of stylistic sympathies or – and more worryingly so – based solely on regional or nationalistic characteristics.

(iv) *Sound and Vision* is by necessity eclectic. It struggles – and, perhaps, inevitably fails – to reconcile difference. Both lists are fiercely subjective: any attempts I made to analyse the exhibition objectively were constantly frustrated by *Abracadabra*'s labyrinthine twists and turns; its chameleon-like ability to constantly reinvent itself. *Sound and Vision* seeks to reflect this intellectual (and emotional) flux. Succinctly summarised by Catherine Grenier as 'everyday burlesque', the artists and artworks featured in *Abracadabra* amplify the slippery eclecticism that has begun to determine the art of the late 1990s. Whilst *Abracadabra* undoubtedly encourages promiscuous historical references, drawing as it does upon the legacies of both earlier modernist formulations (notably Dada and Surrealism) and their more recent counterparts (particularly Pop and Conceptual art), it remains conspicuously unaligned with either grouping's party politics. Instead *Abracadabra* promotes a looser, more free-wheeling set of associations (the 'cut and paste' approach identified by Martijn van Nieuwenhuyzen in his essay). The result of this pluralistic approach suggests (in the words of Grenier), 'a new spirit in contemporary art ... characterised by fantasy, humour, invention, surprise and provocation, applied to the everyday world and everyday life'. This 'associative' model is the basis for *Sound and Vision* , a model that mirrors the exhibition's design: an open-plan terrain – suggestive of Archigram's earlier configurations for the city – whereby artworks are made to forcibly (and gleefully) interact. *Abracadabra* encourages the viewers to 'drift', to negotiate for themselves an independent route *through* the exhibition. *Sound and Vision* might be best understood as my drift through *Abracadabra*.

(v) For the purposes of brevity (and clarity) I decided to limit the lists to 100 titles each. Originally both lists contained several hundred possible candidates, often with one particular

artist or director represented by several works; for example at one point there were four albums listed by Mark E. Smith's seminal group The Fall, whereas in the final list only their 1979 debut *Live at the Witch Trials* remains. A select few artist(e)s, figures who emerged as being central to *my* understanding of *Abracadabra* are represented by more than one title: Sun Ra, Iggy Pop, Pere Ubu, Albert Lewin, Lindsay Anderson and Tim Burton come immediately to mind. (It is certainly true that *Sound and Vision*, like *Abracadabra* itself, is populated by these mavericks – the unorthodox and undisciplined characters that punctuate the histories of both popular music and the cinema, e.g. Tod Browning, Jean Cocteau, Chet Baker, Jacques Tati, Bo Diddley, Stanley Kubrick, Kenneth Anger, Captain Beefheart, Syd Barrett, Miles Davis, John Cassavetes, Nico, Sly Stone, Leonard Cohen, Paul Morrissey, Patti Smith, Mark E. Smith, Fela Kuti, Prince, Alan Rudolph, Lee 'Scratch' Perry, Scott Walker, Morrissey and Lars von Trier.) For the most part I tried to avoid citing *overly* obscure material. Priority was given, where possible, to selecting works that are still in circulation.

(vi) In terms of 'geographies', all of the participating or lists are *based* in either North America or Europe. In her introductory essay Catherine Grenier reasserts this notion, firmly locating *Abracadabra*'s spirit in the 'Western world'. Consequently both lists are informed (unapologetically so) with a bias towards North American and European genres.

2 (i) (With notable exceptions) most of the participating artists were born at various points between the mid-1950s and the mid-1960s. Whilst some would have been just old enough to have experienced the tail-end of the hippy-era, all would have been conditioned by or at least subjected to the carnival spirit of punk – itself, I would suggest, a significant sub-text to *Abracadabra*. This chronological slant is reflected in the emphasis placed on post 1960s recordings.

(ii) It was important that I had at least heard all of the selected records, if not necessarily owned them. Many are old favourites, played countless times over the years, others, barely half-remembered, are included here because they seemed somehow pertinent or

appropriate. I have for the most part resisted the desire to rationalise my selections, although inevitably various loose musical 'themes' did emerge. For instance there is a predilection for a type of introspective 'soul' music (e.g. John Coltrane's *My Favorite Things*, Nico's *Desert Shore*, Marvin Gaye's *What's Going On*, Joy Division's *Unknown Pleasures* or Neil Young's *Sleeps With Angels*), and likewise there is a definite undertow of melancholic urban 'blues' (e.g. *Chet Baker Sings*, The Stooges's eponymous debut, Alternative TV's *The Image Has Cracked*, Steel Pulse's *Handsworth Revolution*, Happy Mondays's *Bummed* or Public Enemy's *Fear Of A Black Planet*). However I would equally argue that what I chose to *exclude* is as significant as what I chose to include: for instance classical music of any kind, and likewise only a handful of non-English language records are cited.

3 The Steve Miller Band's Greatest Hits compilation is included here for the simple reason that it contains his 1981 hit *Abracadabra*, memorable for its rhyming of 'abracadabra' with 'grab ya'.

4 (i) It was important that I had seen all of the films I chose to include (unseen recommendations from friends were politely dismissed), however many of the films included here I have only had the opportunity to see once – and in some cases as many as 20 years ago (I am now 34) – so consequently my memory may well have over compensated for what in some cases were probably no more than youthful enthusiasms. For example I remember watching a fuzzy copy of Abel Ferrara's *The Driller Killer* on video at a school friend's house in the early 1980s and it having a profound effect upon me – although I'm not sure now what that effect necessarily was. Certainly there were other Ferrara films I could have chosen to include here, but none has made such a lasting impression on me. Likewise the only time I saw Slava Tsukerman's (frankly nuts) film *Liquid Sky* was in an Amsterdam nightclub at some point in the mid-1980s. I'm still not sure if it is a great (or even a good) film but given the (memorably) peculiar circumstances in which it was seen, it seems oddly pertinent that it should be included here.

(ii) Whilst some of the films I selected might appear to be highly suggestive of one particular artists' work – for instance it could easily be argued that the splenetic satire of the British director Lindsay Anderson's *Britannia Hospital* shares an immediate kinship with the sardonic realism of Paul Noble's *Doley* , I was ultimately keen to avoid such overly prescriptive, 'linear' relationships. Likewise I was keen to avoid reinforcing hierarchies between works that might be perceived as being either 'high' or 'low' – for instance I would offer no qualitative distinction between Jacques Tati's classic *Mon Oncle* and David Zucker's sublime *The Naked Gun*. From the outset I was always more interested in the cumulative effect of both lists – it was the 'sum of the parts' that I was constantly trying to come to terms with – how within each list otherwise disparate material might find an equivalence or a parity.

(iii) As with the list of records several broad themes emerged when compiling the list of films; for instance the influence of Surrealist cinema prevails throughout, a tendency witnessed in films as different as *A Matter Of Life And Death*, *Pandora And The Flying Dutchman*, *The 5000 Fingers Of Dr T*, *O Lucky Man!* or *Pee-Wee's Big Adventure*, and certainly the 'comedic' films I selected err towards vaudeville – the 'everyday burlesque' of which Catherine Grenier speaks, for example *A Night At The Opera*, *The Rebel*, *The Nutty Professor*, *Playtime*, *Airplane!*, *This Is Spinal Tap*, *The Naked Gun* or *Addams Family Values*. Again as much can be gleaned from what is not included here: for example both Woody Allen and John Waters are noticeable by their absence.

Index a project by Matthew Higgs

This is the index for Charles Jencks and Nathan Silver's seminal 1973 book *Adhocism* (Anchor Books, New York). Sub-titled 'The Case for Improvisation', the book – according to its cover blurb – 'undermines the approved method and preordained result in virtually every realm of human activity, from play to architecture, city planning and political revolutions'. For a book of some 200 pages its scope of enquiry is simply breathtaking. If we were just to consider the entries listed under the letter 'A' alone we could embark on a journey that would take us from Acronyms to Automobiles via Adultery, Advertising, Affluent societies, Africa, Airports, Alienation, Anarchists, Anger (Kenneth), Animals, Antique collecting, Apollo Space Program, Arabs, Archigram Group, Arcimboldo, Arensberg (Walter), Art, Astrology, Athens, Atomic restructuring and ... well I think you get the idea. The index is presented here in full as a self-contained text – an index of possibilities not only for *Abracadabra* but for life itself.

WAYS OF GIVING

The Tate Gallery attracts funds from the private sector to support its programme of activities in London, Liverpool and St Ives. Support is raised from the business community, individuals, trusts and foundations, and includes sponsorships, donations, bequests and gifts of works of art. The Tate Gallery is an exempt charity; the Museums & Galleries Act 1992 added the Tate Gallery to the list of exempt charities defined in the 1960 Charities Act.

TRUSTEES

David Verey (Chairman)
Professor Dawn Ades
Victoria Barnsley
The Hon. Mrs Janet de Botton
Sir Richard Carew Pole
Prof. Michael Craig-Martin
Peter Doig
Sir Christopher Mallaby
Sir Mark Richmond
John Studzinski
Bill Woodrow

DONATIONS

There are a variety of ways through which you can make a donation to the Tate Gallery.

Donations All donations, however small, will be gratefully received and acknowledged by the Tate Gallery.

Covenants A Deed of Covenant, which must be taken out for a minimum of four years, will enable the Tate Gallery to claim back tax on your charitable donation. For example, a covenant for £100 per annum will allow the Gallery to claim a further £30 at present tax rates.

Gift-Aid For individuals and companies wishing to make donations of £250 and above, Gift-Aid allows the gallery to claim back tax on your charitable donation. In addition, if you are a higher rate taxpayer you will be able to claim tax relief on the donation. A Gift-Aid form and explanatory leaflet can be sent to you if you require further information.

Bequests You may wish to remember the Tate Gallery in your will or make a specific donation In Memoriam. A bequest may take the form of either a specific cash sum, a residual proportion of your estate or a specific item of property, such as a work of art. Certain tax advantages can be obtained by making a legacy in favour of the Tate Gallery. Please check with the Tate Gallery when you draw up your will that it is able to accept your bequest.

American Fund for the Tate Gallery The American Fund was formed in 1986 to facilitate gifts of works of art, donations and bequests to the Tate Gallery from the United States residents. It receives full tax exempt status from the IRS.

INDIVIDUAL MEMBERSHIP PROGRAMMES

Friends

Friends share in the life of the Gallery and contribute towards the purchase of important works of art for the Tate. Privileges include free unlimited entry to exhibitions; *tate: the art magazine*; private views and special events; 'Late at the Tate' evening openings; exclusive Friends Room. Annual rates start from £24.

Tate Friends Liverpool and Tate Friends St Ives offer local events programmes and full membership of the Friends in London. The Friends of the Tate Gallery are supported by Tate & Lyle PLC.

Further details on the Friends in London, Liverpool and St Ives may be obtained from:

Membership Office, Tate Gallery, Millbank, London SW1P 4RG
Tel: 0171-887 8752

Patrons

Patrons of British Art support British painting and sculpture from the Elizabethan period through to the early twentieth century in the Tate Gallery's collection. They encourage knowledge and awareness of British art by providing an opportunity to study Britain's cultural heritage.

Patrons of New Art support contemporary art in the Tate Gallery's collection. They promote a lively and informed interest in contemporary art and are associated with the Turner Prize, one of the most prestigious awards for the visual arts. Privileges for both groups include invitations to Tate Gallery receptions, an opportunity to sit on the Patrons' executive and acquisitions committees, special events including visits to private and corporate collections and complimentary catalogues of Tate Gallery exhibitions. Annual membership of the Patrons is £650, and funds the purchase of works of art for the Tate Gallery's collection.

Further details on the Patrons may be obtained from:

Patrons Office, Tate Gallery, Millbank, London SW1P 4RG
Tel: 0171-887 8754

CORPORATE MEMBERSHIP PROGRAMMES

Membership of the Tate Gallery's two Corporate Membership programmes (the Founding Corporate Partner Programme and the Corporate Membership Programme) offer companies outstanding value-for-money and provide opportunities for every employee to enjoy a closer knowledge of the Gallery, its collection and exhibitions. Membership benefits are specifically geared to business needs and include private views for company employees, free and discounted admission to exhibitions, discount in the Gallery shop, out-of-hours Gallery visits, behind-the-scenes tours, exclusive use of the Gallery for corporate entertainment, invitations to VIP events, copies of Gallery literature and acknowledgment in Gallery publications.

Tate Gallery London: Founding Corporate Partners

AMP (UK) plc
CGU plc
Clifford Chance
Freshfields
Goldman Sachs International
Lazard Brothers & Co Limited
Paribas
Pearson plc
Prudential
Railtrack PLC
Schroders

Tate Gallery London: Corporate Members

Partners
BP Amoco
Ernst & Young
Freshfields
Merrill Lynch Mercury
Prudential
Unilever

Associates
Alliance & Leicester plc
Channel Four Television
Credit Suisse First Boston
Drivers Jonas
Global Asset Management
Goldman Sachs International
HUGO BOSS
Lazard Brothers & Co Limited
Linklaters & Alliance
Morgan Stanley Dean Witter
Nomura International plc
Nycomed Amersham plc
Robert Fleming & Co. Limited
Schroders
Simmons & Simmons
The EMI Group
UBS Ag

Tate Gallery Liverpool: Corporate Members

J Blake & Co Ltd
BT
Hitchcock Wright and Partners
Littlewoods
Liverpool John Moores University
Manchester Airport PLC
Pilkington plc
Tilney Investment Management
United Utilities plc

CORPORATE SPONSORSHIP

The Tate Gallery works closely with sponsors to ensure that their business interests are well served, and has a reputation for developing imaginative fund-raising initiatives. Sponsorships can range from a few thousand pounds to considerable investment in long-term programmes; small businesses as well as multi-national corporations have benefited from the high profile and prestige of Tate Gallery sponsorship.

Opportunities available at Tate Gallery London, Liverpool and St Ives include exhibitions (some also tour the UK), education, conservation and research programmes, audience development, visitor access to the Collection and special events. Sponsorship benefits include national and regional publicity, targeted marketing to niche audiences, exclusive corporate entertainment, employee benefits and acknowledgment in Tate Gallery publications.

Tate Gallery London: Principal corporate sponsors
(alphabetical order)

BP Amoco
1990–2000, *New Displays*
1998–2000, Campaign for the Creation of the Tate Gallery of British Art
Channel Four Television
1991–9, *The Turner Prize*
Ernst & Young
1996, *Cézanne**
1998, *Bonnard*
Magnox Electric plc
1995–8, *The Magnox Electric Turner Scholarships*
1997, *Turner's Watercolour Explorations*
1998, *Turner and the Scientists*
Prudential
1996, *Grand Tour*
1997, *The Age of Rossetti, Burne-Jones and Watts: Symbolism in Britain 1860–1910*
Tate & Lyle PLC
1991–2000, Friends Marketing Programme
1997, *Henry Tate's Gift*
Volkswagen
1991–6, The Volkswagen Turner Scholarships

Tate Gallery London: Corporate sponsors
(alphabetical order)

Akeler Developments Ltd
1997–8, Art Now Programme
American Airlines*
1999, *Jackson Pollock* (in kind)
1999, *Chris Burden, 'When Robots Rule': The Two Minute Airplane Factory*
Aon Risk Services Ltd in association with ITT London & Edinburgh
1998, *In Celebration: The Art of the Country House*
L'Association Française d'Action Artistique
1999, *Abracadabra*
AT&T
1997, *Piet Mondrian*
CDT Design Ltd
1995–6, *Art Now*
Classic FM
1995–6, Regional tour of David Hockney's 'Mr and Mrs Clark and Percy' (in kind)

Coutts Group
1998, *Per Kirkeby*
Coutts Contemporary Art Foundation
1997, *Luciano Fabro*
Danish Contemporary Art Foundation
1998, *Per Kirkeby*
The German Government
1997, *Lovis Corinth*
Glaxo Wellcome plc
1997, *Turner on the Loire*
1999, *Turner on the Seine*
The Guardian
1999, *Jackson Pollock* (in kind)
Häagen-Dazs Fresh Cream Ice Cream
1995–6, *Art Now*
The Hiscox Group
1995–9, Friends Room
HUGO BOSS
1997, *Ellsworth Kelly*
Lombard Odier & Cie
1998, *Turner in the Alps*
Morgan Stanley Dean Witter
1998, *John Singer Sargent*
1998, *Constructing Identities*
1999, *Visual Paths: teaching literacy in the gallery*
Pro Helvetia
1997, *Art Now — Beat Streuli*
Romulus Construction Limited
1996, *Bill Woodrow: Fools' Gold*
Spink-Leger Pictures
1997, *Francis Towne*
Tarmac Group plc*
1995–9, Paintings Conservation
The EMI Group
1997, *Centre Stage* education project

**Tate Gallery of Modern Art:
Corporate Sponsors**
(alphabetical order)
Ernst & Young
1997–2000, Tate Gallery of Modern Art
 Visitor Centre

**Tate Gallery Liverpool:
Corporate Sponsors**
(alphabetical order)
Girobank plc
1998, *Great Art Adventure* (education
 programme)
The Littlewoods Organisation PLC
1998, *EYOPENERS* (education programme)
Manchester Airport and Tilney
 Investment Management
1998, *Salvador Dali*
MOMART plc
1991–9 The Momart Fellowship

**Tate Gallery St Ives: Corporate
Sponsors** (alphabetical order)
Marks & Spencer
1998-9, Education Events and Workshops
Northcliffe Newspapers in Education*
1995–7, Education Programme

* denotes a sponsorship in the arts recog-
nised by an award under the
Government's 'Pairing Scheme' adminis-
tered by Arts & Business.

TATE GALLERY FOUNDING
BENEFACTORS (date order)
Sir Henry Tate
Sir Joseph Duveen
Lord Duveen
The Clore Foundation
Heritage Lottery Fund

TATE GALLERY PRINCIPAL
BENEFACTORS (alphabetical order)
American Fund for the Tate Gallery
The Annenberg Foundation
Calouste Gulbenkian Foundation
Friends of the Tate Gallery
The Henry Moore Foundation
The Kreitman Foundation
Sir Edwin and Lady Manton
National Art Collections Fund
National Heritage Memorial Fund
The Nomura Securities Co., Ltd
Patrons of New Art
Dr Mortimer and Theresa Sackler
 Foundation
St Ives Tate Action Group
The Wolfson Foundation and Family
 Charitable Trust

TATE GALLERY BENEFACTORS
(alphabetical order)
The Baring Foundation
Bernard Sunley Charitable Foundation
Gilbert and Janet de Botton
Mr and Mrs James Brice
Mr Edwin C. Cohen
The Eleanor Rathbone Charitable Trust
Esmée Fairbairn Charitable Trust
Foundation for Sport and the Arts
GABO TRUST for Sculpture
 Conservation
GEC Plessey Telecommunications
The Getty Grant Program
Granada Group plc
The Paul Hamlyn Foundation
Horace W. Goldsmith Foundation
John Hughes
The John S. Cohen Foundation
The John Ellerman Foundation
John Lewis Partnership
John Lyon's Charity
The Paul Mellon Centre
The Leverhulme Trust
Museums and Galleries Improvement
 Fund
Ocean Group plc (P.H. Holt Trust)
Patrons of British Art
The Paul Mellon Centre
Peter Moores Foundation
The Pilgrim Trust
Mr John Ritblat
The Sainsbury Family Charitable Trusts
Samsung Foundation of Culture
The Stanley Foundation Limited
Save and Prosper Educational Trust
SRU Limited
Weinberg Foundation

TATE GALLERY DONORS
(alphabetical order)
London
Professor Abbott
Howard and Roberta Ahmanson
The Andy Warhol Foundation for the
 Visual Arts, Inc
The Fagus Anstruther Memorial Trust
Mr and Mrs Halvor Astrup
Lord Attenborough CBE
The Austin and Hope Pilkington
 Charitable Trust
BAA plc
Friends of Nancy Balfour OBE
Balmuir Holdings
The Hon. Robin Baring
B.A.T. Industries plc
Nancy Bateman Charitable Trust
Mr Tom Bendhem
Mr Alexander Bernstein
Anne Best
David and Janice Blackburn
Michael and Marcia Blakenham
George and Mary Bloch
Miss Mary Boone
Frances and John Bowes
The Britwell Trust
Mr and Mrs Donald L. Bryant, Jr
Mrs Melva Bucksbaum
Mr and Mrs Neville Burston
Card Aid
Carlsberg Brewery
Mr Vincent Carrozza
Mrs Beryl Carpenter
Cazenove & Co
Charlotte Bonham Carter Charitable
 Trust
Christie, Manson & Woods Ltd
The Claire Hunter Charitable Trust
The Clothworkers Foundation
Mrs Elisabeth Collins
Mr Christopher Cone
Ricki and Robert Conway
Giles and Sonia Coode-Adams
Mrs Dagny Corcoran
Cognac Courvoisier
Mr Edwin Cox
Paula Cussi
Gordon and Marilyn Darling
Antony d'Offay Gallery
Mr and Mrs Kenneth Dayton
Mr Damon and The Hon. Mrs de Laszlo
Baron and Baroness Elie de Rothschild
Madame Gustava de Rothschild
The Leopold de Rothschild Charitable
 Trust
Baroness Liliane de Rothschild
Deutsche Bank AG
Sir Harry and Lady Djanogly
Miss W.A. Donner
Mr Paul Dupee
Mrs Maurice Dwek
Elephant Trust
Eli Broad Family Foundation
Elizabeth Arden Ltd
Mr and Mrs Georges A. Embiricos
The Essick Foundation
European Arts Festival

Evelyn, Lady Downshire's Trust Fund
Roberto Fainello Art Advisers Ltd
First Boston Corporation
Mr and Mrs Donald G. Fisher
The Fitton Trust
The Flow Foundation
Foreign & Colonial Management Limited
Miss Kate Ganz
Mr Henry Geldzahler
Ms Laure Genillard
Mr and Mrs David Gilmour
The German Government
Goethe Institut
Jack Goldhill
Sir Nicholas and Lady Goodison
 Charitable Settlement
David and Maggi Gordon
Mr William Govett
Mr and Mrs Richard Grogan
Gytha Trust
Mr and Mrs Rupert Hambro
Miriam and Peter Haas
Mrs Sue Hammerson
Harry Kweller Charitable Trust
The Hon. Lady Hastings
The Hedley Foundation
Hereford Salon
Mr and Mrs Michael Heseltine
Mr Rupert Heseltine
Mr Robert Hornton
Mr and Mrs Michael Hue-Williams
Hurry Armour Trust
Idlewild Trust
The Italian Government
Lord and Lady Jacobs
Mrs Gabrielle Keiller
James and Clare Kirkman Trust
Knapping Fund
Dr Patrick Koerfer
Mr and Mrs Richard Knight
Mr and Mrs Jan Krugier
The Kirby Laing Foundation
The Lauder Foundation-Leonard and
 Evelyn Lauder Fund
The Leche Trust
Robert Lehman Foundation, Inc
The Helena and Kenneth Levy Bequest
Mr and Mrs Gilbert Lloyd
Mr and Mrs George Loudon
Mr and Mrs Lawrence Lowenthal
Mail on Sunday
Mr Alexander Marchessini
J & H Marsh & McLennan (Charities
 Fund) Ltd
The Mayor Gallery
Penny McCall Foundation
Midland Bank Artscard
Mr and Mrs Robert Mnuchin
Mr and Mrs Peter Nahum
Mr and Mrs Philip Niarchos
Fondation Nestlé pour l'Art
Dr Andreas Papadakis
The Paradina Trust
Mr William Pegrum
Philips Fine Art Auctioneers
The Earl of Plymouth
Old Possum's Practical Trust
The Hon. Mrs Olga Polizzi

Paul Nash Trust
Peter Samuel Charitable Trust
Mr Jean Pigozzi
Ptarmigan Trust
The Radcliffe Trust
Sir Gordon Reece
Reed International P.L.C.
Richard Green Fine Paintings
Mrs Jill Ritblat
Rothschild Bank AG
Kathy and Keith Sachs
Mrs Jean Sainsbury
The Hon. Simon Sainsbury
Salander-O'Reilly Galleries LLC
Fondazione Sandretto Re Rebaudengo
 per l'Arte
The Scouloudi Foundation
Sebastian de Ferranti Trust
Schroder Charity Trust
Mr and Mrs D M Shalit
Ms Dasha Shenkman
South Square Trust
Mr A. Speelman
Standard Chartered Bank
The Swan Trust
Sir Adrian and Lady Judith Swire
Mr and Mrs Louis A. Tanner
Mr and Mrs Alfred Taubman
Mrs Barbara Thomas
Time-Life International Ltd
The 29th May 1961 Charitable Trust
Lady Juliet Townsend
Laura and Barry Townsley
The Triangle Trust
U.K. Charity Lotteries Ltd
Anne Best
Visiting Arts
Mr and Mrs Leslie Waddington
Waley-Cohen Charitable Trust
Mr Mark Weiss
Mr and Mrs Gérard Wertheimer
Weltkunst Foundation
Mrs Alexandra Williams
Graham and Nina Williams
Willis Faber plc
Mr Andrew Wilton
Thomas and Odette Worrell
The Worshipful Company of Goldsmiths
The Worshipful Company of Grocers
Mrs Jayne Wrightsman
and those donors who wish to remain
 anonymous

Friends Benefactors and Life Members 1958–1998
The André Bernheim Charitable Trust
Dr and Mrs David Cohen
Mrs Isobel Dalziel
Mr and Mrs Charles Dickinson
Lady Gosling
Miranda, Countess of Iveagh
Lord and Lady Jacobs
Mr and Mrs A.G.W. Lang
Sir Sydney and Lady Lipworth
The Sir Jack Lyons Charitable Trust
Mr Michael Rose
Lieutenant Commander and Mrs Shilling
Mrs Jack Steinberg

Mr John B. Sunley
Mr and Mrs Terry Willson

Tate Gallery of Modern Art
Arthur Andersen (pro-bono)
The Annenberg Foundation
Lord and Lady Attenborough
The Baring Foundation
David and Janice Blackburn
Mr and Mrs Anthony Bloom
Mr and Mrs John Botts
Frances and John Bowes
Mr and Mrs James Brice
Donald L. Bryant Jr Family
Mrs Melva Bucksbaum
Monsieur Alain Camu
The Carpenters' Company
Cazenove & Co
The Clore Foundation
Mr Edwin C. Cohen
Ronald and Sharon Cohen
The John S. Cohen Foundation
Gilbert de Botton
Giles and Sonia Coode-Adams
Sir Harry and Lady Djanogly
The Drapers' Company
English Heritage
English Partnerships
Ernst & Young
Esmée Fairbairn Charitable Trust
Doris and Donald Fisher
Richard B. and Jeanne D. Fisher
The Worshipful Company of
 Fishmongers
The Foundation for Sport and the Arts
Friends of the Tate Gallery
The Worshipful Company of Goldsmiths
Noam and Geraldine Gotteman
GJW Government Relations (pro-bono)
The Worshipful Company of
 Haberdashers
Hanover Acceptances Limited
André and Rosalie Hoffmann
Horace W. Goldsmith Foundation
Lord and Lady Jacobs
Irene and Hyman Kreitman
Leathersellers' Company Charitable Fund
Mr and Mrs George Loudon
McKinseys & Co (pro-bono)
The Mercers' Company
The Meyer Foundation
The Millennium Commission
The Monument Trust
Mr and Mrs M.D. Moross
Guy and Marion Naggar
The Paul Hamlyn Foundation
The Nyda and Oliver Prenn Foundation
The Quercus Trust
The Rayne Foundation
The Dr Mortimer and Theresa Sackler
 Foundation
The Salters' Company
Belle Shenkman Estate
Simmons & Simmons
London Borough of Southwark
The Starr Foundation
Sir Dennis and Lady Stevenson
Hugh and Catherine Stevenson

Miss M.F. Stevenson
Mr and Mrs Ian Stoutzker
John Studzinski
David and Linda Supino
The Tallon Chandlers Company
Laura and Barry Townsley
Townsley & Co
The 29th May 1961 Charitable Trust
Arend and Cecilia Versteegh
The Vintners' Company
Robert and Felicity Waley-Cohen
The Weston Foundation
Graham and Nina Williams
Poju and Anita Zabludowicz
and those donors who wish to remain
 anonymous

Tate Gallery of Modern Art: Collections Benefactor
Janet Wolfson de Botton

Tate Gallery of British Art
The Annenberg Foundation
The CHK Charities Limited
The Clore Foundation
Sir Harry and Lady Djanogly
The D'Oyly Carte Charitable Trust
The Dulverton Trust
Maurice and Janet Dwek
Friends of the Tate Gallery
Sir Paul Getty, KBE
Heritage Lottery Fund
Lloyds TSB Foundation for England
 and Wales
Sir Edwin and Lady Manton
The P.F. Charitable Trust
The Polizzi Charitable Trust
Lord and Lady Sainsbury of Candover
Mrs Coral Samuel CBE
Tate Gallery Centenary Gala
The Trusthouse Charitable Foundation
The Duke of Westminster OBE TD DL
The Wolfson Foundation
and those donors who wish to remain
 anonymous

Tate Gallery Liverpool
Association for Business Sponsorship of
 the Arts (Arts & Business)
Arrowcroft Group Plc
Arts Council of England
The Australian Bicentennial Authority
Barclays Bank PLC
The Baring Foundation
BASF
The Bernard Sunley Charitable
 Foundation
Boddingtons plc
British Alcan Aluminium plc
BG plc
BT
Calouste Gulbenkian Foundation
Coopers & Lybrand
Mr and Mrs Henry Cotton
Cultural Relations Committee
David M Robinson Jewellery
Deloitte & Touche
The Eleanor Rathbone Charitable Trust

The John Ellerman Foundation
English Partnerships
The Esmée Fairbairn Charitable Trust
European Arts Festival
European Regional Development Fund
The Foundation for Sport and the Arts
Friends of the Tate Gallery
Girobank plc
GPT Ltd
The Granada Foundation
Granada Television Limited
The Henry Moore Foundation
The Henry Moore Sculpture Trust
Heritage Lottery Fund
Mr John Heyman
Higsons Brewery plc
Ian Short Partnership
IBM United Kingdom Limited
ICI Chemicals & Polymers Limited
The John Lewis Partnership
The John S. Cohen Foundation
The Laura Ashley Foundation
The Littlewoods Organisation PLC
Liverpool John Moores University
Mr & Mrs Jack Lyons
Manchester Airport PLC
Manor Charitable Trust
Merseyside Development Corporation
Mobil Oil Company Ltd
MOMART plc
The Moores Family Charitable
 Foundation
The Museums and Galleries
 Improvement Fund
The Nigel Moores Family Charitable
 Foundation
NSK Bearings Europe Ltd
P & P Micro Distributors Ltd
Parkman Group Ltd
PH Holt Charitable Trust
The Pilgrim Trust
Pilkington plc
Pioneer High Fidelity (GB) Ltd
Rio Tinto plc
Royal & Sun Alliance
Royal Liver Assurance
Sainsbury Family Charitable Trusts
Samsung Electronics (UK) Limited
Save & Prosper Educational Trust
Scottish Courage Limited
Stanley Thomas Johnson Foundation
The Summerfield Charitable Trust
Tate Friends Liverpool
Trinity International Holdings plc
The TSB Foundation for England and
 Wales
The Trustees of the Tate Gallery Liverpool
Unilever plc
United Biscuits (UK) Limited
United Utilities plc
The University of Liverpool
Vernons Pools Ltd
Visiting Arts
Volkswagen
Whitbread & Company PLC
The Wolfson Foundation
and those donors who wish to remain
 anonymous